Worlds of Women

Susan M. Socolow, Samuel Candler Dobbs Professor of
Latin American History, Emory University
Series Editor

The insights offered by women's studies scholarship are invaluable
for exploring society, and issues of gender have therefore become a
central concern in the social sciences and humanities. The Worlds of
Women series addresses in detail the unique experiences of women
from the vantage points of such diverse fields as history, political
science, literature, law, religion, and gender theory, among others.
Historical and contemporary perspectives are given, often with a cross-
cultural emphasis. A selected bibliography and, when appropriate, a
list of video material relating to the subject matter are included in
each volume. Taken together, the series serves as a varied library of
resources for the scholar as well as for the lay reader.

Volumes Published

Judy Barrett Litoff and David C. Smith, eds., *American Women in a
World at War: Contemporary Accounts from World War II* (1997).
Cloth ISBN 0-8420-2570-7 Paper ISBN 0-8420-2571-5

Andrea Tone, ed., *Controlling Reproduction: An American History*
(1997). Cloth ISBN 0-8420-2574-X Paper ISBN 0-8420-2575-8

Mary E. Odem and Jody Clay-Warner, eds., *Confronting Rape and
Sexual Assault* (1998). Cloth ISBN 0-8420-2598-7
Paper ISBN 0-8420-2599-5

Elizabeth Reis, ed., *Spellbound: Women and Witchcraft in America*
(1998). Cloth ISBN 0-8420-2576-6 Paper ISBN 0-8420-2577-4

Martine Watson Brownley and Allison B. Kimmich, eds., *Women
and Autobiography* (1999). Cloth ISBN 0-8420-2702-5
Paper ISBN 0-8420-2701-7

Judy Barrett Litoff and David C. Smith, eds., *What Kind of World
Do We Want? American Women Plan for Peace* (2000).
Cloth ISBN 0-08420-2883-8 Paper ISBN 0-8420-2884-6

What Kind of World Do We Want?

What Kind of World Do We Want?

American Women Plan for Peace

Edited by
JUDY BARRETT LITOFF
and DAVID C. SMITH

 WORLDS OF WOMEN
Number 6

A Scholarly Resources Inc. Imprint
Wilmington, Delaware

Scholarly Resources Inc.
104 Greenhill Avenue
Wilmington, DE 19805-1897
www.scholarly.com

Library of Congress Cataloging-in-Publication Data

What kind of world do we want? : American women plan for peace /
edited by Judy Barrett Litoff and David C. Smith
 p. cm. — (Worlds of women ; no. 6)
 Includes bibliographical references.
 ISBN 0-8420-2883-8 (cloth : alk. paper)—ISBN 0-8420-2884-6
(paper : alk. paper)
 1. Women and peace—United States—History. 2. Women
pacifists—United States—History. I. Litoff, Judy Barrett. II. Smith,
David C. (David Clayton), 1929– III. Series.

JZ5578.W49 2000
940.53'12—dc21 00-037047

Acknowledgments

Numerous friends and colleagues have supported us in our efforts to retrieve the long-neglected but important history of U.S. women and postwar planning. Our dear friend and colleague, Martha Swain, generously shared her extensive files on women and postwar planning with us. The skillful and dedicated support of the staff of the Hodgson Memorial Library at Bryant College promptly, and sometimes it seemed miraculously, answered our many queries. Two student assistants, Kathleen Quigley and Greg Waldron, devoted many hours to checking references and footnotes, locating articles, and formatting the manuscript. Linda Asselin and Dotty Scott eased our work loads by assuming many responsibilities that enabled us to complete this book in a timely fashion. David Lux, chair of Bryant's history department, deserves special thanks for his abiding support.

Susan McElrath, archivist at the Mary McLeod Bethune Council House, patiently and meticulously guided us through the voluminous records of the National Council of Negro Women. The attentive staff of Scholarly Resources went out of their way to ensure that this book is professionally crafted. Vice President and General Manager Richard Hopper, in particular, deserves special praise.

Alyssa, Lock, Nadja, Jim, Sylvia, Clayton, Kit, Jamie, and Joshua have enriched our lives by providing us friendship, encouragement, scholarly advice, unforeseen challenges, wondrous adventures, and, most importantly, their love. To each of you, we offer our heartfelt thanks.

About the Editors

Judy Barrett Litoff, professor of history at Bryant College, and David C. Smith, Bird and Bird Professor of History Emeritus at the University of Maine, have researched and written about women and World War II for the past decade. Their books include *We're in This War, Too: World War II Letters from American Women in Uniform* (1994); *Dear Boys: World War II Letters from a Woman Back Home* (1991); *Since You Went Away: World War II Letters from American Women on the Home Front* (1991); and *Miss You: The World War II Letters of Barbara Wooddall Taylor and Charles E. Taylor* (1990). They have collected thirty thousand wartime letters written by American women and are preparing a seventy-reel microfilm edition, *The World War II Letters of American Women*, to be published by Scholarly Resources.

Contents

Introduction—"The Horrors of War and the Errors of Peace": U.S. Women and Postwar Planning

> The women of this generation who are familiar both with the horrors of war and the errors of peace have an extraordinary opportunity today to plan for the kind of peace they would like to emerge from this war. The task ahead of us all is not that of restoration but of reconstruction.[1]

Vera Micheles Dean, research director of the Foreign Policy Association, a private nonpartisan educational organization founded in 1918, offered this assessment shortly after the German invasion of Poland in September 1939. Dean was not alone in believing that women should play an important role in the construction of "the peace . . . to emerge from this war." Throughout the wartime years, U.S. women assiduously lobbied for full participation in national policymaking councils and international conferences concerned with preparing for the coming peace.

The literature on World War II, ranging from official military histories to privately published memoirs, is voluminous. A wide array of books and articles has scrupulously analyzed the political, economic, diplomatic, military, and social dimensions of the war. In recent years the categories of race, gender, class, ethnicity, and sexual orientation have been added to the World War II lexicon and have broadened our understanding of the tumultuous and unprecedented events that took place between 1939 and 1945.[2] Despite the outpouring of works on World War II, however, little has been written on the steadfast efforts of U.S. women to secure a place at the peace table.[3] That this important subject has eluded the attention of historians provides yet another example of the invisibility of American women's history.[4]

What Kind of World Do We Want? examines the collective efforts of a broad-based group of American women activists who called for the inclusion of women as equal partners with men on postwar planning

councils. It demonstrates that women engaged in a far-reaching and comprehensive dialogue that resulted in the formation of an umbrella interracial organization, the Committee on the Participation of Women in Post War Planning (CPWPWP), which ardently worked for women's inclusion in peacemaking deliberations. These wartime women activists enlisted the support and mobilized the membership of established women's organizations as they brought their message to millions of Americans. With the convening of a special White House Conference, "How Women May Share in Post-War Policy Making" in June 1944, the lobbying and planning efforts of these well-educated, mostly middle- and upper-class women assumed new importance.

The documents included in this volume show how the issues of gender and race played a pivotal role in the thinking of women activists as they planned for the postwar world. These documents offer a new perspective on postwar planning by concentrating on the wide-ranging endeavors of American women to use the war against fascism as an opportunity to press for major reforms, both at home and abroad, that would guarantee the human rights of each and every individual.[5]

Today, some fifty years after the end of World War II, the magnitude of the effort expended by both women *and* men during the war years to map out a course leading to permanent peace is still astounding. A variety of organizations, some with long histories and others founded for the specific purpose of promoting world peace, participated in this work. These organizations included the Council on Foreign Relations, the American Association for the United Nations, the Federal Council of Churches of Christ in America, the Foreign Policy Association, the War Resisters League, the Fellowship of Reconciliation, the World Peace Foundation, the Twentieth Century Fund, the Commission to Study the Organization of Peace, the Institute for Postwar Reconstruction, and the Universities Committee on Post-War International Problems.[6] Yet none of the organizations focused specifically on women and postwar planning.

Months before the United States entered World War II, American women activists began to advocate that they be included in the peace deliberations. As early as the spring of 1940, the *Independent Woman*, the official journal of the National Federation of Business and Professional Women's Clubs (NFBPWC), accentuated the likelihood that women would play an important role in planning for peace when it posed the question: "What can the United States do to realize . . . peace; how can women work for it?"[7] On November 13, 1941, three weeks before the Japanese attack on Pearl Harbor, the New York State Federation of Women's Clubs passed a resolution calling for the participation of women in postwar peace conferences. Four days later, on

November 17, Marjorie Merriweather Post Davies, wife of the former U.S. ambassador to the Soviet Union, acknowledged the special stake that women had in the war against fascism when she addressed two thousand persons in attendance at a New York City meeting assembled by the Council on Soviet Relations. She stated that "to none in this world is the outcome of this war more vital than to women. . . . If the Nazi totalitarian system should dominate our world, the status of women would be horrible to contemplate. It would be reduced to that of the breeder and the housefrau for an ordained super male in a world dominated by a so-called Nordic master race."[8]

Following the entry of the United States into World War II, the role to be played by women in postwar planning took on even greater significance. In June 1942, Congresswoman Mary T. Norton of New Jersey told a regional gathering of the Women's Division of the Democratic National Committee that "the mothers of the world" should be participants in the peace negotiations. At her December 17, 1942, press conference, First Lady Eleanor Roosevelt asked that a woman of "world viewpoint" be given a seat at the peace table. Women's organizations, such as Zonta International, pressed for the inclusion of outstanding women on the peace conference team; the National Women's Press Club encouraged women to participate in the peace discussions; and the 1942 annual meeting of the General Federation of Women's Clubs resolved that "women as mothers of the race" should insist on the inclusion of "qualified women at . . . post-war Peace Councils."[9]

In calling for the participation of women at the peace table, proponents acknowledged fundamental gender differences when they issued maternalist appeals to "the mothers of the world."[10] Arguing that "women as mothers of the race" had a distinct proclivity for peace not shared by men, they concluded that this essential gender difference strengthened women's qualifications to serve as participants on postwar planning councils. Proponents also asserted that women, as citizens of the United States, had the right and the responsibility to participate on an equal basis with men in the construction of the postwar world. Voicing support for what Joan W. Scott has termed the "equality that rests on differences" doctrine, they carefully intertwined the dual arguments of difference and citizenship in justifying their claims that they take an active part in the postwar deliberations. Like their nineteenth-century woman's rights predecessors, women activists of World War II had little difficulty in advocating both gender differences and equality.[11]

By the latter months of 1942 a coordinated campaign to ensure the equitable representation of women at postwar councils had begun to take shape. Mary E. Woolley initiated this effort when she issued a

call to representatives of twenty-one national women's organizations to meet on October 28, 1942, at the headquarters of the Young Women's Christian Association (YWCA) in New York City to discuss women's "full contribution to the planning and establishment of world cooperation." As a delegate to the 1932 Geneva Conference on the Reduction and Limitation of Armaments, Woolley had been the first woman to represent the United States at a major diplomatic conference. This distinction, coupled with her work as a suffragist, longtime peace advocate, internationalist, and president of Mount Holyoke College from 1900 to 1937, made her the logical person to convene such a meeting.[12]

At this gathering, Emily Hickman, another peace activist and a professor of history at the New Jersey College for Women, was selected to chair a committee "through which women's organizations might work together to ensure women's contribution to the planning and establishment of world cooperation." Over the next several months, Hickman enlisted the help of major women's organizations in forming an interracial umbrella organization, the Committee on the Participation of Women in Post War Planning (CPWPWP).[13] Eventually, more than a dozen national women's organizations affiliated with the CPWPWP. Woolley, who was seventy-nine, did not actively participate in the work of the CPWPWP, but she did serve as its honorary chair.[14]

Emily Hickman had launched her career as a crusader for peace in 1925 when she joined the National Committee on the Cause and Cure of War, an organization that had been founded the previous year by the well-known suffragist, Carrie Chapman Catt. Following Catt's advice that she stick to the peace movement, Hickman made two transcontinental lecture tours of the United States under the auspices of the Carnegie Endowment for International Peace during the 1930s. She attributed her steadfast commitment to the peace movement to the efforts of Catt, acknowledging that the renowned women's rights and peace advocate "had more influenced her than any other person." While the elderly Catt did not play a significant role in the activities of the CPWPWP, she was listed as a sponsor on the letterhead of the committee's stationery.[15]

With the exception of Emily Hickman, the vast majority of the women who form the centerpiece of this study were not active participants in the interwar movement for world peace. Yet this should not be construed to mean that these women, including such important public figures as Eleanor Roosevelt, Frances Perkins, Margaret Hickey, Mary McLeod Bethune, and Lucy Somerville Howorth, were disinterested in the issue of peace or that they were operating within a political and

ideological vacuum. As they grappled with the difficult question of whether or not women would be afforded the opportunity to participate fully in the construction of the peace to emerge from the war, they drew from and were guided by the work of the postsuffrage interwar women's movement for peace and social justice with its maternalist emphasis on motherhood and women's "natural" aversion to war.[16]

The dearth of women with strong ties to the peace movement to join in the campaign for women's inclusion in postwar planning councils can be explained, at least in part, to the fact that only two American women's peace organizations survived the war years. Both of these organizations, the United States section of the Women's International League for Peace and Freedom (WILPF) and the Women's Action Committee for Victory and Lasting Peace (WACVLP), affiliated with the CPWPWP. The WILPF, founded in 1915, led a tenuous existence during World War II; its American membership declined from a prewar high of fourteen thousand to less than four thousand at the war's end. Given the nearly unanimous support for the war effort that followed the Japanese attack on Pearl Harbor and the agonizing divisions within the United States section of the WILPF over whether or not to support the war, it is little wonder that it did not play a prominent role in the work of the CPWPWP. Although planning for a peaceful postwar world remained on the WILPF's agenda, its dwindling membership concentrated its efforts on helping war refugees, fighting racial and ethnic discrimination, and supporting conscientious objection.[17]

The Women's Action Committee for Victory and Lasting Peace, a far more mainstream organization than the WILPF, was formed in April 1943 after the National Committee on the Cause and Cure of War was disbanded. Founded for the purpose of uniting "American women to work for full participation by the United States in International efforts to build a world of peace and justice under law," the WACVLP lobbied for world cooperation and the creation of an international organization that would "establish justice" and "prevent war." Eighty-four-year-old Catt supported the dissolution of the Committee on the Cause and Cure of War and the creation of the WACVLP in its stead, but her role in the new organization remained largely honorary. However, she did address the first annual convention of the WACVLP in May 1944, urging the three hundred delegates from seven national women's organizations to "study well what kind of international organization will restrain the war-makers, strengthen the faith of the peace-makers and educate the world at large to see the blessings of peace."[18]

Catt's protégée, Hickman, welcomed the affiliation of the WILPF and the WACVLP with the CPWPWP. However, she also recognized that an aggressive campaign for the appointment of "qualified women

to . . . agencies dealing with post war problems" required more than simply appealing to traditional women's peace organizations.[19] As chair of the CPWPWP, Hickman devoted enormous time and energy to outreach work among women activists and national women's organizations. She undertook a grueling schedule that included carrying out her duties as a professor of history at the New Jersey College for Women in New Brunswick, traveling to New York City four or five times per week for CPWPWP meetings, and making frequent trips to the nation's capital where she helped to coordinate the activities of a Washington subcommittee that kept government officials apprised of the work of the Committee. Praised by one Committee member for her "indefatigable" energy, Hickman's work day rarely ended before midnight.[20]

During the early months of 1943, even as the CPWPWP was in its formative stages, it began to press for the nominations of women to participate in the United Nations Relief and Rehabilitation Administration (UNRRA) conference to be held in Atlantic City, New Jersey, the following November, one of the first international conferences to address the complexity of issues concerning the transition from war to peace. Hickman believed that it was essential that the Committee "move at once to recommend a woman as a member of the United States delegation."[21] In fact, two of the ten advisors to the official U.S. delegation to the Atlantic City UNRRA conference were women: Elizabeth Conkey, Commissioner of Public Welfare, Cook County, Illinois, and Ellen S. Woodward, a member of the Social Security Board.[22]

One of the most active women's organizations to affiliate with the CPWPWP was the National Council of Negro Women (NCNW), an association of twenty-two black women's organizations founded in 1935 by the distinguished educator and political activist, Mary McLeod Bethune.[23] At a time when segregation and discrimination permeated much of American society, the CPWPWP offered a genuine opportunity for black and white women to work together as they prepared for the postwar world. The wartime correspondence between Bethune and Hickman demonstrates that the two women had great admiration for each other. Moreover, the most comprehensive record of the CPWPWP is contained in the papers of the NCNW at the Bethune Museum and Archives in Washington, DC. The NCNW regularly responded to Hickman's requests for nominations of qualified women to postwar planning positions.[24] When Bethune, as president of the Council, requested that an NCNW representative be placed on the executive committee of the CPWPWP, the executive committee speedily and unanimously approved the NCNW nomination of Estell Massey Riddle.[25]

In May 1943, Bethune appointed an NCNW Postwar Planning Committee, with Inabell Burns Linsay of Howard University as its chair, to serve as a liaison group between the Council and the CPWPWP.[26] Linsay's first memorandum to Bethune emphasized the importance of postwar planning and stated that "the most effective war weapon of the democratic countries in this period is their willingness to initiate programs for a constructive peace in the midst of the war." She continued the memorandum with a prescient discussion of how racial and gender issues presented special challenges to "Negro women" as they prepared for the postwar world:

> We suffer the dual disadvantage of race and sex. To the end that these disadvantages shall be minimized or turned to advantages, we must now demonstrate to the world and to America in particular that we are capable of not only carrying our share of responsibility in the present need, but also of contributing to basic active democracy of the future. . . . [T]his committee [should] be the articulate voice of Negro women in pointing out to women of the majority group, areas where our interests coincide and where all women can work together for their country's and their own ultimate welfare.[27]

Historian Susan Lynn persuasively argues that the "first glimmerings of the shift" in women's conceptions of social justice from a "prewar emphasis on economic injustice suffered by working-class women and children . . . to a concern with the U.S. system of racial subordination" occurred during the war years. The interracial alliance of the CPWPWP and the NCNW provides a good example of how a select group of reform-minded women explicitly rejected the system of racial subordination that dominated much of the war-weary nation as they worked to construct a truly democratic postwar world.[28] In addition to cooperating with the CPWPWP, Bethune and the NCNW participated in a variety of other interracial activities concerned with preparing for the postwar world. In February 1944 the NCNW and five other national women's organizations, including the National Council of Catholic Women, the National Council of Jewish Women, the National Council of Women of the United States, the National Women's Trade Union League, and the YWCA, formed an interracial coordinating committee for "building better race relationships." The Coordinating Committee, which met on a regular basis for the remainder of the war, worked to promote better race relations by developing and disseminating bibliographical materials, producing radio programs, and holding interracial conferences and workshops on how women's organizations could help to safeguard human rights in the postwar

world. Indeed, the work of the Coordinating Committee provides still
another example of black and white women working together during
the war years.[29]

In September 1944 the Council, along with eighteen other national
women's organizations, also took part in a Postwar Committee Con-
ference sponsored by the American Legion Auxiliary. The NCNW re-
ported to the conference that "the outcome of the next decade of racial
progress depends upon the Negro woman and her wisdom and activity
as a voter and citizen. . . . [A]s Negro women we can evolve a program
of action rooted firmly in our common devotion to certain fundamen-
tal principles essential to the future of our race."[30] Bethune's interest
in postwar planning was also evinced when the NCNW chose "War-
time Planning for Post-War Security" as the topic for its 1944 Annual
Workshop. Bethune set the tone for the workshop when she urged the
interracial audience of two hundred members, delegates, and visitors
to "gear ourselves to the great task of mapping out a pathway that will
truly lead to a better world for us all." She continued by calling for
"one long strong pull altogether, toward the integration of and partici-
pation in the new found freedoms and opportunities that are opening
daily to the women of America and the world."[31]

One of the featured speakers at the 1944 workshop was Mary
Church Terrell, the highly acclaimed author, educator, and civil rights
advocate. In contrast to most of the other women in this study, Terrell
had strong ties to the women's peace movement that dated back to
1919, when she had addressed the Women's International League for
Peace and Freedom in Zurich, Switzerland. In addition, she served on
the national board of the WILPF during the 1920s and 1930s. Draw-
ing on her long association with the women's movement for world
peace, Terrell captured the spirit of the 1944 workshop in her address,
"Human Relations in Transition to Peace." She reminded the work-
shop participants that there "is only one way . . . to establish and main-
tain peace. To succeed in doing this each and every government must
treat all its citizens justly, no matter what their color may be, nor in
what kind of religion they may believe, nor where they were born nor
in what social class they may move." After appealing to Congress to
establish a permanent Fair Employment Practices Commission (FEPC)
and approve the anti-poll tax and anti-lynching bills, Terrell ended her
talk with a blunt statement: "Personally, I do not see how there can be
any peace during the transition period or at any other time, until col-
ored people are granted all the rights, privileges and immunities to
which they are entitled as citizens."[32]

During the course of the three-day workshop, the interracial com-
mitment of the NCNW to construct a just and equitable postwar na-

tion and world was further underscored when conference attendees heard speeches given by prominent black and white reformers, including Carolyn Ware of the American Association of University Women; Venice Tipton Spraggs of the Employment Department of the NCNW; Dorothy Rosenman, chair of the National Committee on Housing; William H. Hastie, dean of the Howard University Law School and former civilian aide to Secretary of War Henry L. Stimson; Virginia Durr of the Southern Human Welfare Conference; and Thomasina W. Johnson of the National Non-Partisan Council and Alpha Kappa Alpha Sorority. In response to the appeals of the speakers, the workshop adopted proposals on postwar jobs and the need for a permanent FEPC, supported programs "to eliminate slums and blighted areas," and demanded "full citizenship and political rights as guaranteed in the Constitution of the United States" for all Americans.[33] The summary statement of the 1944 workshop provided additional proof that the issues of gender and race ranked at the top of the postwar concerns of Bethune and the NCNW. The statement cautioned the "women of America" that a "formidable task" awaited them as they could not "escape the responsibility for being competent citizens." It continued by urging "Negro women" from "all localities" to "unite . . . and be the backbone of action to revolutionize the thinking and motivation of millions of Negro people . . . [and] reap a harvest rich in political, educational, economic, social and cultural advancement for the Negro."[34]

The persistent and determined efforts of the NCNW and the CPWPWP in behalf of promoting women's participation in postwar planning established a benchmark for U.S. women as they pressed forward with a wide-ranging campaign to be included in the peace deliberations. Women's organizations such as the Ladies Auxiliary of the Veterans of Foreign Wars sponsored national essay contests and public forums on the urgency of establishing a permanent peace. The Women's Division of the Democratic National Committee pressured President Franklin D. Roosevelt to appoint women to planning committees. At the Democratic National Convention, held in Chicago in July 1944, Gladys Tillett, head of the Women's Division, issued a stern warning to the delegates, declaring that "the American woman will not this time tolerate the stupidity of quitting the enterprise of world peace when the guns cease firing." Feature articles extolling the idea that women should be an integral part of the peace initiatives were published in popular women's magazines, and women wrote thoughtful letters to the press on this topic.[35]

Across the nation, middle-class and professional women's organizations convened meetings and conferences to discuss the role of

women in postwar planning. The International Federation of Business and Professional Women sponsored a one-day workshop, "Problems of the Peace Table," in New York City in February 1943. In May 1943 the executive committee of the United Council of Church Women, an organization that represented 10 million women, adopted a report stating that "it is essential that women be represented at the peace conference." The Board of Directors of the American Association of University Women adopted a resolution in June 1943 that supported the "inclusion of competent women" on postwar "policy-making boards, staff, and conferences." The League of Women Voters (LWV) devoted the summer of 1943 to "crystallizing and disseminating . . . the sentiments of their membership regarding post-war principles." The New York branch of the YWCA sponsored a May 1944 conference on peace aims and plans. The Matriots Foundation, a Washington, DC-based organization founded in the fall of 1944, called for " 'changing the predominant masculine domination of civilization and government' in the interests of peace." Other women's organizations that actively supported the participation of women in postwar planning councils included the American Legion Auxiliary, the General Federation of Women's Clubs, and the Quota Club International.[36]

One of the most resolute organizations to demand that women be included in postwar planning councils was the National Federation of Business and Professional Women's Clubs (NFBPWC). Throughout the war years, the *Independent Woman* published articles on the importance of women participating in postwar planning while the national presidents of the NFBPWC pressed for the inclusion of women in peacemaking deliberations.[37] At the NFBPWC's 1944 annual meeting, President Minnie L. Maffett reported that "women were conspicuous for their absence from policy-making posts." After disclosing that women held only eight top-level federal policymaking positions in 1944, Maffett adjured the nearly eighty thousand members of the NFBPWC "to seize upon . . . the opportunity . . . to prove their fitness for bearing an equal part with men in the shaping of the postwar world."[38]

The goal of including women in postwar deliberations took on greater significance with the convening of a series of conferences by the *New York Times* for the express purpose of giving "voice to women's point of view in the many current discussions of post-war planning." Organized by Natalie Wales Latham, director of women's programs at the *Times*, three conferences occurred between April 1943 and December 1944.[39] Anne O'Hare McCormick, the distinguished columnist on foreign affairs for the *Times* and member of the State Department's Advisory Committee on Post-War Foreign Policy, served as moderator and advisor. The first conference, held on April 7, 1943,

addressed the question, "What Kind of World Do We Want?" It featured speeches by such well-known luminaries as Frances Perkins, Virginia Gildersleeve, Dorothy Kenyon, Florence J. Harriman, Pearl Buck, Edna St. Vincent Millay, Margaret Culkin Banning, Fannie Hurst, and Margaret Mead. Judge Dorothy Kenyon, mindful of the other speakers, perceptively intertwined the notions of gender differences and equal rights when she mused:

> We have heard a great deal lately about the Four Freedoms [enunciated by President Roosevelt], all essential, all correlated. . . . But there is, it seems to me, another freedom, which I like to call the fifth freedom, without which these others cannot possibly be considered complete. It is simply freedom for women, or for anybody, to decide for themselves what they shall do in the world; to exercise freedom of choice in the disposition of their lives, to enjoy the same kind and degree of opportunity to exercise their diverse talents, whether in rocking the cradle or ruling the world, that every other human being has.[40]

A second *New York Times* conference, "The Challenge to Women's Organizations," was held on October 27, 1943. Leading national women's organizations, including the National Women's Trade Union League, the LWV, the National Council of Jewish Women, the Women's Christian Temperance Union, and the United Council of Church Women, sent representatives to the conference. In her opening address, the *Times* foreign affairs columnist Anne McCormick warned that women were being excluded from important postwar planning sessions. She told those present that "something is wrong either with women or with the processes of political thought when democratic governments summon only an occasional woman to help solve the greatest human problems that ever overwhelmed mankind." She continued by charging that "too many" women were "mere passengers, content to let others struggle and die to haul us through the storm into the port of safety." Following an assessment of the crucial role that American women were playing in the winning of the war, McCormick concluded: "All this will make women more powerful and important in the post-war world than they have ever been. . . . This spells responsibility, staggering responsibility. Are women ready for it?"[41]

In early December 1944 the *New York Times* hosted a third conference for women, this time built around the theme, "No World War III —A Challenge?" Democratic Congresswoman Emily Taft Douglas from Illinois, one of the featured speakers, noted that the women of the World War II generation were the first women to be "full citizens during a great crisis," and that "we are the first women to have a chance

to help build a peace" as well as have the opportunity to exercise "a decisive voice" in public policy.[42]

Well-placed women in federal government posts joined in the effort to ensure that qualified women were part of the peace process. Margaret A. Hickey, chair of the Women's Advisory Committee of the War Manpower Commission from 1942 through 1945 as well as president of the NFBPWC from 1944 to 1946, voiced pragmatic and expedient reasons for the inclusion of women on postwar planning councils. In a late 1943 speech, she expressed concern that "the flow of women out of industry" at the end of the war would result in "a return to [the] popularity of the theory that the only place for a woman is within the four walls she calls home." But Hickey concluded this speech on an optimistic note, observing that with "mobile people, flexible people, people who can meet change with a spirit of adventure and enthusiasm and people with a sense of social responsibility . . . there will be no questions of 'either-or' in respect to post-war jobs."[43]

On December 3, 1943, the Women's Advisory Committee submitted a formal statement to Bernard M. Baruch, chairman of the Advisory Unit for War and Post-War Adjustment Policy of the Office of War Mobilization, recommending that the "membership of government and industry committees planning for industrial conversion include persons" who will confront "that great problem of the post-war world—the successful employment of *the whole* population." Early in 1944 the Committee published a pamphlet, "The Wartime Responsibility of Women's Organizations," that urged women's associations "to lead the women of their community in transferring over into the postwar period the gains made during wartime." Building on this theme, Hickey addressed the 1944 Arkansas State Convention of Business and Professional Women's Clubs and warned that "women's groups everywhere must be on the alert to see that . . . official wartime policy is practiced now and extended into the postwar period."[44]

Mary Anderson, director of the Federal Women's Bureau, also argued that the appointment of women to postwar planning councils would help to ensure that the wartime gains of working women would be safeguarded during times of peace. In a January 1944 address to the annual meeting of the American Economic Association, Anderson described how "women's role in peacetime employment" was "being overlooked or underestimated." Emphasizing that "full employment means women as well as men," Anderson called for the appointment of "qualified women" to the "various planning committees—whether set up by industry, labor, or government, whether on the local, national, or international level."[45] Linking the "broad objective of the great struggle in which the United States is engaged" to the establish-

ment of the Four Freedoms in the "American economy at home, as well as in the world at large," the Women's Bureau sponsored six conferences on women and postwar employment during 1944 and 1945.[46]

The national dialogue on women's participation in postwar planning reached the highest levels of government when a special White House Conference, "How Women May Share in Post-War Policy Making," was convened on June 14, 1944, in response to numerous appeals by Eleanor Roosevelt that women "be represented at the peace table . . . [and] in every international conference."[47] One of the First Lady's most widely circulated comments on this topic appeared in the April 1944 issue of *Reader's Digest*. Emphasizing that women and men held sharply divergent opinions about war, Mrs. Roosevelt wrote, "Through the years men have made the wars; it is only fair to suggest that women can help to make a lasting peace." Further accentuating these gender differences, she remarked, "Women will try to find ways to cooperate where men think only of dominating." Still, Mrs. Roosevelt asserted that women's participation in postwar councils should not be "to oppose men, but to work with men, to have a share in shaping the new world." Reflecting her belief in the doctrine that equality rests on differences, she maintained that women would bring distinct viewpoints to the peace table that would enable them to broaden and enhance the postwar agenda as they worked in equal partnership with men.[48]

In response to the growing demand that women participate in postwar planning, Charl Ormond Williams, director of Field Service for the National Education Association (NEA) and former president of both the NEA and the NFBPWC, wrote to Eleanor Roosevelt on January 29, 1944, suggesting that a small "exploratory group" be formed to discuss the issue of the appointment of women to postwar commissions. Heeding this suggestion, Mrs. Roosevelt invited representatives from thirteen of the nation's leading women's organizations to a luncheon at the White House on May 11. Recognizing the need for swift action, this "exploratory group" recommended that a national conference on women and postwar planning be held at the White House on June 14.[49]

As coordinator of the White House Conference, "How Women May Share in Post-War Policy Making," Williams relied upon the advice and aid of other prominent women, such as Minnie L. Maffett, president of the NFBPWC; Kathryn McHale, general director of the American Association of University Women; and Lucy Dickinson, president of the General Federation of Women's Clubs. However, the bulk of the organizational work for the conference depended on the capable skills of Williams and her NEA staff. Writing to the First Lady just three days before the conference, Williams remarked: "We have worked like

beavers on this conference, Mrs. Roosevelt, but it has been a labor of love."[50] Invitations to the conference were sent to more than two hundred distinguished women, including leaders of seventy-five women's organizations. In a June 7 letter to the delegates, Williams noted that women from "every section of the country" would be represented, and she predicted that the meeting would be "an historic milestone in women's contributions to society."[51]

Eleanor Roosevelt opened the day-long conference with brief welcoming remarks. The keynote address, "Women's Responsibilities in World Affairs," was delivered by Lucy Somerville Howorth, a senior attorney in the Office of the Legislative Counsel at the Veterans Administration as well as a member of the CPWPWP. Howorth told her audience: "You are the voice of multiplied thousands of women in the homes and kitchens, in fields and factories, in cloistered college and public ways. It is for you not only to think and act, but to stir those whom you can reach to thought and action." She discussed the likelihood that the forthcoming peace settlement would be built upon a "series of general international [and] technical conferences" rather than a "full-dress peace conference on the Versailles model." Howorth continued her remarks by asserting that if women did not "push and shove themselves into policy-making positions," they would be "ineffective in this hour of destiny."[52]

The morning session of the White House Conference featured speeches by Josephine Schain, Ellen Woodward, Elizabeth Conkey, C. Mildred Thompson, Congresswoman Margaret Chase Smith, and Secretary of Labor Frances Perkins—all of whom had participated in international councils concerned with postwar issues.[53] The experience of Thompson, dean of Vassar College and the only woman delegate appointed to the Conference of Allied Ministers of Education held in London in April 1944, underscored the barriers that women faced as they sought positions on postwar councils. Thompson told the conferees that her belated appointment to the American delegation was an "afterthought" that occurred only after the five men "were appointed and ready to go." In fact, Thompson had only three days' notice to prepare for the trip.[54]

Several of the morning speakers used maternalist arguments that accentuated women's "natural" affinity for peace to support their demand that qualified women be appointed to postwar councils. In her keynote address, Lucy Howorth stated that "women are the natural planners of the human race," while Josephine Schain remarked that "women are the conservers of life and therefore they naturally react against the terrible destruction that is brought about by modern hostilities." C. Mildred Thompson argued that postwar conferences on

educational aid to liberated countries "would naturally fall within the province of women's interests and qualifications." As advocates of gender differences, the speakers further asserted that the peacemaking process would profit from women and men, each with their distinct qualifications, working together on postwar councils. Perhaps the clearest articulation of this tenet occurred when Schain told the conferees: "The best results are generally achieved by men and women working together, for men's ideas, approach and convictions plus women's ideas, approach and convictions make a unified whole."[55]

Adeptly entwined into these maternalist arguments, with their emphasis on gender differences, was the belief that qualified women, as citizens of the United States, had the right and the responsibility to participate fully in postwar planning. Josephine Schain declared that "women are citizens and should have a share in government." C. Mildred Thompson insisted "that qualification for the job be the sole test for the privilege and the duty to serve our country in post-war planning." Frances Perkins forthrightly asserted: "American women today do not make their claim to positions of responsibility and trust because they are women. They will be used successfully only as they are patriotic, trustworthy, responsible citizens of demonstrated ability."[56]

The afternoon session of the White House Conference was devoted to a discussion of future opportunities for women in national and international policymaking positions. Speakers included G. Howland Shaw, assistant secretary of state and the only man to address the conference; Helen Rogers Reid, vice president of the *New York Herald-Tribune*; and Ruth Bryan Rohde, former U.S. minister to Denmark. Assistant Secretary of State Shaw assured those in attendance that the State Department was "looking for the best in the land [to serve on postwar planning councils] . . . those who possess preeminently the requisite qualifications will be chosen, whether they be men or women." Rohde, however, took exception to Shaw's statement, caustically remarking, "If this were more than theory, that citizens are chosen on their qualifications, we wouldn't need to be here now." Although not a featured speaker at the White House Conference, Mary McLeod Bethune used the afternoon forum to press for the inclusion of Negro women on international commissions.[57]

The White House Conference concluded by adopting a resolution entreating women to "take every step within our power to further the active participation of qualified women in positions of responsibility pertaining to the conduct of public affairs, national and international." Accentuating essential gender differences while also emphasizing the rights and responsibilities of women as citizens of the United States, the official summary statement of the conference offered strong

support for the inclusion of women on postwar planning councils when it declared: "No part of the citizenry holds a greater stake in the democratic way of life, in plans for the reconstruction of an ordered world, than the women of the nation. Women have been called upon to share the burdens of war, to stand side by side with men on the production line and to complement men in the fighting services. So women must share in the building of a post-war world fit for all citizens—men and women—to live and work in freely side by side."[58] In order to help ensure that qualified women be appointed to postwar policy positions, conference delegates endorsed a suggestion made by Lucy Somerville Howorth in her keynote address that a roster be compiled of "the names of able, intelligent, personable women, qualified to serve in conferences to come." A six-person Continuation Committee, headed by Charl Ormond Williams, was appointed to oversee the creation of the roster.[59]

The press provided substantial coverage to the work of the White House Conference. Eleanor Roosevelt devoted parts of two of her "My Day" newspaper columns to the meeting. An editorial writer for the *New York Times* applauded the goals of the conference, noting that there had been "few such appointments [of women]. There should be more. It would be superfluous to dwell on the high feminine competence obvious to everybody. . . . It would be for the good of the country that their representation be larger." Ellen Woodward reported to Charl Williams that "the men have all been asking questions about the meeting and I think they know that women mean business—that they intend to have a share in the planning of the post-war world."[60]

The enthusiasm generated by the June 1944 White House Conference provided the impetus for conferences at the state and regional levels on the participation of women in local, state, regional, and international postwar planning councils. On September 7, 1944, a Texas "White House" Conference, "How Women May Share in State Government," met in Austin. A January 1945 South Carolina "White House" Conference brought together one hundred representatives of women's organizations from throughout that state. The Altrusa Club of Chicago, assisted by the Altrusa Clubs of Illinois, Wisconsin, and Indiana, sponsored a November 20, 1944, planning conference on women and postwar policymaking. On the day of the conference, Williams was featured on the *National Farm and Home Hour*, a syndicated radio program that originated at WLS in Chicago. Both she and Elizabeth Conkey addressed the planning conference. This meeting, in turn, served as the springboard for a February 22, 1945, midwestern conference, "Women's Share in Postwar Planning," which three hundred delegates attended at the Palmer House in Chicago.[61]

During the six months following the June 1944 White House Conference, the Continuation Committee, under the leadership of Williams, solicited information on 730 nominees to be considered for inclusion on the proposed roster. From this number, 260 names were placed on the official "Roster of Qualified Women," which was presented to President Roosevelt on January 5, 1945, and to Secretary of State Edward R. Stettinius, Jr., on January 17. Williams had hoped that President Roosevelt would issue a strong public statement in support of the Roster, but FDR, occupied by preparations for his forthcoming trip to Yalta, stated at his January 16 press conference that the announcement of the Roster would occur at his wife's January 22 press conference. On January 22, with Williams at her side, the First Lady told the press that "now no man can ever say he could not think of a woman qualified in a particular field. It is not that men do not want to use women on various commissions, but it is because they forget."[62]

By the time the Roster of Qualified Women had been presented to the president and the secretary of state, U.S. women had suffered a major setback. They had been excluded from the Dumbarton Oaks deliberations, held in Washington, DC, from August 21 to October 7, 1944. These pivotal negotiations, conducted by representatives from the United States, the Soviet Union, England, and China, led to the proposals that provided the outline for the United Nations organization.[63] The omission of women from Dumbarton Oaks, coming in the wake of Assistant Secretary of State Shaw's assurance at the June 14 White House Conference that the State Department was "looking for the best in the land . . . whether they be men or women," brought forth a swift and angry response. Congresswomen Clare Boothe Luce, Edith Nourse Rogers, and Margaret Chase Smith issued strong statements of condemnation to the press. Prompted by the exclusion of women from Dumbarton Oaks, the *New York Herald-Tribune* interviewed ten distinguished women in political and public life who produced a list of fifty-six women whom they regarded as eminently qualified to hold positions in future international parleys. Twenty-four of these women were introduced at a *Herald-Tribune* forum held on October 18. An incredulous Emily Hickman informed the members of the CPWPWP that the State Department's explanation for the exclusion of women at Dumbarton Oaks was that it considered the meeting to be "an exploratory set of conversations by experts and not a regular international conference."[64]

In failing to invite women to participate in the Dumbarton Oaks deliberations, the nation's political leaders had demonstrated that they did not consider the inclusion of women at the peace table to be a top priority. As they planned for the postwar world, President Roosevelt

and his key advisors concentrated their attention on military, strategic, and geopolitical issues. While the postwar world envisioned by wartime women activists was not exclusively advocated by women, it is clear that the male-dominated political establishment did not view the war as an opportunity to bring about significant reforms both at home and abroad with the same seriousness and urgency as did women. In bitter recognition of this reality, Ellen Woodward, one of only two women advisors to the 1943 UNRRA conference, wrote to Lucy Howorth bemoaning the fact that there was "so little social thinking among the men on the USA delegation."[65] While men might give lip service in support of the inclusion of women in the peace deliberations, they also recognized that the participation of reform-minded women on postwar planning councils would, most likely, confound their problems. Moreover, as citizens who remained on the periphery of the nation's economic, political, and military infrastructure, women lacked the credentials needed to convince policymakers to accept them as major players in the international political arena.

Although women were excluded from Dumbarton Oaks, Secretary Stettinius and his associates in the State Department had no hesitancy in calling on women's associations to use their well-honed organizational skills to educate the American citizenry about the importance of supporting the proposals that emerged from the deliberations. In the hope that the mistakes that had occurred in the aftermath of World War I could be avoided, when isolationists mounted a campaign that led to the Senate defeat of the League of Nations, women's organizations enthusiastically responded to the State Department's request.

The Women's Division of the Democratic National Committee, the League of Women Voters, the NCNW, and the NFBPWC assumed leadership roles in arranging community meetings and mobilizing public opinion in support of the Dumbarton Oaks Proposals, which called for the establishment of an international peacekeeping organization. The activities of the LWV were particularly noteworthy. During the fall of 1944, the organization trained five thousand members for a nationwide "Take It to the People" campaign that involved the distribution of over a million pieces of literature, including the popular pamphlet, *The Story of Dumbarton Oaks*, written by historian Anne Firor Scott, then a young woman working with the Washington, DC, chapter of the LWV. Of equal importance was the work of the NCNW in ensuring that discussions of the Dumbarton Oaks Proposals extended to African-American communities throughout the nation. These myriad activities culminated with the celebration of "Dumbarton Oaks Week"

in mid-April 1945 when women's organizations sponsored speeches, rallies, luncheons, teas, radio programs, and forums around the nation in behalf of the United Nations Conference to be convened on April 25 in San Francisco.[66]

The State Department announcement of February 13, 1945, that Virginia Gildersleeve, dean of Barnard College, would be one of the eight U.S. delegates to the San Francisco Conference rekindled hope that women would, in fact, take their rightful place at the peace table. Helen Dwight Reid, international relations representative of the American Association of University Women, hailed Gildersleeve's selection for the UN meeting as "recognition of women by the Department of State." Noting that there had been "a marked acceleration in the number of able women appointed to important commissions," Reid attributed these gains to the diligent work of "women's organizations in developing an informed public opinion on issues like Dumbarton Oaks" and the availability of a Roster of Qualified Women. Gildersleeve, herself, recognized the importance of the Roster in her selection as a delegate, commenting in an interview that "I feel I was appointed because American women made a drive for representation and my name was on the roster they compiled. Therefore I do represent our women, but I hope I also represent my fellow citizens as a whole."[67]

In response to a question from journalist Agnes Meyer about the "woman's point of view" at the forthcoming peace conference, Gildersleeve replied that "women the world over are determined to prevent another war, though we must not talk as if fathers minded less than women when their sons are killed in battle." Elaborating on this idea, Gildersleeve expressed qualified support for gender differences, acknowledging that "if there is one difference between the sexes, it is that women have a deep instinct for the conservation of life and are less belligerent than men."[68] In her memoir, *Many a Good Crusade*, Gildersleeve observed that her appointment to the U.S. delegation to the San Francisco Conference made her "the most conspicuous woman in the United States." As a member of the Committee on the Preamble, the Purposes, and the Principles, Gildersleeve helped to draft the Preamble to the United Nations. She stated that she was pleased that her version of the first paragraph of the Preamble was approved by the Committee, but, as a professor of literature, she expressed disappointment over the "clumsiness of phrasing" of the Preamble in its entirety. Gildersleeve's other committee assignment, the Committee on Economic and Social Cooperation, included promoting cultural and educational exchanges as well as helping to ensure that a Commission on Human Rights be established. She noted that most delegations that

"had women members assigned a woman to the Economic and Social Committee, since it was apparently regarded as a suitably feminine field."[69]

Nonetheless, a controversy soon arose among the women who were assigned to the Economic and Social Committee over single-sex organizing as a strategy to bolster women's power base within the United Nations. In commenting on this dispute, Gildersleeve contrasted the position of the "militant feminists" who endorsed the "idea of women as a separate group" and women, such as herself, who supported the "conception of women in the Conference as equal comrades with men working for the same end and on the same basis." The "militant feminists," under Dr. Bertha Lutz, a pioneering leader of the woman suffrage movement in Brazil, proposed that a Commission on the Status of Women, composed entirely of women, be established. But Gildersleeve opposed separatist organizing within the United Nations, arguing that "women should be regarded as human beings as men were and the Commission on Human Rights would adequately care for their interests." She further asserted that if women "should be segregated in this special feminine commission, then it might well happen that the men would keep them out of other commissions and groups, saying that they had plenty of scope in their own organization." Following a heated and lengthy debate, Lutz's proposal was rejected. Subsequently, however, a UN commission on women was established.[70]

Considering the emphasis that U.S. women placed on their rights and responsibilities as citizens to work as equal partners with men in planning for the postwar world, it is not surprising that Gildersleeve rejected the single-sex organizing strategy of Lutz. The separatist dimension of American women's organizational efforts to be included as participants in the peace deliberations represented a temporary expedient to be abandoned when they achieved their rightful place at international councils and parleys. Given her long tenure as the dean of Barnard College, Gildersleeve could have scarcely failed to recognize that the shared experiences of women in female-centered organizations often led to a collective consciousness that spurred them to public activism and strengthened their position within the larger male-dominated political arena. Nonetheless, Gildersleeve opposed separatist organizing within the United Nations and confidently declared that women and men should work together as "equal comrades . . . for the same end and on the same basis."[71]

Accompanying the eight U.S. delegates to the San Francisco Conference were 246 consultants, associates, advisors, experts, aides, and other assistants. Among the forty-two private organizations invited by the State Department to send representatives to the conference as con-

sultants were five women's groups: the American Association of University Women, the General Federation of Women's Clubs, the National Federation of Business and Professional Women's Clubs, the League of Women Voters, and the Women's Action Committee for Victory and Lasting Peace. In total, fifty-four women represented the United States at the United Nations Conference.[72]

The State Department described its list of forty-two consulting organizations as constituting a "fair cross section of citizens groups." However, African-American women's organizations were notably absent from the list. The ever-vigilant Mary McLeod Bethune protested this omission, and the NCNW fired off a series of letters to State Department officials exhorting Secretary of State Stettinius to appoint Bethune as a consultant to the U.S. delegation. Although these protests were initially rebuffed, Bethune eventually found her way to San Francisco, where she joined W. E. B. Du Bois and Walter White as representatives of the National Association for the Advancement of Colored People (NAACP). In a summary report about her work at the San Francisco Conference, Bethune told the 800,000 members of the NCNW that "it is not the mere presence of the few women delegates, counselors, consultants, special advisers, observers, secretaries, stenographers, teletype operators, messengers, information booth attendants, and canteen workers that is significant. The presence of women here marks their maturing political vision."[73]

Building on her experiences at the San Francisco Conference, Bethune wrote in September 1945 to Nannie H. Burroughs, the well-known African-American educator and founder of the National Training School for Women and Girls: "These are the days when women must think and work together."[74] In actuality, women activists, representing a broad-based, loosely configured coalition of women's organizations, had worked tirelessly over the previous six years for the inclusion of women at the peace table; their efforts had touched the lives of millions of American women.

Led by influential public figures such as Eleanor Roosevelt, Mary McLeod Bethune, Anne O'Hare McCormick, Ellen Woodward, Lucy Somerville Howorth, Charl Ormond Williams, Emily Hickman, and Virginia Gildersleeve, who had amassed distinguished records in government and public service dating back to the early twentieth-century suffrage movement, women throughout the United States had compellingly asserted their belief that they had the right and the responsibility to participate fully in postwar planning councils. While they paid tribute to essential gender differences, maintaining that their role as mothers of the human race strengthened their qualifications to serve as equal participants with men at the peace table, they also argued that

as U.S. citizens who had "shared in the work and suffering of war," they must now accept the "tasks of peace." Routinely intertwining the dual arguments of female distinctiveness and citizenship, wartime women activists valiantly demanded that they take part in the construction of the postwar world.[75] Moreover, they reasoned that their participation in peacemaking deliberations would provide them with the opportunity to strengthen and augment the gains in behalf of racial and gender equality that they had helped to foster during the war years.[76] They did not consider these wartime advances to be temporary victories that would be abandoned at the end of the conflict. Rather, they viewed these accomplishments as representing important steps toward the creation of a better and more democratic nation and world.[77]

At the war's end, the CPWPWP could report that women had been appointed to numerous postwar planning conferences, including the June 1943 International Food and Agriculture Conference in Hot Springs, Virginia; the November 1943 UNRRA conference at Atlantic City, New Jersey; the April 1944 conference of Allied Ministers of Education in London; the July 1944 UN Monetary and Financial Conference in Bretton Woods, New Hampshire; and the April 1945 United Nations Conference at San Francisco, California.[78] Yet despite the tenacity, energy, and hard work exhibited by America's wartime women, the nation's political leaders demonstrated only lukewarm support for the inclusion of reform-minded women on postwar councils. Situated far from the political, economic, and military centers of power, women activists encountered enormous obstacles as they campaigned for a place at the peace table alongside men. They were excluded from the influential Dumbarton Oaks deliberations, and they were woefully underrepresented at other postwar conferences and councils. As marginalized members of the peacemaking deliberations, women were denied an effective voice in the postwar discourse.

In an October 1945 letter to members of the CPWPWP, Hickman deplored the limited success of women's postwar planning efforts when she remonstrated that "we still have to beg and petition for the privilege of helping the policy-making work of our government. We even have to persuade them to tell us soon enough when conferences are being scheduled so that we may have time to secure the nomination of qualified women." Two years earlier, Woodward had written to Hickey from the 1943 UNRRA conference and observed: "I do not want to be trite but I want to say and with all due emphasis—this is still a man's world." In 1945 women who continued to push for full participation in national policymaking councils and international peace assemblies had little cause to dispute Woodward's statement.[79] Without question, the postwar agenda constructed at national and international councils had

been impoverished by the underutilization and omission of U.S. women from these deliberations.

The world that emerged in the aftermath of the war, with its rigid Cold War politics, massive armament expenditures, and blatant disregard for human rights, was vastly different from and inferior to the world that women activists had so tirelessly striven to create. They had imagined a postwar world that promised equal rights and responsibilities for all people, regardless of gender, race, religion, or social class; the full and successful employment of both women and men; the opportunity for women to assume their rightful places in the halls of government and public life at the local, national, and international levels; and an unfaltering respect for human differences. Calling for the renewal and expansion of democracy at home and abroad, they had hoped to construct a permanent peace that would protect the human rights of every person.

That women activists of World War II lacked the political power to construct the postwar world they had envisioned should not cause us undue despair. Historically, male-dominated political establishments have denied women the opportunity to participate fully in the making and implementing of international policies. Within this context, the diligent efforts, ambitious agenda, and limited successes of wartime women activists take on new meaning. Moreover, their vision and nearly forgotten legacy can serve the present generation of Americans well, as socially conscious women (and men) continue in the struggle to create the world championed by women activists some fifty years ago.[80]

Notes

1. Vera Micheles Dean, "Over European Horizons," *Independent Woman* 19 (February 1940): 41. For biographical information on Dean, see Judy Barrett Litoff and Judith McDonnell, eds., *European Immigrant Women in the United States: A Biographical Dictionary* (New York, 1994), 73–74. Dean also wrote *The Four Cornerstones of Peace* (New York, 1946).

2. On the extent of the World War II literature, see John Keegan, *The Second World War* (New York, 1990), 596–98. In compiling the bibliography for his book, Keegan noted that 15,000 titles in Russian alone had been published prior to 1980. For information on works of particular interest to American historians, see Jim F. Heath, "Domestic America during World War II: Research Opportunities for Historians," *Journal of American History* 58 (1971): 384–414; and James E. O'Neill and Robert W. Krauskopf, eds., *World War II: An Account of Its Documents* (Washington, DC, 1976). Each issue of the *World War II Studies Association Newsletter* contains a lengthy section of recent books and articles about World War II.

3. During World War II, the term "peace table" was construed to be a general expression that referred to national and international gatherings concerned with

preparing for the postwar world. Important works on women's roles and their status during World War II may be found at the end of this volume in Suggested Readings.

4. Much, of course, has been written on the invisibility of women's history. A particularly useful work is Anne Firor Scott, *Making the Invisible Woman Visible* (Urbana, IL, 1984).

5. For a provocative discussion of the efforts of Eleanor Roosevelt to persuade Franklin Roosevelt to use the war against fascism abroad to bring about reform and a renewal of democracy at home, see Doris Kearns Goodwin, *No Ordinary Time: Franklin and Eleanor Roosevelt—The Home Front in World War II* (New York, 1994).

6. Ruth B. Russell, *A History of the United Nations Charter: The Role of the United States, 1940–1945* (Washington, DC, 1958), 215–16 provides a brief discussion about the work of the major wartime organizations concerned with postwar planning. A more recent work, Townsend Hoopes and Douglas Brinkley, *FDR and the Creation of the U.N.* (New Haven, CT, 1997), focuses on the role that Roosevelt and his key advisors played in the establishment of the United Nations. The World Peace Foundation, established in 1910, published a series of important pamphlets, *America Looks Ahead*, during the war years. The Twentieth Century Fund published a series of books, *When the War Ends*, during the war years. The Commission to Study the Organization of Peace published a series of widely distributed monographs on aspects of world peace. The Institute for Postwar Reconstruction held conferences on postwar reconstruction and published the proceedings of these meetings. On the Universities Committee on Post-War International Problems, see *International Conciliation* 401 (June 1944), 405 (November 1944), and 410 (April 1945). Of particular interest is Arnold L. Zurcher and Richmond Page, eds., *Postwar Goals and Economic Reconstruction* (New York, 1944). We have identified more than fifty books on postwar planning, written by American citizens, that were published during the war years. Examples include Carl Becker, *How New Will the Better World Be? A Discussion of Post-War Reconstruction* (New York, 1944); Earl Browder, *Victory and After* (New York, 1942); John Foster Dulles, *War, Peace and Change* (New York, 1939); Herbert Hoover and Hugh Gibson, *The Problems of Lasting Peace* (Garden City, NY, 1942); Walter Lippmann, *U.S. War Aims* (Boston, 1944); A. J. Muste, *Non-Violence in an Aggressive World* (New York, 1940); Archbishop Francis J. Spellman, *The Road to Victory* (New York, 1942); Norman Thomas, *What Is Our Destiny?* (Garden City, NY, 1944); Henry A. Wallace, *The Century of the Common Man* (New York, 1943); and Wendell L. Willkie, *One World* (New York, 1943). The fact that all of these books were written by men should not obscure the fact that the question of the postwar world weighed heavily on the minds of U.S. women. As this work demonstrates, women organized conferences and committees, gave papers, wrote newspaper and magazine articles, and devoted immense energy to sundry activities concerned with postwar planning. But they did not write books that focused specifically on this topic during the war years. However, women writers occasionally devoted sections of larger works to questions concerning the postwar world. See, for example, Susan B. Anthony II, *Out of the Kitchen—Into the War* (New York, 1943), especially chapter 15, "Women and the Post-War World," 232–46.

7. "Business Women in a Democracy," *Independent Woman* 19 (April 1940): 115.

8. Nona Baldwin, "Women Ask Place at Post-War Table," *New York Times*, November 14, 1941. "Need for Quick Aid to Russia Stressed," *New York Times*, November 18, 1941.

9. "Mrs. Norton Urges Mothers Aid Peace," *New York Times*, June 17, 1942. "Seek Role at Peace Table," *New York Times*, July 4, 1942. "First Lady Suggests Woman at Peace Talk," *New York Times*, December 18, 1942. "Women Told to Ask Peace Table Seats," *New York Times*, November 11, 1942. "Resolution Adopted by the General Federation of Women's Clubs, Fort Worth, Texas, May 1942," reprinted in Report of the Conference, "How Women May Share in Post-War Policy Making." Addresses delivered at the White House Conference, June 14, 1944. Distributed by the General Federation of Women's Clubs. Charl Ormond Williams Papers, Box 8, Manuscript Division, Library of Congress (LC), Washington, DC.

10. Seth Koven and Sonya Michel have defined maternalist as "using political discourses and strategies" to transform "motherhood from women's primary *private* responsibility into *public* policy." While Koven and Michel focus their attention on the early twentieth-century efforts of maternalist reformers to create welfare states that protected the interests of women and children, they note that "maternalist women . . . also generated searching critiques of state and society." Seth Koven and Sonya Michel, eds., *Mothers of a New World: Maternalist Politics and the Origins of Welfare States* (New York, 1993), 2. An important study that focuses on maternalist alliances and the politics of the welfare state in the United States is Theda Skocpol, *Protecting Soldiers and Mothers: The Political Origins of Social Policy in the United States* (Cambridge, MA, 1992). Linda Gordon has also produced useful studies of maternalist organizations and the welfare state in the United States. See, for example, Linda Gordon, ed., *Women, the State, and Welfare* (Madison, 1990); and idem, "Putting Children First: Women, Maternalism, and Welfare in the Early Twentieth Century," in *U.S. History as Women's History: New Feminist Essays*, Linda K. Kerber, Alice Kessler-Harris, and Kathryn Kish Sklar, eds. (Chapel Hill, 1995), 63–86.

11. Joan W. Scott, "Deconstructing Equality-Versus-Difference: Or, The Uses of Poststructuralist Theory for Feminism," *Feminist Studies* 14 (Spring 1988): 48. For another important discussion of this topic, see Karen Offen, "Defining Feminism: A Comparative Historical Approach," *Signs* 14 (1988): 119–57. Useful discussions of women's special proclivity for peace appear in Harriet Hyman Alonso, *Peace as a Women's Issue: A History of the U.S. Movement for World Peace and Women's Rights* (Syracuse, 1993), 10–13; Leila J. Rupp, "Constructing Internationalism: The Case of Transnational Women's Organizations, 1888–1945," *American Historical Review* 99 (December 1944): 1582–84; and Leila J. Rupp, *Worlds of Women: The Making of an International Women's Movement* (Princeton, 1997). For an excellent discussion of "a distinct female perspective on foreign policy" at the turn of the twentieth century, see Judith Papachristou, "American Women and Foreign Policy, 1898–1905: Exploring Gender in Diplomatic History," *Diplomatic History* 14 (Fall 1990): 493–509.

12. For biographical information on Woolley, see Edward T. James, Janet Wilson James, and Paul S. Boyer, eds., *Notable American Women, 1607–1950*, vol. 3 (Cambridge, MA, 1971), 660–63; Jeanette Marks, *Life and Letters of Mary Emma Woolley* (Washington, DC, 1955); and Anna Mary Wells, *Miss Marks and Miss Woolley* (Boston, 1978). "Report of Meeting Held on October 28, 1942 on Invitation of Miss Mary E. Woolley." Records of the NCNW, Series 5, Box 37,

Folder 522, Mary McLeod Bethune Council House (MMBCH), Washington, DC. Margaret E. Burton, "The Committee on Women in World Affairs," December 18, 1946, 1. Somerville-Howorth Papers, Series III, Box 7, Folder 145, Schlesinger Library on the History of Women in America (SL), Radcliffe College, Cambridge, MA. On the selection and work of Woolley at the 1932 Geneva Conference, see Dorothy Detzer, *Appointment on the Hill* (New York, 1948), 100–113; and Wells, *Miss Marks and Miss Woolley*, 211–22.

13. During the wartime years "postwar" was written as "post war," "postwar," and "post-war." When quoting from contemporary sources or referring to specific wartime organizations, we have employed the form that was then in usage.

14. For information on the history and work of the CPWPWP, see Report of Meeting Held on October 28, 1942 on Invitation of Miss Mary E. Woolley. Records of the NCNW, Series 5, Box 28, MMBCH. Also useful is the eight-page typescript, Burton, "The Committee on Women in World Affairs," Somerville-Howorth Papers, Series III, Box 7, Folder 145, SL. Information on Emily Hickman is located in the Deceased Alumna File, Carl A. Kroch Library, Rare and Manuscript Collections, Cornell University Library, Ithaca, NY. Also see the "Emily Hickman" entry in Anna Rothe, ed., *Current Biography 1945* (New York, 1946), 281–83.

15. Rothe, ed., "Emily Hickman," *Current Biography 1945*, 281–83.

16. On the work and ideology of the interwar women's movement for peace and social justice, see Alonso, *Peace as a Women's Issue*, 85–156, 260–64. On the international dimensions of the interwar women's movement, see Rupp, *Worlds of Women*.

17. Alonso, *Peace as a Women's Issue*, especially chapter 5, "Dilemmas, Quandaries, and Tensions during War, 1935–1945," 125–56. Also useful is Margaret Hope Bacon, *One Woman's Passion for Peace and Freedom: The Life of Mildred Scott Olmsted* (Syracuse, 1993), 214–37; Barbara Miller Solomon, "Dilemmas of Pacifist Women, Quakers and Others, in World Wars I and II," in *Witnesses for Change: Quaker Women over Three Centuries*, Elisabeth Potts Brown and Susan Mosher Stuard, eds. (New Brunswick, 1989), 123–48; and Virginia R. Boynton, "Surviving Adversity: The Women's International League for Peace and Freedom during World War II," *Mid-America* 75 (January 1993): 67–83. Dorothy Detzer's memoir, *Appointment on the Hill*, includes a good first-hand account of the challenges and painful internal divisions experienced by the U.S. section of the WILPF during World War II (235–52). Lawrence Wittner, *Rebel against War: The American Peace Movement, 1941–1960* (New York, 1969) describes the controversial decision of Emily Greene Balch, recipient of the 1946 Nobel Peace Prize, to support World War II and retain her membership in the WILPF (52–53). For additional information on the activities and tenuous existence of the WILPF during World War II, see "The Women's International League for Peace and Freedom Papers, 1915–1978," Microfilm Reels 28 and 49.

18. See Mrs. Norman de R. Whitehouse to Mary McLeod Bethune, April 2, 1943; and "Sample Letters," WACVLP. Records of the NCNW, Series 5, Box 38, Folder 534, MMBCH. "Bolder Peace Aims Urged by Mrs. Catt," *New York Times*, May 5, 1944. After the war, the word "Victory" was dropped from the committee's title. Following the establishment of the United Nations organization at the end of the war and the death of Catt in 1947, the committee disbanded in 1949. Alonso, *Peace as a Women's Issue*, 152–54. Robert Booth Fowler, *Carrie Catt: Feminist Politician* (Boston, 1986), 31–38.

19. Emily Hickman to Committee Members, May 19, 1944. Records of the NCNW, Series 5, Box 28, Folder 413, MMBCH. Burton, "The Committee on

Women in World Affairs," 2. Somerville-Howorth Papers, Series III, Box 7, Folder 145, SL.

20. Rothe, ed., "Emily Hickman," *Current Biography 1945*, 282. Lucy Somerville Howorth, "1958 Statement to accompany file of Women in World Affairs." Burton, "The Committee on Women in World Affairs," 5. Somerville-Howorth Papers, Series III, Box 7, Folder 145, SL.

21. Emily Hickman to Members of the Committee on the Participation of Women in Post-War Planning, June 14, 1943. Records of the NCNW, Series 5, Box 28, Folder 412, MMBCH. For information on the early efforts of the CPWPWP to have women included on postwar planning councils, see Emily Hickman to Mrs. Howorth, July 28, 1943 and CPWPWP Minutes, October 21, 1943. Somerville-Howorth Papers, Series III, Box 7, Folder 145, SL.

22. Department of State, *Postwar Foreign Policy Preparation, 1939–1945*, Publication 3580 (Washington, DC, 1950), 205. "Only Two Women On UNRRA Council," *New York Times*, November 22, 1943. On the efforts of the CPWPWP to expand its membership and influence, see "Post-War Plans Mapped," *New York Times*, March 3, 1944. On the work of Ellen Woodward at the 1943 UNRRA conference, see Martha H. Swain's excellent biography, *Ellen S. Woodward: New Deal Advocate for Women* (Jackson, 1995), 172. Woodward also participated in the September 1944 UNRRA conference in Montreal and the August 1945 UNRRA conference in London. See Swain, *Ellen S. Woodward*, 173–74.

23. While historians have examined the pathbreaking work of Bethune as the head of Negro Affairs of the National Youth Administration between 1936 to 1943 and her participation in the New Deal's "black cabinet," far less attention has been focused on her important World War II work. See, for example, B. Joyce Ross, "Mary McLeod Bethune and National Youth Administration: A Case Study of Power Relationships in the Black Cabinet of Franklin D. Roosevelt," *Journal of Negro History* 60 (January 1975): 1–28; and Elaine M. Smith, "Mary McLeod Bethune and the National Youth Administration," in *Clio Was a Woman: Studies in the History of American Women*, Mabel E. Deutrich and Virginia C. Purdy, eds. (Washington, DC, 1980), 149–77. For a history of the National Council of Negro Women, see Bettye Collier-Thomas, *N.C.N.W. 1935–1980* (Washington, DC, 1981).

24. For example, see Mary McLeod Bethune to Emily Hickman, August 7, 1943. Records of the NCNW, Series 5, Box 28, Folder 412, MMBCH.

25. Mary McLeod Bethune to Emily Hickman, April 10, 1944. Emily Hickman to Mary McLeod Bethune, April 22, 1944. Records of the NCNW, Series 5, Box 28, Folder 413, MMBCH.

26. Mary McLeod Bethune to Emily Hickman, May 6, 1943. Records of the NCNW, Series 5, Box 14, Folder 238, MMBCH.

27. "The Postwar Planning Committee of the National Council of Negro Women, Inc.," n.d. Records of the NCNW, Series 5, Box 28, Folder 412, MMBCH.

28. Susan Lynn, *Progressive Women in Conservative Times: Racial Justice, Peace, and Feminism, 1945 to the 1960s* (New Brunswick, 1992), 4–5. Also useful is Susan Lynn, "Gender and Progressive Politics: A Bridge to Social Activism of the 1960s," in *Not June Cleaver: Women and Gender in Postwar America, 1945–1960*, Joanne Meyerowitz, ed. (Philadelphia, 1994), 103–27. In chapter two of *Progressive Women in Conservative Times*, Lynn specifically focuses on the gradual development of the YWCA into an interracial organization during the 1940s and 1950s (40–67). A good case study of the interracial movement within the YWCA is Sharlene Voogd Cochrane, " 'And the Pressure Never Let Up':

Black Women, White Women, and the Boston YWCA, 1918–1948," in *Women in the Civil Rights Movement: Trailblazers and Torchbearers, 1941–1946,* Vicki L. Crawford, Jacqueline Anne Rouse, and Barbara Woods, eds. (New York, 1990), 259–69. On attempts at interracial cooperation during the 1920s and 1930s, see Rosalyn Terborg-Penn, "Discontented Black Feminists: Prelude and Postscript to the Passage of the Nineteenth Amendment," in *Decades of Discontent,* Louis Scharf and Joan M. Jensen, eds. (Boston, 1987), 261–78.

29. For information on the Coordinating Committee for Building Better Race Relations, see "From the National Planning Conference on Building Better Race Relationships," *Aframerican Woman's Journal* 3 (Spring 1944): 4–7; and "Roundtable Discusses Race Relations," *Aframerican Woman's Journal* 4 (Fall 1944): 16–17. "Statement of Conference—February 11, 1944." "Roundtable Conference on 'Building Better Race Relations,' November 18, 1944." "Agenda— Coordinating Committee for Building Better Race Relations, November 24, 1945." Records of the NCNW, Series 5, Box 9, Folders 161, 162, 164, MMBCH.

30. American Legion Auxiliary, "Postwar Committee Conference of National Women's Organizations," Hotel Lexington, New York City, September 14, 1944, 3, 13. Records of the NCNW, Series 5, Box 8, Folder 142, MMBCH.

31. "The Annual Workshop," *Aframerican Woman's Journal* 4 (Fall 1944): 3.

32. "Human Relations in Transition to Peace. For National Congress of Negro Women. Oct. 13, 1944." Mary Church Terrell Papers, Box 31, Manuscript Division, Library of Congress (LC), Washington, DC. Alonso, *Peace as a Women's Issue,* 267. Terborg-Penn, "Discontented Black Feminists," 270–71.

33. "The Annual Workshop," *Aframerican Woman's Journal* 4 (Fall 1944): 3–12. Susan Lynn argues that conferences of this type often "provided interracial experiences that transformed racial consciousness." Lynn, "Gender and Progressive Politics: A Bridge to Social Activism of the 1960s," 112. However, Lillian Smith, the well-known white southern author and civil rights advocate, felt that "the warm personal comradeship that is necessary to the developing of any friendship" was difficult to achieve at conventions and conferences where "we . . . make speeches to each other." For this reason, she invited a select group of black and white women to her mountaintop home near Clayton, Georgia, "to form with each other really warm and personal friendships." Lillian E. Smith to Mrs. Terrell, September 4, 1943. Mary Church Terrell Papers, Box 13, Manuscript Division, LC. For other comments by Smith on this interracial gathering, see Margaret Rose Gladney, ed., *How Am I to Be Heard? Letters of Lillian Smith* (Chapel Hill, 1993), 74–78.

34. "The Annual Workshop," *Aframerican Woman's Journal* 4 (Fall 1944): 12. Also see, Jeanetta Welch Brown, Executive Secretary, NCNW, "The Role of the Negro Woman in the Post War World," n.d. NCNW, Series 5, Box 14, Folder 239, MMBCH.

35. Mary McLeod Bethune served as a judge for a 1943 nationwide essay contest sponsored by the American Jewish Congress on the subject, "What Youth Seeks in the Post War World." Nathan Zuckerman to Mary McLeod Bethune, November 4, 1943. Mary McLeod Bethune to Nathan Zuckerman, November 8, 1943. Records of the NCNW, Series 5, Box 3, Folder 53, MMBCH. Mary Church Terrell served as a judge for the 1943–44 nationwide essay contest sponsored by the Ladies Auxiliary of the Veterans of Foreign Wars on the subject, "Unity for Peace." Mary Church Terrell to Eola Wright, May 24, 1944. Mary Church Terrell Papers, Box 13, Manuscript Division, LC. In December 1942 the National Council of Women and the *Atlantic Monthly* magazine sponsored an essay contest,

"What Post-War World Do Women Demand?" See "Women Open Contest on Post-War Needs," *New York Times*, December 27, 1942. "Essayists Appeal for World Unity," *New York Times*, April 4, 1943. On the efforts of Democratic women to pressure President Roosevelt to include women on planning councils, see Swain, *Ellen S. Woodward*, 173–74, 182. *Official Proceedings of the Democratic National Convention*, Chicago, Illinois, July 19–21, 1944, 25. Also see Winifred Hayes, "Woman's Place in the Future World Order," *Catholic World* 157 (August 1943): 482–87. Anne Kavanagh Priest to the editor of the *New York Times*, January 5, 1943. L. G. Wentworth to the editor of the *New York Times*, June 7, 1944. Nora Stanton Barney to the editor of the *New York Times*, September 2, 1944.

36. "Post-War Equality for Women Urged," *New York Times*, March 1, 1943. "Women Ask Part in Peace," *New York Times*, May 23, 1943. "Resolution adopted by the AAUW Board of Directors, June 14–16, 1943." Charl Ormond Williams Papers, Box 8, Manuscript Division, LC. Kathleen McLaughlin, "Post-War Planning Advanced," *New York Times*, August 1, 1943. "Conference on Peace Aims," *New York Times*, May 20, 1944. "Matriots to Seek Power for Peace," *New York Times*, October 3, 1944. American Legion Auxiliary, *Postwar Committee Conference of National Women's Organizations*, September 14, 1944. Records of the NCNW, Series 5, Box 8, Folder 142, MMBCH. June 23, 1943, Press Release, Quota Club, International. Somerville-Howorth Papers, Series III, Box 7, Folder 145, SL. "Women Leaders Seek Place at Peace Table," *New York Times*, April 26, 1944. "Peace Plan Roles Urged for Women," *New York Times*, September 16, 1944. "Bids Women Take Responsible Role," *New York Times*, January 14, 1944. "Resolution Is Adopted by the Directors of Business Clubs," *New York Times*, July 13, 1943. "Sound Basis Urged for Enduring Peace," *New York Times*, May 28, 1944. "Women Ask Peace at World Parleys," *New York Times*, December 3, 1944. "Women Select Peace Delegates," *New York Times*, January 8, 1945.

37. See, for example, Major George Fielding Eliot, "Women and a People's Peace," *Independent Woman* 22 (May 1943): 131–32. Emma Gelders Sterne, "Shock Troops for the Coming Peace," *Independent Woman* 22 (July 1943): 203, 219. "Wanted: Qualified Women for Postwar Planning," *Independent Woman* 23 (June 1944): 190. "D-Day and H-Hour," *Independent Woman* 23 (August 1944): 239–40.

38. "D-Day and H-Hour," *Independent Woman* 23 (August 1944): 239–40.

39. "Women to Confer on Peace Problems," *New York Times*, March 23, 1943.

40. *Postwar Foreign Policy Preparation*, 69–78. "12 Women Leaders Agree World Cooperation Is Vital," *New York Times*, April 8, 1943. The full texts of the speeches were printed in the April 8, 1943, issue of the *Times*.

41. "Women Map Plans for Better World," *New York Times*, October 28, 1943. As a follow-up to the 1943 conferences, the *New York Times* hosted a four-part discussion series during the early months of 1944 "to study the place and the responsibilities of women in the post-war world." "Discussion Series Planned by *Times*," *New York Times*, December 20, 1943. "Rise in Efficiency of Women Hailed," *New York Times*, March 28, 1944. "Leadership Study Urged for Women," *New York Times*, May 19, 1944.

42. "Stettinius Policy Upheld by Women," *New York Times*, December 7, 1944.

43. "Draft of Miss Hickey's Speech." Margaret A. Hickey Papers, Series V, Box 30, General Speeches, 1943–1956. Western Historical Manuscript Collection (WHMC), Thomas Jefferson Library, University of Missouri-St. Louis, St. Louis, MO.

44. "Statement of WMC Women's Advisory Committee Relative to Post War Employment of Women, December 3, 1943." Margaret A. Hickey Papers, Series V, Box 30, General Speeches, 1943–1956, WHMC. Women's Advisory Committee, *The Wartime Responsibility of Women's Organizations* (1944), 7, located in NCNW, Series 5, Box 38, Folder 52, MMBCH. Advance Release, "Womanpower on the Alert," War Manpower Commission, Text of address by Margaret A. Hickey to Arkansas State Business and Professional Women's Clubs, May 27, 1944. NCNW, Series 5, Box 38, Folder 528, MMBCH. On the history of the Women's Advisory Committee, see "History of the Women's Advisory Committee, War Manpower Commission, Revised, February, 1945," Records of the NCNW, Series 5, Box 38, Folder 528, MMBCH. Also useful is *Womanpower Committees during World War II*, Women's Bureau Bulletin No. 244 (Washington, DC, 1953), 1–48. Unfortunately, the efforts of Hickey and the Women's Advisory Committee to protect the rights of working women after the war were routinely ignored. See Eleanor Ferguson Straub, "Government Policy toward Civilian Women during World War II," Ph.D. dissertation, Emory University, Atlanta, Georgia, 1973, 43–63, 325–27. Eleanor F. Straub, "United States Government Policy toward Civilian Women during World War II," *Prologue* 5 (Winter 1973): 253. A similar view is presented in Judith Sealander, *As Minority Becomes Majority: Federal Reaction to the Phenomenon of Women in the Work Force, 1920–1963* (Westport, CT, 1983), 105–7. In the spring of 1945, in a last-ditch effort to affect postwar employment policies for women, the Women's Advisory Committee issued a pamphlet, *Woman in the Postwar*, that asserted the right of "each individual regardless of sex, race, or economic status . . . to choose whether to work or not." Straub, "Government Policy toward Civilian Women during World War II," 325–26.

45. Mary Anderson, "The Postwar Role of American Women," Papers and Proceedings of the Fifty-sixth Annual Meeting of the American Economic Association, *American Economic Review* 34 (March 1944): 237–44.

46. Mary Elizabeth Pidgeon, *A Preview as to Women Workers in Transition from War to Peace*, Women's Bureau Special Bulletin No. 18 (Washington, DC, 1944), iv, 1. The Women's Bureau, like the Women's Advisory Committee, failed in its efforts to protect the rights of working women in the postwar era. An analysis of this failure appears in Straub, "Government Policy toward Civilian Women during World War II," 42, 313, 330–35; Straub, "United States Government Policy toward Civilian Women during World War II," 247; and Sealander, *As Minority Becomes Majority*, 103–5.

47. This statement was issued by Eleanor Roosevelt in late March 1944. See "Woman's Role in Peace Talks," *New York Times*, March 31, 1944. This was one of many statements made by Eleanor Roosevelt on the subject of women participating in postwar councils.

48. Eleanor Roosevelt, "Women at the Peace Conference," *Reader's Digest* 44 (April 1944): 48–49.

49. Report of the Conference, "How Women May Share in Post-War Policy Making." Background and Facts on Roster of Qualified Women, January 22, 1945. Charl Ormond Williams Papers, Box 8, Manuscript Division, LC.

50. Charl Ormond Williams to Mrs. Franklin D. Roosevelt, January 29, April 10, April 18, May 5, June 11, 1944. Charl Ormond Williams Papers, Box 7, Manuscript Division, LC.

51. For a list of the women who attended the conference, see "Conference on How Women May Share in Post-War Policy Making." Charl Ormond Williams to

Member of the White House Conference, June 7, 1944. Charl Ormond Williams Papers, Boxes 7, 8, Manuscript Division, LC.

52. For a transcript of the keynote speech, see Lucy Somerville Howorth, "Women's Responsibility in World Affairs," *Journal of the American Association of University Women* 37 (Summer 1944): 195–98.

53. Josephine Schain, "Women Should Share in Government," 4; Ellen S. Woodward, "My Experience at the UNRRA Conference," 4–6; Elizabeth A. Conkey, "Contribution of Women to International Policy Making," 12–13; C. Mildred Thompson, "Conference of Allied Ministers of Education in London, April 1944," 7; Margaret Chase Smith, "The Need for Qualified Women on Policy Making Bodies," 8–10; and Frances Perkins, "Contribution of Women at the International Labor Conference," 11. Report of the Conference, "How Women May Share in Post-War Policy Making." Addresses delivered at the White House Conference, June 14, 1944. Distributed by the General Federation of Women's Clubs. Charl Ormond Williams Papers, Box 8, Manuscript Division, LC. Additional information on the June 14, 1944, White House Conference is located in the Margaret Chase Smith Papers, Margaret Chase Smith Library, Skowhegan, Maine.

54. Ann Cottrell, "Women Assert Right to Join in Policy Making," *New York Herald-Tribune*, June 15, 1944.

55. Howorth, "Women's Responsibility in World Affairs," 195. Josephine Schain, "Women Should Share in Government," 4; and C. Mildred Thompson, "Conference of Allied Ministers of Education in London, April 1944," 7. Report of the Conference, "How Women May Share in Post-War Policy Making." Addresses delivered at the White House Conference, June 14, 1944. Distributed by the General Federation of Women's Clubs. Charl Ormond Williams Papers, Box 8, Manuscript Division, LC.

56. Josephine Schain, "Women Should Share in Government," 4; C. Mildred Thompson, "Conference of Allied Ministers of Education in London, April 1944," 7; and Frances Perkins, "Contribution of Women at the International Labor Conference," 11. Report of the Conference, "How Women May Share in Post-War Policy Making." Addresses delivered at the White House Conference, June 14, 1944. Distributed by the General Federation of Women's Clubs. Charl Ormond Williams Papers, Box 8, Manuscript Division, LC.

57. G. Howland Shaw, "Opportunities for Women in the Conduct of International Relations," 16. Report of the Conference, "How Women May Share in Post-War Policy Making." Addresses delivered at the White House Conference, June 14, 1944. Charl Ormond Williams Papers, Box 8, Manuscript Division, LC. Genevieve Reynolds, "Failure to Draft Women Called 'Major Tragedy': Postwar Role Demanded at White House Parley," *Washington Post*, June 15, 1944.

58. Report of the Conference, "How Women May Share in Post-War Policy Making." Addresses delivered at the White House Conference, June 14, 1944. Distributed by the General Federation of Women's Clubs, 21. Charl Ormond Williams Papers, Box 8, Manuscript Division, LC.

59. Howorth, "Women's Responsibility in World Affairs," 197.

60. "Women to Confer on Policy Making," *New York Times*, June 14, 1944. "Women Ask Place in Peace Councils," *New York Times*, June 15, 1944. "200 Women Leaders at White House Told to 'Stick Together,'" *Washington Evening Star*, June 14, 1944. Mary Hornaday, "200 Women to Compile Roster of Postwar Policy Planners," *Christian Science Monitor*, June 14, 1944. Ann Cottrell, "Women Assert Right to Join in Policy Making," *New York Herald-Tribune*, June 15, 1944.

Elinor Pillsbury, "White House Conclave Seeks to Put Women at Peace Table," *Oregon Journal*, June 15, 1944. Virginia Pasley, "Parley Depicts Key Postwar Role for Women," *Washington Times-Herald*, June 15, 1944. Genevieve Reynolds, "Postwar Role Demanded at White House Parley," *Washington Post*, June 15, 1944. Ida B. Wise Smith, "How Women May Share in Post-War Policy Making," *The Union Signal*, July 1, 1944. "Conference at the White House," *Independent Woman* 23 (July 1944): 225. Eleanor Roosevelt, "My Day," June 15, 16, 1944. "Women and the Peace," *New York Times*, June 16, 1944. These and other press notices about the June 14, 1944, White House Conference are located in the Charl Ormond Williams Papers, Box 8, Manuscript Division, LC. Ellen S. Woodward to Charl Ormond Williams, June 22, 1944. Charl Ormond Williams Papers, Box 8, Manuscript Division, LC.

61. "A Conference on How Women May Share in State Government, Austin, Texas, September 7, 1944." "Background and Facts on Roster of Qualified Women, January 22, 1945." "South Carolina Holds Its 'White House' Conference." Stella Ford Walker to Charl Ormond Williams, November 6, 1944. "Altrusa Club of Chicago Conference—November 20, 1944." "Women's Share in Postwar Planning—Chicago Area Conference Program, February 22, 1945." Transcript of Interview on *National Farm and Home Hour*, Monday, November 20 (77 stations on Blue Network coast to coast) between Charl Ormond Williams and Kay Baxter. Charl Ormond Williams Papers, Boxes 7, 8, Manuscript Division, LC. Neola Northam, "Women Urged to Aid in Postwar Planning," *Chicago Sun*, February 23, 1945. In addition, between May and October 1944, a series of four women's conferences on international affairs, organized by Helen Montfort Moodie, were held in Washington, DC. Representatives from fifty national women's organizations heard reports from policymaking officials on the important postwar issues of relief and rehabilitation, education, food and agriculture, and the monetary fund and the world bank. For reports of the four conferences, see Records of the NCNW, Series 5, Box 38, Folder 537, MMBCH.

62. "Background and Facts on Roster of Qualified Women, January 22, 1945." Charl Ormond Williams to President, January 5, 1945. Charl Ormond Williams to The Honorable Edward R. Stettinius, Jr., January 17, 1945. Charl Ormond Williams to Mrs. Roosevelt, January 6, 17, 1945.The names of the 260 women on the Roster were not published in the press. For a complete list of these names, see "Roster of Qualified Women, January 5, 1945," Charl Ormond Williams Papers, Box 8, Manuscript Division, LC. Ann Cottrell, "260 Women Designated to Aid in Shaping Post-War Policies," *New York Herald-Tribune*, January 23, 1945. "500 Women Urged for Planning Duty," *New York Times*, August 26, 1944. Elinor Pillsbury, "260 Qualified Women Listed for Policy Aid," *Oregon Journal*, February 4, 1945. Doris Lockerman, "Women Will Be Heard in Postwar Parleys," *Atlanta Journal*, February 20, 1945.

63. On the history of Dumbarton Oaks, see Russell, *A History of the United Nations Charter*, 205–477; Robert C. Hilderbrand, *Dumbarton Oaks: The Origins of the United Nations and the Search for Postwar Security* (Chapel Hill, 1990); and Hoopes and Brinkley, *FDR and the Creation of the U.N.*, 133–58.

64. Ann Cottrell, "Women Absent at Four-Power Peace Sessions," *New York Herald-Tribune*, August 21, 1944. "Peace Conference, [1944]," Clare Boothe Luce Papers, Box 677, Manuscript Division, LC. Ann Cottrell, "56 U.S. Women Nominated for Peace Parleys," *New York Herald-Tribune*, August 31, 1944. "24 Women Leaders Introduced as Qualified for Peace Talks," *New York Herald-Tribune*, October 19, 1944. "Urges Women Take World Peace Role," *New York Times*, Octo-

ber 12, 1944. Emily Hickman to Fellow Member, October 23. 1944, Charl Ormond Williams Papers, Box 8, Manuscript Division, LC.

65. See, for example, Hoopes and Brinkley, *FDR and the Creation of the U.N.*, and Robert Dallek, *Franklin D. Roosevelt and American Foreign Policy, 1932–1945* (New York, 1979). The Ellen Woodward quote appears in Swain, *Ellen S. Woodward*, 171.

66. On the work of the NCNW in promoting community activities in support of Dumbarton Oaks, see "Dumbarton Oaks Proposals, 1944–1945." Records of the NCNW, Series 5, Box 10, Folder 186, MMBCH. "Women Lead Drive for Peace Discussion," *New York Times*, November 25, 1944. On the work of the NCNW in behalf of "Dumbarton Oaks Week" and "World Security Month," see World Security Month Programs. Records of NCNW, Series 5, Box 38, Folder 541, MMBCH. On the efforts of the National Business and Professional Women's Clubs, see Doris Herrick Cochran, "Evolving a 'Pattern for Peace' at Dumbarton Oaks," *Independent Woman* 23 (October 1944): 299, 328. For information on the programs sponsored by the Women's Division of the Democratic National Committee, see "A Panel Discussion on Dumbarton Oaks," Mayflower Hotel, Washington, DC, February 1945; and "Steps to Peace and Security," Mayflower Hotel, Washington, DC, March 14, 1945. Records of NCNW, Series 5, Box 10, Folder 186, MMBCH. Information on the League of Women Voters appears in Louise M. Young, *In the Public Interest: The League of Women Voters, 1920–1970* (New York, 1989), 142–45. Letter of Lucile W. Heming, President, New York State League of Women Voters, to the editor of the *New York Times*, December 14, 1944. "Women Rally for Peace," *New York Times*, April 17, 1945. "Women Voters Support Parley," *New York Times*, April 18, 1945. Conversations with Anne Firor Scott at the annual meeting of the Southern Historical Association, New Orleans, LA, November 8–11, 1995, and November 30, 1995, letter to Judy Barrett Litoff from Anne Firor Scott. Scott, *Making the Invisible Woman Visible*, xiv. By contrast, the America First movement, which included a network of right-wing mothers' groups, opposed a United Nations-type of internationalism. See Laura McEnaney, "He-Men and Christian Mothers: The America First Movement and the Gendered Meanings of Patriotism and Isolationism," *Diplomatic History* 18 (Winter 1994): 47–57; and Glen Jeansonne, *Women of the Far Right: The Mothers' Movement and World War II* (Chicago, 1996).

67. *Postwar Foreign Policy Preparation*, 416. Bess Furman, "Hails Honor Given Dean Gildersleeve," *New York Times*, February 15, 1945. Agnes E. Meyer, "Dean Gildersleeve—Popular Choice," *Journal of the American Association of University Women* (Spring 1945): 151–53. For additional information on Gildersleeve's appointment to the San Francisco Conference, see Virginia C. Gildersleeve, "Women Must Help Stop Wars," *Woman's Home Companion* 72 (May 1945): 32; and Edith Efron, "Portrait of a Dean and Delegate," *New York Times Magazine*, April 1, 1945, 13, 43. Charl Ormond Williams also believed that the "Roster of Qualified Women" was largely responsible for Gildersleeve's appointment. See Charl Ormond Williams to Mrs. Roosevelt, February 23, 1945, March 1, 1945. Charl Ormond Williams Papers, Box 8, Manuscript Division, LC. CPWPWP member Lucy Somerville Howorth maintained that some of the credit for Gildersleeve's appointment was due to the hard work of Gladys Tillett, head of the Women's Division of the Democratic National Committee. See Lucy Somerville Howorth to Gladys Tillett, February 18, 1945, Somerville-Howorth Papers, Series III, Box 5, Folder 114, SL.

68. Meyer, "Dean Gildersleeve—Popular Choice," 152–53.

69. Gildersleeve, *Many a Good Crusade* (New York, 1954), 317, 330–31, 346–47.

70. Gildersleeve, *Many a Good Crusade*, 349–50, 352. Gildersleeve wrote that the "British and American men were bored and irritated by the repeated lengthy feminist speeches. . . . Some of the American staff bestowed on Dr. Lutz the nickname 'Lutzwaffe' as a humorous adaptation of the German Luftwaffe" (352–53).

71. In her study of transnational women's organizations between 1888–1945, Leila Rupp determined that "the notion of women's difference from men . . . found organizational expression in the separatist nature of the major international bodies and the coalitions they formed. Although European women most often asserted that single-sex organizing represented a temporary expedient or even expressed a preference for organizing with men, associating separatism with 'the New World,' none of the bodies changed its policies." Ironically, at the San Francisco Conference, it was the European-educated Bertha Lutz who supported single-sex organizing while American women, such as Virginia Gildersleeve, opposed this strategy. Rupp, "Constructing Internationalism," 1586; and Rupp, *Worlds of Women*, 207–29. For information on Bertha Lutz, see June E. Hahner, *Emancipating the Female Sex: The Struggle for Women's Rights in Brazil, 1850–1940* (Durham, NC, 1990), 134–36, 140–49, 166–74. For an excellent analysis of recent historical literature that explores the role of female-centered organizations in prodding women to public activism, see Nancy F. Cott, "What's in a Name? The Limits of 'Social Feminism': or, Expanding the Vocabulary of Women's History," *Journal of American History* 76 (December 1989): 809–29, especially 236–329. Barbara Solomon argues that nineteenth and early-twentieth-century college-educated women, whether they attended single-sex or coeducational institutions, "felt connected both as collegians and by a common belief in the worth of women. . . . In their whirl of studies and activities, undergraduates agreed that they had responsibilities to think, act, and contribute as adults, not only within their families but in the larger society." Barbara Miller Solomon, *In the Company of Educated Women: A History of Women and Higher Education in America* (New Haven, CT, 1985), 114. Solomon provides a brief evaluation of the advantages of single-sex education for women (208–12). Lynn D. Gordon maintains that early twentieth-century single-sex colleges afforded women the opportunity to take on "leadership roles not available to them elsewhere," but she also states that "separatism . . . [has] always been a double-edged sword, its ideology and rhetoric used as often to hold women back as for their advancement." Lynn D. Gordon, *Gender and Higher Education in the Progressive Era* (New Haven, CT, 1990), 11, 191.

72. Russell, *A History of the United Nations Charter*, 590–95. *Postwar Foreign Policy Preparation, 1939–1945*, 414–23. For a list of the forty-two private organizations invited to send representatives to serve as consultants to the U.S. delegation, see Department of State Press Release, April 10, 1945, No. 323. A copy of the press release is located in the Records of the NCNW, Series 5, Box 34, Folder 493, MMBCH. "Named to Aid Conferees," *New York Times*, April 17, 1945. "Report Lauds Work of Parley Advisors," *New York Times*, May 19, 1945. For additional information on the work of American women at the San Francisco Conference, see Pauline Frederick, "Eyes of the World on San Francisco," *Independent Woman* 24 (May 1945): 137, 141. Bessie Beatty, "Women of One World," *Independent Woman* 24 (July 1945): 178–80. Margaret A. Hickey, "Everybody's Business," *Independent Woman* 24 (July 1945): 181, 200. A complete list of the 254 persons from the United States who attended the UN confer-

ence appears in Department of State, *Charter of the United Nations: Report to the President on the Results of the San Francisco Conference* (Washington, DC, 1945), 254–66.

73. Department of State Press Release, April 10, 1945, No. 323. Jeanetta Welch Brown to William L. Clayton, April 11, 1945. Jeanetta Welch Brown to Archibald MacLeish, April 11, 1945. Jeanetta Welch Brown to Edward Stettinius, Jr., n.d. W. L. Clayton to Mary McLeod Bethune, April 13, 1945. Francis H. Russell to Mrs. Bethune, April 17, 1945. Mary McLeod Bethune to Dear Friends, May 10, 1945. Records of the NCNW, Series 5, Box 34, Folder 493, MMBCH. Mary McLeod Bethune, "Our Stake in Tomorrow's World," *Aframerican Woman's Journal* 5 (June 1945): 2.

74. Mary McLeod Bethune to My dear friend, September 28, 1945. Nannie H. Burroughs Papers, Box 3, Manuscript Division, LC.

75. Hickey, "Everybody's Business," 181. For an excellent discussion of the political efforts and accomplishments of public women during the New Deal years, see Susan Ware, *Beyond Suffrage: Women in the New Deal* (Cambridge, MA, 1981); and Susan Ware, *Partner and I: Molly Dewson, Feminism, and New Deal Politics* (New Haven, CT, 1987). On the linkage between the women's suffrage movement and the women's peace movement, see Alonso, *Peace as a Women's Issue*, 85–124.

76 . This statement does not mean that the rank-and-file membership of white women's organizations unfailingly supported racial equality. However, the women activists who led the campaign for the inclusion of women on postwar councils voiced strong support for racial equality throughout the war years.

77. The question of whether or not World War II served as a watershed with lasting political, economic, and social changes for American women has been the subject of a number of thoughtful works. See, for example, William H. Chafe, *The American Woman: Her Changing Social, Economic, and Political Role, 1920–1970* (New York, 1972); Straub, "Government Policy toward Civilian Women during World War II"; Leila J. Rupp, *Mobilizing Women for War: German and American Propaganda, 1930–1945* (Princeton, 1978); Karen Anderson, *Wartime Women: Sex Roles, Family Relations, and the Status of Women during World War II* (Westport, CT, 1981); Susan M. Hartmann, *The Home Front and Beyond* (Boston, 1982); D'Ann Campbell, *Women at War with America: Private Lives in a Patriotic Era* (Cambridge, MA, 1984); Maureen Honey, *Creating Rosie the Riveter: Class, Gender, and Propaganda during World War II* (Amherst, 1984); Sherna B. Gluck, *Rosie the Riveter Revisited: Women, the War, and Social Change* (Boston, 1987); Ruth Milkman, *Gender at Work: The Dynamics of Job Segregation of Sex during World War II* (Urbana, 1987); Mary Martha Thomas, *Riveting and Rationing in Dixie: Alabama Women and the Second World War* (Tuscaloosa, 1987); Amy Kesselman, *Fleeting Opportunities: Women Shipyard Workers in Portland and Vancouver during World War II and Reconversion* (Albany, 1990); Judy Barrett Litoff and David C. Smith, *Since You Went Away: World War II Letters from American Women on the Home Front* (New York, 1991); and idem, *We're in This War, Too: World War II Letters from Ameican Women in Uniform* (New York, 1994). For a collection of perceptive essays that examines "historical links between the wartime and postwar eras," see Meyerowitz, *Not June Cleaver*.

78. Emily Hickman to President, National Council of Negro Women, October 27, 1945. The NCNW and the CPWPWP also worked with women's organizations outside the United States to promote the participation of women from around the world in postwar planning councils. See Report of the Women's International

Democratic Federation (WIDF) Held in Paris, November 26–30, 1945. WIDF, [1945]. WIDF, Standing Orders Adopted by the Constitutive Congress 25th to 30th November 1945. Records of the NCNW, Series 5, Box 28, Folder 414; Box 8, Folders 144, 145; Box 38, 538, MMBCH. On the origins of the WIDF, a pro-Soviet left-leaning organization, see Amy Swerdlow, "The Congress of American Women: Left-Feminist Peace Politics in the Cold War," in *U.S. History as Women's History*, Kerber, Kessler-Harris, and Sklar, eds., 296–312. On the history of transnational women's organizations between 1888 and 1945, see Rupp, "Constructing Internationalism," 1571–1600; and idem, *Worlds of Women*.

79. Emily Hickman to President, National Council of Negro Women, October 27, 1945. Records of the NCNW, Series 5, Box 28, Folder 414, MMBCH. The Ellen Woodward quote appears in Swain, *Ellen S. Woodward*, 172. On the efforts of Woodward to obtain appointments for women in the Truman administration, see pp. 181–82. In June 1946, Democratic stalwart Harriet Elliot wrote to Ellen Woodward: "I agree with you. . . . [I]t makes my blood boil when I think about the control which men have in all public affairs." Quoted in Swain, *Ellen S. Woodward*, 182. On the dearth of women appointed to government positions during the early years of the Truman presidency, see Cynthia Harrison, *On Account of Sex: The Politics of Women's Issues, 1945–1968* (Berkeley, 1988), 54–58; Hartmann, *The Home Front and Beyond*, 154–56; and the Somerville-Howorth Papers, Series III, Box 6, Folder 120, SL.

80. Over the past fifty years, the struggle to broaden the membership of national and international policymaking councils to include fair and appropriate participation by women has continued. The gains, however, remain modest. See, for example, Judith Ewell, "Barely in the Inner Circle: Jeane Kirkpatrick," and Joan Hoff-Wilson, "Conclusion: Of Mice and Men," in *Women and American Foreign Policy*, Crapol, ed., 153–88; Barbara Crossette, "At Lunch with Jeane Kirkpatrick—a Warrior, a Mother, a Scholar, a Mystery," *New York Times*, August 17, 1994; and "The President's Adviser: Jeane Jordan Kirkpatrick," in *Her Excellency*, Morin, ed., 247–62. A recent effort to increase the visibility of women in foreign policy, reminiscent of Charl Williams's campaign to create a "Roster of Qualified Women," occurred in the mid-1980s when the Women's Foreign Policy Council, an organization founded by Bella Abzug, established a directory of women knowledgeable about foreign affairs. Nancy E. McGlen and Meredith Reid Sarkees, *Women in Foreign Policy: The Insiders* (Wilmington, DE, 1993), 2–4. Rhodri Jeffreys-Jones, *Changing Differences: Women and the Shaping of American Foreign Policy, 1917–1994* (New Brunswick, 1995), also contains important information about the obstacles women have encountered as they have attempted to enter the arena of foreign affairs. One woman who has surmounted these obstacles is Madeleine Korbel Albright, the first U.S. woman to be appointed secretary of state (January 1997–). Much has been written about Albright's life and her role as secretary of state. Two informative biographies are Ann Blackman, *Seasons of Her Life: A Biography of Madeleine Korbel Albright* (New York, 1998); and Michael Dobbs, *Madeleine Albright: A Twentieth-Century Odyssey* (New York, 1999).

I A Prescient Call

Even before the United States officially entered World War II, American women began to map out a far-reaching agenda for the post-war world. One of the first statements advocating that women take leadership roles in planning for peace appeared in an article by Vera Micheles Dean that was published early in 1940 in the *Independent Woman*, the official journal of the National Federation of Business and Professional Women's Clubs (NFBPWC). As the research director of the prestigious Foreign Policy Association, Dean was the ideal person to sound this call. Indeed, she devoted her life to promoting public understanding of foreign politics and world peace. Writing for the nearly 80,000 members of the NFBPWC, Dean provided a highly sophisticated and nuanced analysis of the early months of World War II. Dean's audience of business and professional women took her ideas seriously; throughout the war years, the NFBPWC played a prominent role in calling for women to take an active part in the construction of the peace.

1 Over European Horizons

Vera Micheles Dean

W HEN THE PEOPLE OF FRANCE AND BRITAIN, thoroughly aroused by Hitler's occupation of Prague in March 1939, forced their governments to abandon the policy of appeasement, war with Germany became inevitable. After making successive concessions to Hitler for six years, the French and British finally took a firm stand on Poland. They did so not because they had a special interest in Poland. Theoretically, at least, Britain should have been more interested in preventing Italo-German intervention in Spain, and France in defending its

Vera Micheles Dean, "Over European Horizons," *Independent Woman* (February 1940): 41–42, 62–63. Reprinted by permission of Business and Professional Women/USA.

ally, Czechoslovakia. Their action was not merely because they thought Germany guilty of wrong-doing—they had begun to recognize their own post-war errors. Nor did they want territory from Germany— France and Britain are satisfied with what they already have. Nor did they act solely for the sake of defending small nations against German aggression—they themselves felt directly menaced by Germany after the occupation of Prague.

Their decision to fight was determined, first and foremost, by the desire to end the recurring crisis to which Hitler had been subjecting Europe, and thus clear the way for resumption of more or less normal existence. In that sense, paradoxical though it may seem, actual warfare, grim as it is, proved easier to bear than the nerve-racking anticipation of catastrophe which had effectively served Hitler as a smoke-screen for his conquests of Austria and Czechoslovakia.

In this second world war, so far marked by the use of diplomatic and economic rather than military weapons, the most dramatic development has been the rapprochement between Germany and the Soviet Union, both of which hope to benefit by the break-up of the British Empire. This rapprochement disillusioned both those conservatives who had regarded Nazism as a bulwark against Communism, and those "friends" of the Soviet Union who had done Moscow a great disservice of claiming for it the attributes of Utopia. Under the impact of this disillusionment, many former Nazi and Soviet "fellow-travelers" now support a form of rejuvenated democracy, which might combine tested democratic institutions with some of the constructive social and economic ideas developed in Germany and the Soviet Union.

This sudden expansion of "center" opinion in Western countries at the expense of right and left extremism may—provided it does not degenerate into blind reaction—pave the way for a revival of democracy, reinterpreted in twentieth-century terms. Such a revival would coincide with a renewed popular interest in religion, accompanied by simultaneous recognition on the part of religious leaders of their responsibility not only for the consciences, but also for the social and economic welfare, of their flocks.

The women of this generation who are familiar both with the horrors of war and the errors of peace have an extraordinary opportunity today to plan for the kind of peace they would like to emerge from this war. The task ahead of us all is not that of restoration but of reconstruction. Our most crying need is not for new institutions, but for a new attitude toward relations within and between nations. Once this attitude has been developed, it will in turn channel itself into new institutions. This new attitude must flow from a realization that power cannot be divorced from responsibility. Just as the individual must

think in terms not only of his own liberty but also of his responsibility toward the community in which he lives, so the national group must learn to think in terms not only of national interest and security, but also in terms of the welfare of international society as a whole.

While the Soviet-German pact has brought greater political unity to Western countries, it has proved less fruitful for Germany and the Soviet Union than these two countries, each according to its needs, had originally anticipated.

During the first six weeks of the war Moscow directly benefited from Germany's preoccupation with the conflict in the west, which Hitler had hoped the Soviet pact would avert. This interval permitted the Soviet government to strengthen its defense position against future invasion by Germany, with or without Allied assistance, by occupying Poland and establishing air and naval bases in Estonia, Latvia, and Lithuania. It also raised Germany's hopes that it might obtain in the U.S.S.R. sufficient stocks of foodstuffs and raw materials to counteract the effects of Britain's naval blockade.

The Soviet invasion of Finland, however, played havoc with both Soviet and German plans, and may eventually rank with Hitler's occupation of Prague as a serious political blunder. This invasion alienated Soviet sympathizers abroad who, while admitting the internal excesses of the Moscow dictatorship, had hitherto contended that the U.S.S.R. had no territorial aspirations of an "imperialist" character. It also revealed the inadequacy of the Soviet army—shorn of its officers by the purge of 1937—both as a carrier of revolutionary doctrines and as a potential military ally of Germany.

The successful resistance of the Finns gave fresh courage to countries which feared they were next on Stalin's list. Typical of this reaction was the statement by Premier George Tatarescu on January 1 that Rumania will defend Bessarabia (former Russian province) and Bukovina (former province of the Austro-Hungarian Empire) "to the last man" against foreign invasion.

True, the Soviet-German pact saved Germany from the necessity of fighting the war on two fronts—but only at the price of surrendering eastern Poland and the Baltic countries to Moscow. And the increasing difficulties of the Finnish campaign may make the Soviet government more dependent on Germany than it was last August. These very difficulties, however, have curtailed the ability of the Soviet Union to supply the Reich with foodstuffs and raw materials, thus greatly reducing the value of Soviet collaboration to Germany.

But the military reverses suffered by Soviet troops in Finland may not prove decisive either for Moscow's Finnish campaign or for the future prospects of Communism in Eastern Europe. Skillful as the Finns

have been in their utilization of terrain and war material, their resources of manpower are strictly limited; and the aid extended to them thus far by other countries in the form of volunteers, money, airplanes, guns, and ammunition may not prove sufficient to withstand the sheer weight of Soviet mass armies.

Early in 1940 the Allies were faced with the alternative of diverting men as well as supplies to the aid of Finland, and becoming involved in war with the Soviet Union or concentrating their efforts on a decisive blow against the Reich at the risk of abandoning Finland, temporarily at least, to the mercies of Moscow, whose desire to obtain ice-free ports on the Atlantic also menaces Norway and Sweden.

The controversy in Allied countries regarding the merits of these alternative courses may have been responsible, in part at least, for the summary dismissal of the British War Secretary, [Leslie] Hore-Belisha, who is thought to have favored a defensive campaign in the west accompanied by diversionary operations in other theatres of war—the Baltic or the Balkans. His departure would indicate that the Allies have decided not to be diverted from their principal war aim, which they have repeatedly defined as the destruction of "Hitlerism."

This decision has no doubt been affected by reports that the Reich is preparing to launch a spring offensive, utilizing mines, airplanes, and a new fleet of "vest-pocket" submarines in an effort to cripple the British navy which so far, in spite of heavy losses, has succeeded in enforcing a strict blockade of Germany and in maintaining Britain's "life-line" with the rest of the world. A fierce counter-offensive such as "the world has never known" against the Allied blockade was predicted by Field Marshal [Hermann] Goering on December 30; while Chancellor Hitler, in his New Year's message, declared that the "heaviest battle is still to come" in a war which, according to him, is fought by Germany for the purpose of establishing the "socialist millenium" in Europe by revolution against the Western democracies and "Jewish" capitalism.

While the two European wars—that of the Allies against Germany, and that of the Soviet Union against Finland—are proceeding side by side as yet, actually merging into a common stream, another theatre of war may develop in the Balkan countries, which continue to be torn by the conflicting interests of the great powers.

When the Soviet-German pact was signed, it was at first expected that Germany and the U.S.S.R. would partition the Balkan countries into spheres of influence, as they had done in Poland, Germany asserting its control over Rumania and Yugoslavia, with their valuable resources of oil and minerals, while the U.S.S.R. would recover

Bessarabia from Rumania and obtain a foothold in Bulgaria, whose population has retained pro-Russian sympathies.

Such a partition, however, would have aroused the opposition not only of the Balkan peoples themselves, weary of being used as pawns of the great powers, but also of the Allies and of Germany's Axis partner, Italy. The Allies, which after Munich appeared to have given Germany a free hand in Eastern Europe, sharply altered their course when Hitler occupied Prague. In quick succession they guaranteed the independence of Poland and Rumania, then menaced by German aggression, as well as Greece and Turkey, which had been alarmed by Italy's conquest of Albania. They also tried to draw the Balkan countries away from Germany's economic orbit by granting them credits and increasing their purchases of Balkan products. The Allies scored their principal diplomatic triumph in this region by concluding an alliance with Turkey in October, under which Turkey promised to aid France and Britain in the event of a conflict in the eastern Mediterranean—with one qualification: that this alliance would not involve it in war with the Soviet Union.

The Allies might benefit—as they did in the first world war—by the possibility of inflicting a thrust at Germany through southeastern Europe; but it is definitely not in the interest of the Reich to have the Balkans transformed into a theatre of war. Such a development would not only force Germany to fight on two fronts, a necessity Hitler tried to avoid by his pact with the Soviet Union, but would also make it difficult for Germany to obtain supplies of oil and other essential raw materials from the Balkan countries. Germany would, therefore, prefer to have these countries remain neutral. To the extent that Soviet aspirations in the Balkans threaten to provoke war in the Balkans, they run counter to Germany's plans—and this may explain Germany's acquiescence in Soviet attempts at expansion in northern Europe.

It is against this backdrop of diplomatic conflicts that one must watch Italy's attempts to foster the creation of a neutral Balkan bloc which might resist Soviet expansion in this region. The nucleus of such a bloc would be Italy's long-standing friendship with Hungary. In an effort to bridge the gap that has separated Hungary from Rumania and Yugoslavia—both of which acquired Hungarian territory at the end of the World War—Italy has apparently urged the Hungarians to soft-pedal their territorial claims for the time being.

Another obstacle to Italy's plans for neutralization of the Balkans is the claims of Bulgaria, which demands return of the Dobrudja by Rumania and Western Thrace by Greece, and apparently hopes to enlist Moscow's support for its revisionist campaign. Bulgaria's recent

trade treaty with the Soviet Union, and negotiations for an airline be-
tween Moscow and Sofia, have disturbed Italy.

Alarmed by what it regards as Soviet inroads in a region it had
considered its sphere of influence, Italy is seeking a pretext for inter-
vention in the Balkans. Such a pretext might be provided, as in Spain,
by real or alleged Communist activities. The sudden epidemic of Com-
munist riots in Yugoslavia may be the first fruits of Soviet penetration
in the Balkans. Some observers, however, believe that the drastic anti-
Communist measures adopted by the Belgrade government were dic-
tated less by dread of Communism than by fear that Italy might
intervene under the slogan of "saving Yugoslavia from Bolshevism."

Italy apparently hopes to enlist the support of the Vatican for the
campaign it is gradually shaping up against Communism in the Balkans.
And there can be little doubt that much of the emotion displayed in
Catholic countries over the fate of Finland (for example, in Franco
Spain and Latin America, where German aggression aroused little or
no protest) is due less to sympathy for the Finns than to the desire to
destroy the "anti-Christian" doctrines of Communism. But while
[Benito] Mussolini probably shares the Pope's desire to restore peace
in Europe and check Soviet expansion, it may be doubted that he is
ready to accept the Pontiff's five-point peace program, or abandon his
hope for territorial gains in Africa and the Mediterranean at the ex-
pense of France and Britain. Italy is determined to remain a "non-
belligerent," but it would be a mistake to believe that, merely because
it is not directly helping Germany, it had become pro-Ally. What
Mussolini hopes to do is to extract for Italy all possible advantages,
political and economic, from the present crisis without involving his
own country in war.

The Allies' preoccupation with events in Europe has made it in-
creasingly difficult for them to resist Japan's efforts to set up a "new
order" in Asia. This task seems to devolve more and more on the United
States, whose trade treaty with Tokyo expired on January 26 amid de-
mands, on the part of many Americans, for an embargo on exports to
Japan. Meanwhile, the Japanese government, adopting Germany's tac-
tics toward France and Britain, sought to obtain American support for
the puppet government it plans to establish in China by threatening, if
balked, to come to terms with the Soviet Union. But the appointment
as Premier of Admiral Yonai, a Japanese liberal favorable to Western
interests, is taken as an indication that Japan will seek to improve its
relations with the United States.

In a situation whose pattern undergoes daily, and even hourly,
change, it is difficult for the belligerents to look ahead into the future,

and define peace terms in advance without knowing under what circumstances peace may have to be concluded.

Many people favor the establishment, after the war, of a European federation in which the sovereignty of individual states would be gradually whittled down, and nations would learn to accept responsibility for the welfare of the international community as a whole.

Others—especially in France, which has faced war with Germany three times in the span of one generation—believe that Germany must be crushed once and for all before Europe can know peace. From the point of view of the Nazis, who want to establish the rule of Greater Germany over non-German peoples reduced to the status of helots, neither a European federation recognizing equality of rights nor the dismemberment of the Reich offers a basis for a negotiated peace.

Before such a peace can be broached, one or the other of the belligerents will have had to win some decisive victory in the field. Yet as the conflict grows more bitter, the hope of achieving a peace free from the hatreds of 1919 becomes increasingly dim.

II The Formation of the Committee on the Participation of Women in Post War Planning (CPWPWP)

By the latter months of 1942, a coordinated campaign to ensure the equitable representation of women at postwar councils had begun to take shape. In mid-September 1942, Mary E. Woolley, a longtime peace advocate and president of Mount Holyoke College from 1900–1937, hosted a luncheon for several of her female friends to discuss the role to be played by women in postwar planning. This luncheon prompted Woolley to invite representatives of twenty-one national women's groups to an organizational meeting at the headquarters of the Young Women's Christian Association (YWCA) in New York City on October 28, 1942. Document 2 offers a report of this meeting. At this gathering, Emily Hickman, another peace activist and professor of history at the New Jersey College for Women, was selected to chair a committee to ensure that women would work together in planning for the postwar world. Enlisting the support of major women's organizations, Hickman oversaw the establishment of an interracial umbrella organization, the Committee on the Participation of Women in Post War Planning (CPWPWP). Document 3, "Why Another Committee?", is a reprint of an early recruitment pamphlet. Document 4, the October 21, 1943, Minutes, provides important information about the efforts to have women appointed to postwar planning councils.

Documents 5 and 6 underscore the interracial makeup of the CPWPWP. During an era when racial segregation and discrimination prevailed throughout the nation, the Committee successfully reached out to both black and white women. Joining the CPWPWP in the spring of 1943, the National Council of Negro Women (NCNW)

became one of its most stalwart members. Mary McLeod Bethune, the president of the NCNW, and Emily Hickman worked closely together throughout the war years. As chair of the CPWPWP, Hickman clearly understood the importance of extending the Committee's influence to a broad-based audience. Eventually, more than a dozen national women's organizations were affiliated with the CPWPWP.

2 Report of Meeting Held on Invitation of Miss Mary E. Woolley

ON OCTOBER 28, 1942, representatives of twenty-one women's organizations, national and international, met at 600 Lexington Avenue, New York, N.Y., at the invitation of Miss Mary E. Woolley, to discuss the question: How can we make sure that women will have the opportunity to make their full contribution to the planning and establishment of world cooperation, and what specific steps should be taken now?

Miss Woolley opened the meeting, explaining its unofficial character and the purpose for which it was called. She then introduced Miss Marjory Fry of the British Information Service, who spoke of the experience of British women, emphasizing both the contribution of women equipped by specialized training to meet today's problems and that of many other women, not experts, who help to build up intelligent public opinion. Miss Woolley also asked Miss Marinobel Smith of International [Business] Machines Corporation, just returned from South America, to report on the interest of the women of that continent in the war and postwar problems.

The morning's discussion attempted to define the definite goals to be sought if women are to be able to make their rightful contribution to the building of the future; that of the afternoon centered on the immediate steps to be taken to attain these goals. It was emphasized that women's organizations must think beyond their own membership to all women, and in terms of local, as well as national and international groups. The fact that women recognized as experts are already

Report of Meeting Held on October 28, 1942, on Invitation of Miss Mary E. Woolley. Records of the National Council of Negro Women, Series 5, Box 37, Folder 522, War Department—Women's Interest Section 1942–43. National Park Service, Mary McLeod Bethune Council House National Historic Site, Washington, DC.

serving on several government commissions dealing with war and post-war problems was brought out, and it was generally agreed that in urging the further representation of women in such groups, women's organizations should make specific recommendations of highly qualified women, after having consulted authoritative sources in regard to the women best fitted to serve in given fields. It was recognized that the contribution of women in the formation of public opinion is as essential as that of the experts who bring their specialized training and experience to the work of policy-shaping groups; and that education is, therefore, of fundamental importance. It was, however, urged that while action taken without adequate education may be dangerous, education that does not result in action will be valueless.

At the opening of the afternoon session Dr. [Emily] Hickman moved that the chairman be asked to appoint a small committee to draw up plans, in the light of the morning's discussion, for the formation of a continuing committee through which women's organizations might work together to ensure women's contribution to the planning and establishment of world cooperation. After full discussion of the nature, purpose, and task of such a planning committee, it was unanimously voted that Miss Woolley appoint a committee of five, with power to co-opt two members, of other than American nationality, to consult with them. After a unanimous vote of thanks to Miss Woolley for calling and preparing for the meeting, and to the National Board of the Young Women's Christian Association for its hospitality, the meeting was adjourned.

3 CPWPWP Pamphlet, "Why Another Committee?"

WHEN THE WAR IS WON, we must not let the chance escape this time to build a peace that will last. The various governments are already at work (as they should be) planning certain aspects of the post-war world, and we believe the representation of women in their policy-forming groups to be both just and indispensable. The new world will call for new thinking, and all our minds are not too many. Nor can we dispense with that warm, direct sympathy on the simply human level, which is part of women's special contribution to any public project.

"Why Another Committee?" Charl Ormond Williams Papers, Box 8, Folder, White House Conference, "How Women May Share in Post-War Policy Making," Press Materials, Manuscript Division, Library of Congress, Washington, DC.

How Can Women Secure Such Representation?

Through the Committee on the Participation of Women in Post-War Planning.

What Is This Committee?

A committee co-ordinating the efforts of twelve women's national organizations (supported by a growing number of individuals) to insure the inclusion of highly qualified women in the policy-forming groups concerned with international post-war matters.

Why Should Women be Included in Such Groups?

Because women have long believed that international co-operation is both possible and necessary, and that its basic conditions should be peace, justice, equality and economic advancement for all.

Women did not participate in the organization of the world after the First World War, but they are sharing in its fateful consequences. And in the world that will emerge from this Second World War, women—and children—will have to live as much as men.

Why *shouldn't* they have a hand in planning it?

What Does the Committee Do?

It informs its members of coming international conferences; with their aid it lists one or more qualified women and urges their appointment to the official delegations of the United States.

It urges women in other countries to secure appointment of competent women to the delegations of their countries. It is interested in securing representation of women in semi-private, semi-governmental conferences.

On What Sort of Conferences Does It Work?

Food and Agricultural Conferences

United Nations Relief and Rehabilitation Authority

Anglo-American Aviation Conference

United Nations Monetary Conference

Civilian Advisory Council of the Department of State

And other conferences as announced.

What Machinery Does It Have?

An Executive Committee in New York City to make decisions.

A Sub-Committee in Washington to keep in touch with the Government.

A Sub-Committee to advise on inter-American affairs, likewise in Washington.

Does the Committee Urge the Election of More Women to Congress?

Yes, as soon as we can undertake it.

What Are the Greatest Obstacles in Its Way?

The inertia of women

The unawareness of men
The concerted public promotion of "glamour."
Why Has the Committee Not Accomplished More than It Has?
Because it has lacked funds and needs them.

**

Committee on the Participation of Women in Post-War Planning
1819 Broadway, New York 23, N.Y.
I subscribe $........ to the work of the Committee on the Participation
of Women in Post-War Planning.

I should be glad to enroll as an active member of the Committee on
the Participation of Women in Post-War Planning. (Dues are $3, the
financial year beginning May 1.)
Name _____
Address _____
City_____ Zone No. _____ State _____

4 CPWPWP Minutes

A GENERAL MEETING OF THE COMMITTEE on the Participation of Women
in Post War Planning was held in the Assembly Room of the
Y.W.C.A. on October 21st.
Present were:

Dr. Emily Hickman, Chairman	Judge Anna M. Kross
Miss Margaret E. Burton	Mrs. James W. Irwin
Miss Charlotte Van Manen	Mrs. Edgerton Parsons
Mrs. Arthur C. Holden of	Miss Gertrude Baer
the National Women's Party	Miss Louise Bache
Miss Florence Codman	Mrs. Maxwell Ehrlich
Miss Edesse Dahlgren	Miss Helen Raebeck
Mrs. Matthew Swerling	

The minutes of the previous meeting were read and accepted.
Dr. Hickman reported on the work of the Executive Committee
since the last meeting of the general Committee. She stated that no

CPWPWP Minutes, October 21, 1943. Somerville-Howorth Papers, Series
III, Lucy Somerville Howorth, Box 7, Folder 145, Committee on Women in World
Affairs, Arthur and Elizabeth Schlesinger Library on the History of Women in
America, Radcliffe College, Cambridge, MA.

meeting was held before the summer because of re-organization which took place in the plans of the Committee.

It had been previously thought advisable to have a general Committee in Washington, and a Sub-Committee in New York. The Executive Committee later agreed, however, that it would be better to have the headquarters of the Committee in New York and a Sub-Committee in Washington. Dr. Hickman was named Chairman of the Committee, and Mrs. Irwin, Chairman of the Washington Sub-Committee.

The main lines of action taken by the Executive Committee since last Spring are as follows:

The Chairman of the Committee stated that just following the last meeting, the names of the delegates to the Food Conference were announced. No woman was included on the list. The Chairman telegraphed then Under-Secretary of State Sumner Welles expressing the disappointment of the Committee about the omission of a woman delegate. Mr. Welles' reply expressed regret but indicated that no further action was taken. Sometime later, it was announced that Miss Josephine Schain would be one of the delegates from the United States. Although Miss Schain's name had not been presented by this Committee, the Committee expressed its appreciation in the appointment of a woman delegate.

When the announcement came about the projected relief and rehabilitation conference, the Executive Committee wrote to the general Committee asking for suggestions as to who should be recommended by the Committee. It was finally agreed that the name of Miss Helen Hall should be submitted, and letters were sent out accordingly.

It now appears, however, that only one or two delegates from each country will attend the relief and rehabilitation conference in Atlantic City, and that there probably will not be an opportunity for Miss Hall to be a delegate.

Because of a possibility that a conference on international aviation will be held in the near future, Judge Dorothy Kenyon and Miss Louise Bache were asked to canvass the field as to suggestions for possible women who might be recommended for a place at such a conference. The final report of this sub-committee has not yet been completed.

The procedure followed by the Committee in connection with these conferences has been this: When a conference is announced or anticipated, all members of the Committee are asked to suggest names of possible delegates. These suggestions are then turned over to a sub-committee which considers those names submitted as well as other possibilities. Their report is then submitted to the Executive Committee and to the Washington Committee. When these groups agree on a

particular person, all members of the Committee are asked to write to the appropriate quarter recommending the particular woman as a delegate to the particular conference.

It had also been suggested that the Committee endeavor to get in touch with foreign women in order to encourage the appointment of women to delegations from other countries. Dr. Hickman, therefore, got in touch with Mrs. Papanek, the head of the Woman's Committee for the United Nations Information Office. Mrs. Papanek wrote the Committee that her group was aware of the need for such appointments and that wherever possible they would urge the particular governments to appoint women as delegates to international conferences.

Dr. Hickman also got in touch with Winifred Culles of the British Information Office who has been in the United States, but has now gone back to England. Miss Culles agreed to consult with British women about this problem upon her return. Miss Mary Woodsmall of the Y.W.C.A. also has been in England and discussed the problem with the United Nations women there.

Secretary's Report

The secretary reported that the following organizations are now members of the Committee:

National Council of Jewish Women
Women's International League for Peace and Freedom
National Council of Negro Women
National Women's Party
Women's Overseas Service League
Women's Action Committee for Victory and Lasting Peace
National Board of the Young Women's Christian Association
Zonta International

About fifteen other organizations have also been asked to become members. Many of these organizations are considering joining and are awaiting action by their Directors. In addition, the Secretary reported that there are about forty individual members of the Committee.

The treasurer submitted a financial report as follows:

Cash Received		**Expenses**	
Early Expenses	$21.36	Early Expenses	$21.36
Organizational Dues	50.00	Petty Cash	20.00
Individual Dues	81.00	Printing	13.50
Interest	17	Balance in Bank	97.67
Total	**$152.53**		**$152.53**

Mrs. Irwin then submitted a report from the Washington Committee. She stated that she had spoken to Mr. Dickey of the State Department asking him what conferences were projected for the near future. She said that Mr. Dickey had told her that in all probability, there will be no general aviation conference along the lines of the food conference. If any discussions are held on the subject of international aviation, it will probably be done through diplomatic channels. She did list the following conferences as likely to occur in the near future:

1. A conference among China, Latin American countries, Sweden and the United States. This conference was suggested by the National Association of Manufacturers and would be of a semi-official nature.
2. In addition, there may be a conference of the Chambers of Commerce of such countries as Canada, Great Britain and Latin American countries.

The two above-mentioned conferences may be held separately or jointly. Also, there is a projected international conference of the Inter-American Development Commission which is of a semi-official nature which will probably be concerned with problems of industrial development and commerce. It was suggested that plans be made to get in touch with the National Association of Manufacturers and the Chamber of Commerce asking for further information about the conferences and then exploring the field to determine what women might be suggested to participate in the conferences.

It was also suggested that the Committee in Washington get in touch with Miss Mary Winslow of the Latin American Commission of Women to get further information about the Inter-American Development Commission Conference.

Miss Gertrude Baer suggested that further efforts be made to have additional women appointed as experts to such conferences. Dr. Hickman agreed but pointed out that there was less opposition to women as experts than as actual policy makers. Miss Bache brought up the question of the advisability of women accepting advisory positions as women rather than fighting for policy-making positions as integral parts of planning agencies.

Dr. Hickman reported that there was a vacancy on the Board of Visa Appeals, which has two members, who are the final board of review for all visas, and said that Miss Mary Dewson had been suggested as an excellent choice for the position. After some discussion, it was voted to recommend Miss Mary Dewson for the position.

Judge Kross pointed out the need for women in Congress, and urged that letters be written to the political parties insisting that they nominate more women for congressional office.

Meeting was adjourned.

Respectfully submitted,
Helen Raebeck
Secretary

5 Letter, Mary McLeod Bethune to Emily Hickman

Dr. Emily Hickman, Acting Chairman
27 Seaman Street
New Brunswick, New Jersey

My dear Dr. Hickman:

THE NATIONAL COUNCIL OF NEGRO WOMEN is happy to become a part of the Committee on the Participation of Women in Post War Planning. Mrs. Inabell Linsay of Howard University is Chairman of our Post-War Planning Committee. She may be reached at the above address.

The following names are those of our members who are highly recommended for service on policy-forming groups:

Mrs. Bessye Bearden
351 West 114th Street
New York City

Mrs. Mabel Staupers, R.N.
160—12, 73rd Avenue
Flushing, N.Y.

Dorothy Boulding Ferebee, M.D.
1809 2nd Street, N.W.
Washington, D.C.

Mrs. Harriet C. Hall
60 Windsor Street
Boston, Mass.

Atty. Sadie Mosell Alexander
1708 Jefferson Street
Philadelphia, Pa.

Atty. Edith Sampson
310 E. 38th Street
Chicago, Illinois

Letter, Mary McLeod Bethune to Emily Hickman, May 6, 1943. Records of the National Council of Negro Women, Series 5, Box 14, Folder 238, Correspondence H 1943. Reprinted by permission of National Park Service, Mary McLeod Bethune Council House National Historic Site, Washington, DC.

Executive Secretary Miss Jeanetta Welch
National Council of Negro Women
1812 Ninth Street, N.W.
Washington, D.C.

Our membership fee of $10.00 is being requisitioned from our Treasurer, and you will receive it in a short while.

Please know that we are willing to cooperate with your organization in any way we can.

<div align="right">

Sincerely yours,
Mary McLeod Bethune
President

</div>

6 Letter, Emily Hickman to Mary McLeod Bethune

Mrs. Mary McLeod Bethune, President
National Council of Negro Women
1318 Vermont Avenue, N.W.
Washington, D.C.

M y dear Mrs. Bethune:

THANK YOU FOR YOUR LETTER of April 10. At the meeting of the Executive Committee of the Committee on the Participation of Women in Post War Planning on April 20, I discussed with them your suggestion that we ask Mrs. Riddle to be a member of the Executive Committee. The suggestion met with unanimous approval and I am writing to Mrs. Riddle asking her if she will serve on the Executive Committee.

<div align="right">

Sincerely,
Emily Hickman
Chairman

</div>

Letter, Emily Hickman to Mary McLeod Bethune, April 22, 1944. Records of the National Council of Negro Women, Series 5, Box 28, Folder 43, Post War Planning Committee of National Council of Negro Women, 1944 March–May. National Park Service, Mary McLeod Bethune Council House National Historic Site, Washington, DC.

III The National Council of Negro Women (NCNW) and Postwar Planning

Mary McLeod Bethune, the distinguished educator and political activist, founded the National Council of Negro Women (NCNW), an association of twenty-two black women's organizations, in 1935. By the 1940s, the membership of the NCNW totaled 800,000. When the NCNW joined the Committee on the Participation of Women in Post War Planning (CPWPWP) in the spring of 1943, the Council also established its own Postwar Planning Committee to serve as a liaison group between the NCNW and the CPWPWP. Document 7 is a report that describes the purpose and plan of the NCNW's Postwar Planning Committee. Of particular note is the prescient way in which Inabelle Burns Lindsay, the chair of the committee and author of this report, called attention to how racial and gender issues would present special challenges to "Negro women" as they prepared for the postwar world. Throughout the war years, the NCNW participated in a variety of interracial activities concerned with establishing an equal place for all women at the war's end.

The NCNW placed great importance on postwar planning. The Council devoted its entire 1944 Annual Workshop to the theme, "Wartime Planning for Post-War Security." At this workshop, Bethune brought together leading black and white advocates for social justice and interracial harmony. Document 8 provides excerpts from Bethune's keynote speech in which she urged the interracial audience of 200 members, delegates, and visitors to "gear ourselves to the great task of mapping out a pathway that will truly lead to a better world for us all." She continued by calling for "one long strong pull all altogether, toward the integration of and participation in the new found freedoms and opportunities that are opening daily to the women of America and the world." A highlight of the workshop was a powerful talk presented by the acclaimed

author, educator, civil rights advocate, and peace activist, Mary Church Terrell. Document 9 contains her speech in which she championed the creation of a postwar world that treated all citizens equally, "no matter what their color may be, nor in what kind of religion they may believe, nor where they were born, nor in what social class they may move."

7 Report of the Postwar Planning Committee of the National Council of Negro Women

I. Purpose

T HE MOST EFFECTIVE WAR WEAPON of the democratic countries in this period is their willingness to initiate programs for a constructive peace in the midst of the war. It is particularly significant to citizen members of minority groups in these democracies that they can speak frankly in urging greater recognition and opportunity to share the privileges of a complete democracy. To conserve whatever gains are made now, and to use those as a foundation for a just and prosperous peace, postwar planning becomes of paramount importance.

The American Negro constitutes the largest minority in this country. Our men are engaged with all the vigor, courage, and energy which they possess in the actual establishment of a just peace by bearing arms, by working for industries, and by contributing to the country's plans for the future. It is essential that Negro women likewise assume their full responsibility. We suffer the dual disadvantage of race and sex. To the end that these disadvantages shall be minimized or turned to advantages, we must now demonstrate to the world and to America in particular that we are capable of, not only carrying our share of responsibility in the present need, but also of contributing to basic active democracy of the future. The purpose of organizing a committee on postwar planning is that we may think with unity and plan together the most constructive steps to achieve this purpose. It is further urged that this committee be the articulate voice of Negro women in

Report of the Postwar Planning Committee of the National Council of Negro Women. Records of the National Council of Negro Women, Series 5, Box 28, Folder 412, Post War Planning Committee of NCNW 1944 March–May. Reprinted by permission of National Park Service, Mary McLeod Bethune Council House National Historic Site, Washington, DC.

pointing out to women of the majority group areas where our interests coincide and where all women can work together for their country's and their own ultimate welfare.

II. Plan of Organization

The National Resources Planning Board's recently released report sets up a blueprint for a post war world. Areas stressed in this report of particular significance to women, and especially to Negro women, are the areas indicated by the topics Education, Health, and Welfare. We propose, therefore, that this committee be subdivided into three sub-committees each exploring our peculiar responsibilities in one of those larger areas. In addition, there should be a regional postwar planning committee organized in the same way as the national committee and with representatives charged with the major responsibilities of investigating need and proposing suitable measures for meeting such need for each field. While it is expected that the specialists in those various fields who will be called upon to help outline the approach [to] each of these problems will have contributions to make, in general, it might be proposed that attention be directed somewhat as follows:

Education
Rural
Urban
Secondary
College
Content of particular significance for Negro students
Financing of higher education
Employment opportunities.

Health
Infant and maternal health.
Public health programs and centers (for example, with tuberculosis,
 venereal diseases, and other communicable diseases in mind)
Personnel from the Negro group for public health services
Hospital facilities
Physical rehabilitation of the war-injured.

Welfare
Housing
Recreation
Employment
Child Care programs
Public Assistance

Social Insurance programs
Personnel counseling for individual or family problems.

Note: This tentative program from the Post-War Planning Committee is for your evaluation and approval. The final revision of plans as agreed upon by all of us will be distributed as a guide to our members.

<div align="right">

Inabelle Burns Lindsay, Chairman
National Chr. Post-War Planning Committee

</div>

8 1944 NCNW Annual Workshop

T HE 1944 WORKSHOP, THE ANNUAL MEETING of the National Council of Negro Women held from October 12 through October 15, will be recorded as one of the greatest meetings in Council history. The sessions were held in the Department of Labor Auditorium and Conference Rooms, at Constitution Avenue and Fourteenth Street, in Washington, D.C. Representatives from twenty-one member organizations and Metropolitan Councils were in attendance. Two hundred life members, delegates and visitors form nineteen states—Florida, Georgia, Alabama, Tennessee, North Carolina, Mississippi, Kentucky, Ohio, Indiana, Illinois, Missouri, Michigan, Oklahoma, Virginia, Maryland, New York, New Jersey, Massachusetts, Pennsylvania—and the District of Columbia were in attendance.

The theme of the Workshop meeting was "Wartime Planning for Post-War Security." The keynote of the meeting was sounded by President Mary McLeod Bethune in her message which opened the meeting:

"The National Council of Negro Women meets at a time when unity among organizations is imperative. Representing in our membership, as we do, thousands of advantaged women and girls, a grave responsibility rests upon us. Our united thinking, planning and working together must of necessity be placed upon high ground. I therefore beseech you in all our deliberations to be void of pettiness and selfishness. Let us gear ourselves to the great task of mapping out a pathway that will truly lead to a better world for us all. We meet today to

"The Annual Workshop: Council Holds Historic Meeting," *Aframerican Woman's Journal* (Fall 1944): 3–4. Records of the National Council of Negro Women, Series 13, Box 2, Folder 15. Reprinted by permission of National Park Service, Mary McLeod Bethune Council House National Historic Site, Washington, DC.

seriously consider the happenings and achievements of the past year, to strengthen our weak points and to reinforce our strong points according to the needs of the hour. We meet to set our goal for the year ahead and to doubly re-unite our efforts for one long strong pull all together, toward the integration of and participation in the new found freedoms and opportunities that are opening daily to the women of America and the world. This is a crucial year. We are in the midst of the greatest struggle known to mankind. May I ask that we unitedly gather spiritual strength to fortify us as we give so freely our sons, our daughters, our loved ones, ourselves, that peace and freedom and democracy may envelop the world."

"Human Relations in Transition to Peace" was the theme of the International Night, a public session held during the 1944 Workshop. The meeting was planned to show how peoples of all countries must work together if world freedom is to exist, and we are to gain universal peace.

A feeling of international fellowship and good-will was established in the several greetings from emissaries of the allied nations. Those bringing personal greetings included Mrs. Sarah Simpson George, Monrovia, Liberia; Dr. Diosdado M. Yap, Filipino Lecturer; Dr. Pedro de Albe, Pan-American Union; Mr. C. C. Husum, Attache, Danish Legation; Senor Francisco Linares-Aranda, Secretary, Guatemala Embassy; Mr. Francis Irgens, Counselor, Norwegian Embassy; Senor Don Eugenio de Anzorema, Second Secretary, Mexican Embassy; Senor Don Jorge Hazere, First Secretary, Costa Rican Embassy; M. Xavier de la Chevalerie, Minister Plenipotentiary, Provisional Government of the French Republic; Mr. B. S. Lee, First Secretary, Chinese Embassy; Monsieur Andre Liautaud, Ambassador, Haitian Legation; Mr. Richard T. G. Miles, Third Secretary, British Embassy; Mr. Carlos van Bellinghen, Second Secretary, Belgian Embassy.

Also present on this program were representatives from the National Council of Catholic Women, the National Council of Jewish Women and the International Council of Women of the United States.

Principal speakers were Mrs. Mary Church Terrell, Historian to the National Council of Negro Women; Mrs. J. Borden Harriman, American United World Organization, Inc.; and Dr. Rayford Logan, Member of the Advisory Committee, Coordinator of Inter-American Affairs. Each speaker pointed out the need for international collaboration and understanding.

The Reverend A. F. Elmes, Peoples' Congregational Church, rendered the invocation and the Reverend Francis W. McPeek, Director, Department of Social Welfare, Washington Federation of Churches, the benediction.

Musical selections were given by Mrs. Margaret McDaniels and Miss Louise Burge, soloists, and the Howard University Choir under the direction of Dean Warner E. Lawson, School of Music at Howard University.

Mrs. Harriet C. Hall, Manager of the *Aframerican Woman's Journal*, NCNW, presided at the meeting.

9 Human Relations in Transition to Peace

Mary Church Terrell

O NE DOES NOT HAVE TO BE A PHILOSOPHER or a wiseacre to state definitely there is only one way transitionally or at any other time to establish and maintain peace. To succeed in doing this, each and every government must treat all its citizens justly, no matter what their color may be, nor in what kind of religion they may believe, nor where they were born, nor in what social class they may move.

There is no doubt that injustice is the root of much if not all of the evil which disturbs the peace and brings on wars. In all the aggressor countries, however, there are doubtless large numbers who hate the injustice and cruelty of which they seem a part. But they sit quietly by while violence is being planned without protesting against it, because they lack the courage to stand up for what they know is just and right. And so it is easy for oppressors and persecutors to carry out their diabolical plans.

Personally, I believe if the leaders in those countries whose duty it was to prevent Japan from seizing Manchuria had had the courage to speak out boldly and to act bravely, this flagrant case of highway robbery might not have occurred. But seeing [that] the leaders and the good citizens of those countries had yielded practically without a struggle, a group of robbers in another land were encouraged to ply their nefarious trade, so later on Ethiopia fell prey to Italy.

On the same principle and for the same reason the relations between the dominant race in this country and two minority groups are not as cordial as they might and should be and are certainly not conducive to peace. And yet, I am sure that large numbers of the dominant

Mary Church Terrell, "Human Relations in Transition to Peace," Speech to 1944 NCNW Annual Workshop. Mary Church Terrell Papers, Box 31, Folder, Human Relations in Transition to Peace, Manuscript Division, Library of Congress, Washington, DC.

race here believe in justice theoretically, at least, for they know that without justice there can be no peace. I believe large numbers of the dominant race regret that colored people are handicapped, hindered, humiliated and harassed in so many ways, that often it is impossible for them to secure employment so that they can earn their daily bread. Right here in Washington I believe there are many in the dominant race who regret that race prejudice bars qualified colored men from being employed as operators of buses and street cars, especially since the city so sadly needs their services and the colored men so sorely need the jobs. . . .

Though the attitude toward colored people manifested by many in the dominant race is fair and just, the fact remains that for more than seventy years the justice-loving people in the North, East and West, that is, in three fourths of the States, have been allowing the prejudice-ridden law-defying people in one fourth of the States continually to violate the 14th and 15th amendments to the Constitution, so that hundreds of thousands of colored people have been disfranchised and have been deprived of their rights. Not long ago the Chairman of the Senate District Committee declared right here in the National Capital that no Negro would ever be allowed to vote in Mississippi, no matter what the Constitution says.

It is also true that the justice-loving people of the North, East and West have made few if any protests against the iniquitous Convict Lease System, the Contract Labor System and other devices used by some of the States practically to reduce hundreds of colored people to slavery in that section where the majority live.

Very reluctantly I refer to reports about the colored soldiers sent to southern camps where, it is said, many have been deprived of proper recreational facilities, have been refused transportation on buses, have been beaten and murdered by bus drivers, civilians and M.Ps. So long as a rebellious, law defying group is allowed to commit with impunity acts which shame our country and cause other nations to ridicule our claim of being a democracy, there can be no peace either during the transition period or any other time.

Those who want to establish human relations during the transition which will be conducive to peace must face those ugly facts without trying to conceal them, so that we may correct the conditions which breed hatred and strife. We ourselves must cultivate moral courage enough to take a definite, firm stand for justice and right. Just now there is a practical method of taking some steps which will pave the path to peace. We must urge Congress to establish a Permanent Fair Employment Practice Committee, also to pass the Anti-Poll Tax and Anti-Lynching bills, also to sponsor other measures which will right

some of the wrongs we have endured so long, so that we may have the same chance to develop that other races enjoy.

Personally, I do not see how there can be any peace during the transition period or at any other time, until colored people are granted all the rights, privileges and immunities to which they are entitled as citizens, and until they are allowed to reach any height along any line of human endeavor to which by their ability and their industry they are able to attain.

IV Women Demand a Place at the Peace Table

Throughout the United States, middle-class and professional women demanded that women be granted seats at the peace table. The documents in this section provide examples of the strength of this movement. Document 10 is a June 17, 1942, news account about the first regional conference on women and the war, sponsored by the Women's Division of the Democratic National Committee. A featured speaker was Congresswoman Mary T. Norton of New Jersey. Document 11 reports on speeches, given at the Women's National Press Club on November 10, 1942, exhorting women to help make the peace. One of the speakers, Agnes E. Meyer, would go on to write an important book, *Journey through Chaos* (1943), about life on the home front during World War II. Document 12, a 1943 New Year's Day letter to the editor of the *New York Times*, argues that the future of "civilized humanity" depends upon "equal collaboration between the best qualified from among both our women and our men" at the peace conference to follow the war.

Documents 13 through 15 are statements by three well-known public figures that underscore the importance of women's participation in postwar planning councils. Document 13 is the text of the address that Mary Anderson, director of the Women's Bureau of the U.S. Department of Labor, gave at the 1944 annual meeting of the American Economic Association. Emphasizing that "women's role in peacetime employment" was "being overlooked or underestimated," Anderson called for the appointment of "qualified women" to the "various planning committees—whether set up by industry, labor, or government, whether on the local, national, or international level."

In Document 14, Minnie L. Maffett's August 1944 presidential address to the National Federation of Business and Professional Women's Clubs is reprinted. Maffett observed that "women are still conspicuous for their absence from policy-making posts," and

that the time was now to demand "an equal part with men in the shaping of the postwar world." She issued a special charge to business and professional women, whom she characterized as the "shock troops . . . in the great army of women striving for better conditions in a better world."

Document 15, a 1944 address given by Republican Congresswoman Clare Boothe Luce of Connecticut, sharply criticizes men for their centuries-long record of failure in "drafting a lasting and durable and equitable peace." She continued by expressing the hope that "someday women will sit down at a peace table on an equal footing with the men to add their determination, their devotion to peace, their vision of a better world to the practical experience of older diplomats."

10 Mrs. Norton Urges Mothers Aid Peace

B OSTON, JUNE 16—A WARNING THAT "the short-sighted policy" prevailing after the last war must not be allowed to influence Congress when peace is planned this time, was sounded today by Representative Mary T. Norton of New Jersey before the first regional conference on women and the war, sponsored by the women's division of the Democratic National Committee.

"A small minority in the United States Senate worked destruction through prejudice and personal hatred instead of uniting in making the world safe for democracy," Mrs. Norton said.

She attributed the split in the Senate after the last war to "the leadership of [Henry Cabot] Lodge and a few others of his kind."

Mrs. Norton extolled "the magnificent service of your Senator Dave Walsh."

"I have known Dave Walsh for many years," she said. "He was a classmate of my brother's at Holy Cross. I know there is no man in this country who has given better service not merely to his party but to his country."

She suggested as participants around the council table where peace will be discussed not only "the mothers of the world" but "the young men fighting our battles."

"Mrs. Norton Urges Mothers Aid Peace," *New York Times*, June 17, 1942. Reprinted by permission of the *New York Times*.

"They are better educated in what freedom means than the young men of that other war," the chairman of the House Labor Committee said. "They can be depended on to finish the job."

Urging women to train for politics in their communities, she said that men might just as well realize that more and more women will be elected to public office.

Urges Aid to "Patriotic" Nominees

One of the war tasks she advised women to assume was organizing and working "for candidates who have shown themselves to be fearless and patriotic before it became popular to be patriotic."

Praising the war effort of labor, she said that although much publicity is given in isolated cases of selfishness in the ranks of the unions, much more should be given to the enormous production job being accomplished through the cooperation of workers and industry.

The importance of a fair and just representation of the peoples of the world on the peace panel after the war was emphasized at a morning discussion presided over by Miss Josephine Schain of the women's division, consultant on international affairs.

Labor must have a part in the peace conference, declared Miss Dorothy Bellance of the Amalgamated Clothing Workers of America. Stressing the need for an understanding of problems of the working men of the world, she said that "labor here cannot divorce itself from the rest of the world. If workers are hungry in other countries they will undermine us even if we have food."

A place for women will be found at the peace table, predicted Judge Dorothy Kenyon of New York City. Suggesting that in Germany women be used to help re-educate the youth after the war, she declared, "I have not lost confidence in the women of Germany. I cannot believe that they like to be brides of the State, that they like their present state of degradation."

11 Women Told to Ask Peace Table Seats

WOMEN OF THE UNITED NATIONS must help make the peace for which we are fighting so valiantly if that peace is to insure freedom and justice, Senora Isabel de Palenira, Spanish-born reporter, author

"Women Told to Ask Peace Table Seats," *New York Times*, November 11, 1942. Reprinted by permission of the *New York Times*.

and formerly Spanish Republic Minister to Finland and Sweden, told the Women's National Press Club today.

Senora de Palenira declared that Hitler is beaten although the Allies have not won yet. We have yet to win the freedom and justice for which we are fighting, she said.

Another speaker, Mrs. Agnes E. Meyer, wife of Eugene Meyer, publisher of the *Washington Post*, predicted that women will, in fact, help make the peace.

"The women of Great Britain are doing such a heroic piece of work in carrying their share of the burden of the war that I think they will not only be able to ask for a place at the peace table but it will be granted as obvious recognition of the part they have played," she said.

Mrs. Meyer returned recently from a month in Britain.

Other guests included Mrs. Ralph William Close, wife of the Minister of the Union of South Africa, and several delegates to the annual convention of the Inter-American Commission of Women.

Senora de Palenira credited the "restraint" of the American press as largely responsible for the success of American military forces in North Africa. Her husband, Senor Ceferino Palenira, will exhibit a collection of his oil paintings on Mexican folk art this Spring in Washington.

12 Women for Peace Conference

T o the Editor of the *New York Times*:

THESE DAYS, FAINTLY VOICED AND in widely scattered areas of thought and geography, a suggestion is being made that some woman be given the high honor—and, incidentally, be it said, the possibly futile labors and almost unbearable responsibility—of sitting in with our men at the conference to follow upon the winning of the war.

This suggestion strikes me as appalling, by no means because of its revolutionary character, but because of its utter and flagrant insufficiency. If after this latest demonstration of the combative and homicidal tendencies still apparently uneradicated from the masculine constitution as it expresses itself in the field of international economics and politics, and in view of the increasing potentialities of the destructive forces, we have not very generally arrived at the conclusion that it is only by the most consecrated, active, vigilant and—insofar as is possible—equal collaboration between the best qualified from among

"Women for Peace Conference," *New York Times*, January 5, 1943.

both our women and our men that society can be improved and balanced and civilized humanity saved from annihilation, then, in my humble opinion, the outlook for peace in the future will probably continue to remain quite as dark and problematical as it has ever been.

Anne Kavanagh Priest
New York, Jan. 1, 1943

13 The Postwar Role of American Women

Mary Anderson

I AM GLAD THAT THE AMERICAN ECONOMIC ASSOCIATION recognizes the importance of giving attention at this time to the postwar role of women. My only regret is that I am unable to bring to the discussion the weight of extensive research that the Women's Bureau is about to initiate—as a result of a special appropriation granted by Congress.

Even while the war is being waged—with the end not yet in sight— and even while thousands of women are still being recruited to take the place of men as workers on the home front, we hear on many sides the question: In the postwar period what will happen to all the women now employed? Even broader questions are being asked by our women both as individuals and as members of organizations: What will be the role of American women in the reconstruction period? What will be their status and their share in the peace program—on the national and international levels? Will they have greater opportunity to hold outstanding positions and to mold policies affecting the interests of women than in the past, than in the present war period?

These are challenging questions. They call for careful analysis of the many vital factors in the equation. Such action is necessary to guarantee a fair deal to women and a sound basis to our future economy and social order.

There are some would-be planners who have a quick and simple solution. "Women will return to the home," they say. A letter received at the Women's Bureau recently is a good illustration of this attitude. It came from a union man—a young man, too. In writing about his industry—one in which women have been employed for a long time and which is just being organized—he ended as follows: "Wishing

Mary Anderson, "The Postwar Role of American Women," *American Economic Review* 34 (March 1944): 237–44. Reprinted by permission of the *American Economic Review*.

you success in your work and hoping for the day when woman may relax and stay in her beloved kitchen, a loving wife to some man who is now fighting for his beloved country."

I can match this viewpoint with that of some economists and industrialists. Several weeks ago I heard a man who holds a key position in an extensive program concerned with future economic developments announce on a lecture platform that he was not worried about women workers in the postwar world. He said, somewhat facetiously, he thought they would quit their jobs and stay in the home.

Fortunately, other authorities concerned with the transition from a war to a peacetime economy take a more realistic approach. They see the value of studying the relation of women to the future labor market and industrial production, to the postwar social and economic order, to national reconstruction and prosperity, and to a lasting peace.

Women themselves take such a stand through their organizations. You may remember the Women's Centennial Congress back in November, 1940. The theme of the Congress as representative of the women participants was: "To look backward over achievements won, look outward at discriminations still existing, look forward to the emphases imperative for the advancement of mankind." This expressed purpose for the future must be the keynote of women's postwar planning today.

Take the matter of women's postwar employment, a question in which I am vitally interested. Certainly, no one believes that women should be employed at the expense of ex-servicemen or be the cause of their selling apples on the street. But this belief does not preclude a program of analyzing the problems and probabilities as to women's future employment, for women are a part of mankind. President Roosevelt in his message to the Congress in January stressed the right of every American citizen to a useful and remunerative job. This means not only men but women workers whose services and sacrifices are essential factors in winning the war, and who have equally vital roles to enact in winning the peace.

Since the role of women as wage earners is such an important part of my comprehensive subject, I would like to add a few suggestions from my vantage point in the Women's Bureau.

We have the example of the last war to prove the need of present planning for future adjustment of women—if we are to keep history from repeating itself in bringing injustices and undue hardships to women. In World War I as in the present conflict womanpower became increasingly valuable. Much as today—though on a considerably less extensive scale—women stepped into the breaches. They took the place of men in munitions making and in essential civilian industries. They

rendered efficient and indispensable service. Nevertheless, no sooner had hostilities ceased than a reaction against women workers set in. The Woman in Industry Service, which was set up as a war agency in the United States Department of Labor to promote the effective utilization of women and which later became the Women's Bureau, was unable to turn this tide of discrimination. Various public speakers as well as certain labor organizations (upheld in one case by the National War Labor Board of the period) took the stand that women who entered industry during the war should relinquish their jobs after the war—regardless of resulting hardships to women. The attitude was due largely to the fear that lower-paid women would be competitors to men.

With this background let us look into some of the facts and factors of women's employment in the coming postwar period.

Statistics have a significant story to tell of women in the labor force before, during, and after this war. In the spring of 1940 not only were there 11 million women actually in employment but an additional 2 million in search of jobs—or a total of 13 million women workers. Current estimates place the number of employed women at about 16 million, with a possible peak of 18 million by the end of the war. Such a figure would indicate an influx of about 4 million new women workers into the labor market since the beginning of the emergency.

We can expect the flood tide of women in the labor force to recede rapidly with the coming of peace to possibly 15 million. The large number of young girls who have temporarily left school for war jobs will be drawn back into the educational system when workers become more plentiful than work. Some older women who during the labor shortage have sought or held on to employment from choice rather than necessity will retire, though there will probably be more women in their forties and fifties in the labor market than before the war. Large numbers of housewives who due to the exigencies of war have joined the wage-earning ranks will voluntarily and gladly give up their jobs—but not all. War casualties and postwar training of servicemen will impose serious breadwinning responsibilities on many of these so-called "duration" workers.

These are some of the ideas stressed by John D. Durand in an article in the December *International Labor Review*. Basing his estimate on historical trends he predicts that in a possible labor force of 59 million persons by 1950, women may number 16 or 17 million. He declares that such a total would be very few more than might have been expected had there been no war. Thus, should the war end in 1945, an estimated 15 million women having or wanting employment during the reconstruction period seems not an abnormal situation.

In regard to his estimates John Durand goes on to say:

> Such a supply of labor is a challenge to American industry and Gov-
> ernment. If full employment can be attained by providing jobs for
> all who wish to work, rather than by discouraging the employment
> of women and trying to cut down the labor force, the expansion re-
> sulting from the war can mean greater prosperity than the Nation
> has ever known. To this end the need to provide jobs for a much
> larger number of women should be recognized in the plans which
> are now being laid to maintain employment in the postwar period.

The Women's Bureau is in complete agreement with this idea. We
know from our twenty-five years of study of women wage earners'
problems that the vast majority of women workers seek employment
from economic need.

Calm recital of facts and figures will scarcely allay rising fear in
some quarters that women will take jobs from returning soldiers. Nor
will statistical statements prevent unjust and unfounded discrimina-
tion against women workers. Facing the special problems of women
and formulating specific solutions must be the line of action. Other-
wise, in the transition period of sudden demobilization of both mili-
tary and industrial forces, with large numbers of jobless persons
competing for work, women will be the victims of a catch-as-catch-
can situation. Another complication looms, as a result of women's
migration in the past two years from less to more essential jobs, from
civilian to war industries: Many women, having burned their occupa-
tional bridges behind them, may try in vain to go back to former fields
unless given special assistance.

When out of work, women as a class are offered less of a helping
hand by unemployment compensation than men are. Benefits are based
on wages and in general women are on lower wage levels. To secure
benefits women quite generally have extra hurdles to clear—due to
marriage functions, or assumption of household obligations. Women
who simply quit their jobs are considered no longer members of the
labor force, therefore not entitled to benefits. They must prove their
intention if they expect to continue paid employment. An extended
and improved social security system is necessary to cushion postwar
unemployment, but such measures are only stopgaps.

Full employment of our productive resources—both human and
material—is essential to save the country from a worse depression than
the one that began in 1929. Fortunately, demobilization of both the
armed and the labor forces promises to be more gradual than after
World War I. Already some cutbacks in war materials and correspond-
ing increases in civilian goods are being effected. Plans are under way

to give further training and discharge pay to servicemen. There is some talk of a dismissal wage for munitions workers. The future employment of millions of men is now being given expert attention by leaders in industry, labor, and government. Nevertheless, except in rare instances, women's role in peacetime employment is being overlooked or underestimated. Full employment means women as well as men. Readjustment and re-employment of men and women must be worked out.

A policy to be woven into the whole picture is the equal-pay standard for women. To evaluate women's services on a cheaper basis than men's or to permit women to compete with men as workers on lower wage levels is neither sound nor just. I prefer to state the equal-pay policy in a somewhat different way—in the terms advocated by the Women's Bureau from its beginning—that wage rates should be based on occupation and not on sex. During the war considerable progress towards this goal has been achieved through the efforts of government, labor, and industry. But much greater gains must be made to keep the double wage standard from undermining our postwar employment program and economy.

Then take the matter of wartime training—another significant feature in labor adjustments after the war. As never before, women have acquired through vocational courses and in-plant instruction new mechanical skills, which will be invaluable to reconverted industries. Perhaps an even more influential factor in postwar readjustments is the training that has been given large numbers of men in the Army and Navy, along many technical lines, which some of the men may prefer to follow in peacetime rather than to return to their prewar pursuits. A former machine operator may choose to continue as an aviator, a bank teller as a radar expert, a railroad information clerk as a transportation specialist, and women who during the war stepped into the gaps in many fields may be retained after the war.

Full employment is not just a fantastic dream if plans for reconstruction equal to war blueprints can be formulated and carried out with similar urgency and speed. Why not? For us again to limit production as we did in our prewar economy would be nothing short of disastrous. It has been estimated that in 1929 our productive resources were used to only 81 per cent; that 100 million man years of labor in this country were wasted through unemployment; that this waste caused the loss of 200 billion dollars' worth of potential goods and services— or the equivalent of a $6,000 house for every family in the country, or enough to build a railroad system for the nation five times over.

Full employment seems a real possibility when we hear economists stress the essential and rapid expansion of all kinds of consumer

goods manufactured on a scale never before conceived to replenish depleted stocks the world over—especially in view of the international programs of relief, rehabilitation, and nutrition already launched. By way of illustration are the U.S. Chamber of Commerce forecasts on postwar demands for almost 3 billion dollars' worth of automobiles for 3,675,000 families, over 1 million new homes valued at nearly 7 billion dollars, over a billion dollars' worth of such appliances as refrigerators, kitchen mixers, and so on.

It takes no stretch of the imagination to foresee extensive employment of women in this industrial expansion. Women have for years constituted large proportions of the work force in the service industries and in textiles, clothing, food, and other types of consumer goods, and will probably hold their own or even advance in the years ahead.

The electrical industry looms as a veritable promised land for women, in view of the large number in this field before the greater number added during the war, in conjunction with the future development of the industry that is sure to be stimulated by electronics, television, and so on. Then the near-magic realm of plastics, with its war mushroom growth, offers peacetime prospects of miraculous new products, exciting expansions, and employment opportunities for women.

Though aircraft manufacture will undoubtedly be scaled down from its war peak, we have reason to believe—what with global aviation forecasts—that it will remain in the big-industry class. Surely women will be given a chance to apply their skills, after their amazing record— some 4,000 women in airplane production before Pearl Harbor, 360,000 so employed two years later.

Even in the more strikingly masculine strongholds such as machine-tool plants and automobile factories there may well be a place in the future for the most competent women of the war period, who have even surpassed men at certain processes. There seems less likelihood that women will be retained to any real extent in steel mills or shipyards.

Concerning factory office jobs opening up to women because of the war, the general office manager of a large industrial corporation has this to say: "We believe there will be plenty of room for them (women) even after the men are discharged from the services. Quite possibly we shall be happy, later on, that during the war we did develop womanpower in our offices."

As plants reconvert and eventually swing into spectacular peacetime strides, they may continue to have a place for some of the professional women who have gained war footholds as draftsmen, chemists, technicians, engineering aides in industrial laboratories.

In general the unusual wartime opportunities that have opened up to professional women in their chosen fields will not shut down in the future. It seems safe to predict that many women who have performed with outstanding success will be retained in spite of male competition. The success of such women will create a growing demand for others in the new economy which we hope to achieve. Moreover, I believe a much larger number of highly trained and competent women will have leading roles on the national and international stage. The number has been deplorably small to date.

All this suggested participation by women in the winning of peace cannot be achieved by optimistic prediction, wishful thinking, or faith without works. Therefore the Women's Bureau is not only giving specific study to possible postwar developments for women workers but is urging women's organizations to assume a share in educational efforts along these lines. Such organizations—national and international—are already giving thought to these matters. But they should see to it that qualified women are included on the various planning committees—whether set up by industry, labor, or government, whether on the local, national, or international level.

Women's responsibilities as American citizens in the postwar period go much farther, as many women are keenly aware. Last October, women leaders from big national and international organizations met in New York City, called together by Anne O'Hare McCormick, of the *New York Times*, to discuss problems of war and peace and to map plans for a better world. This past week I took part in a somewhat similar panel discussion in New York on women's postwar economic status.

On neither occasion did the women participants take a narrowly feminist view. Instead they approached the discussion on a broad humanitarian basis. The vital and traditional role of women in the home and the valuable services they have to render in the community were not overlooked or minimized in the clarion call urging them to take a greater share in national and world affairs—both now and after the war.

Mrs. McCormick posed some very pointed and pertinent questions. "What's the matter with us that women's tasks are turned over to men?" she asked. "What have women citizens done or failed to do that they are not even thought of when positions of high responsibility are assigned? Is their world going to be reorganized without their counsel? Why aren't women in charge of food rationing? Why aren't they on official planning boards? Why aren't they called into the administration of relief and rehabilitation?" She charged too many women with being mere passengers, content to let others struggle and die to haul us through the storm into the port of safety.

These questions are signposts showing women the roles they must play and the roads they must travel both in the throes of war and with the coming of peace.

Women deserve credit for their achievements as organized groups in improving community conditions, getting better laws passed in many instances, rendering valuable service in all emergencies. But women have barely begun to use their powers as American citizens. We have in this country many able and well-trained women who could and should serve in state legislatures and the Congress of the United States, as well as in government positions on the policy-making level. Certainly a number of women—not because they are women but because they are qualified for the roles—should take their place side by side with men in the international organizations now existing or growing out of the war: the international labor organization, the organizations for relief, rehabilitation, and nutrition, the conference that will be called to make the peace, the organization that will be set up to preserve world peace and to promote security of nations and their populations.

Women cannot afford not to be represented fully in all these movements. Women have certain peculiar contributions to make somewhat different from those of men. Women are even more vitally concerned with the welfare of individuals and families, with protecting the weak, healing the hurt, helping the needy, with settling difficulties in the field of human relations.

The challenge of American women is greater than ever before—to become better citizens in our own democracy and better citizens in the world. Many women are already aware of and ready to meet this challenge. I believe they will do their part—if given the chance—to help make this world worth all the blood and grief being paid today as the price for a free tomorrow.

14 D-Day and H-Hour for Women

Minnie L. Maffett

A T THIS, THE TWENTY-FIFTH milepost in our progress as an organization, we women citizens in this great democracy must realize with startling clarity that time marches on with relentless insistence.

Minnie L. Maffett, "D-Day and H-Hour for Women," *Independent Woman* (August 1944): 239–40. Reprinted by permission of Business and Professional Women/USA.

Viewed in retrospect, we recall at this time of global war that just a quarter of a century ago we had just won what we thought was a glorious victory and felt justified in indulging the utopian hope that it was a holy "war to end all wars" and that, with this great victory, we had truly made the world "safe for democracy." The Treaty of Versailles was signed, and many people thought it was a just peace that guaranteed to all people, both victors and vanquished, a full measure of security and enduring freedom.

When the League of Nations was set up, many hoped that it would furnish the necessary machinery for implementing this idealistic international cooperation. We felt that the world had accepted the challenge and sacrifice of those who died on Flanders Field in order that freedom might live, and we felt that henceforth we could, and would, carry the torch of liberty and human justice and pass it on to all succeeding generations of men and women who love the American way of life and a democratic government.

How far short of these ideals we have come is a matter of tragic record. Regardless of our own failures at that time (notably our refusal to join the League of Nations and our unrealistic idea of preventing war simply by declaring that "there should be no more wars"), I believe that sober reflection on this quarter of a century and our present global conflict have truly made us internationally minded to the extent of knowing that whatever affects Europe and Asia brings prosperity or chaos to all other parts of the world. A new conception of international cooperation and international alignment against aggression and injustice is no doubt the philosophy of the millions of men and women on the battlefields of the world, a necessary philosophy if an enduring peace is to be built after victory. This constitutes the greatest possible challenge to women. After this war, they will be in the majority in Europe and, to a lesser degree, in the United States.

As our women have led the march of progress in all domains from suffrage to the opening up of the business and professional fields, so will we, I hope, remain the standard-bearers of women's advance the world over. In particular, I feel that it will unquestionably be true that the business and professional women will constitute the shock troops of this onward march, for please remember that we are responsible and trained workers in the great army of women striving for better conditions in a better world.

There is no comprehensive data for women's employment for 1917–18, but it is known that in January, 1920, there were approximately 8.5 million women workers while a total of 18 million women will probably be employed in present war industries prior to the close of this year. Therefore, it is safe to assume that more than double the

number of women are employed today in comparison with the number employed in World War I. A broader view of the stride that women have taken in gainful employment can be shown from the fact that in 1870 only 1,836,288 women (or 13.1 percent of all women of working age) were employed; in 1940, 12,845,259 women (25.4 percent of all women of working age) were employed. The 1940 census shows that there were almost 13 million women in the labor force two months before the United States launched the defense program, including almost 2 million unemployed women workers. These formed approximately a fourth of the total labor force as well as of the total woman population of the country. After January, 1942, came the sudden and rapid rise in women's employment resulting in an increase of 50 percent within the past three years. War, of course, has lowered barriers to women, resulting in an increase of some 5 million women workers.

In any survey of the greater use of womanpower as a result of the war, and future scaling down after peace, account should be taken of the spectacular increase of women in the executive branch of the Federal government from a little over 186,000 at the end of June, 1940, to nearly a million at the end of June, 1943—mainly in Army and Navy departments and war agencies.

In addition to the women in the civilian labor force in June, 1943, there were 36,000 nurses on duty with the armed forces and 100,000 women who were WACs, WAVES, SPARs, Marines, and WAFS.

During the next year, it is estimated that some 2 million more workers will be needed in munition plants and 1,300,000 of these must be women. Approximately 200,000 more women are now needed for other essential civilian industries including the great number employed by various relief agencies.

In the executive branch of the government, we find a woman social secretary in the office of the President of the United States. In the Bureau of the Budget, there are seven women in executive or near-executive posts. Though the roster is a meager one, I propose to call the roll again as I have for the past several years.

These figures are bad enough, but, if one considers the top flight executive jobs in some 12 large government agencies, one finds more than 500 top executive jobs to be filled, only 10 of which are filled by women. You may have heard me say at Denver in 1942, and again during our Board Meeting at Lake George last summer, what I thought about the OPA for its failure to use women's brains and ability in planning the rationing of food and other materials used by the nation's housewives.

Women in the past seem to have found their best opportunities, however, for holding office on a local level. After the elections in

Women in Policy-Making Posts

	1942 Officials-Women		1944 Officials-Women	
War Production Board	146	0	192	0
Office of Price Administration	69	1	50	0
Office of Facts and Figures*	8	0	29	3
Office of Overseas Branch			18	0
Office of Civilian Defense	29	0	27	2
Office of Lend-Lease Administration†	12	0	27	0
National War Labor Board	45	0	27	0
Office of Defense Transportation	16	0	51	0
Office of Scientific Research and Development	11	0	27	0
Office of the Coordinator of Inter-American Affairs	23	0	20	0
Office of Defense, Health, and Welfare‡	8	0	2	0
War Manpower Commission	9	1	76	3
Board of Economic Warfare§	25	0	27	0
Total	401	2	573	8

*Consolidated into Office of War Information in Office for Emergency Management, June 13, 1942.

†Transferred to Foreign Economic Administration, July 15, 1943.

‡Committee on Physical Fitness is successor to Office of Defense, Health, and Welfare Services under Federal Security Agency, April 29, 1943.

§Consolidated into Foreign Economic Administration, September 25, 1943. Same as Lend-Lease Administration above; also transferred to Foreign Economic Administration, July 15, 1943.

Women in Policy-Making Posts
Listed in U.S. Governmental Manual, Winter 1943–44

Office of War Information—Katherine C. Blackburn: Chief, Bureau of Special Services (Domestic Operations Branch). Charlotte Hatton: Chief, Press Intelligence Division (Domestic Operations Branch). Dorothy H. Ducas: Chief, Magazine Bureau (Domestic Operations Branch).

Office of Civilian Defense—Frances G. Knight: Public Counsel Division Chief. Madeline Berry: Divisional Chief, Report Analysis and Statistics.

War Manpower Commission—Frances Perkins: Secretary of Labor. Charlotte Carr: Assistant to the Vice Chairman. Margaret A. Hickey: Chairman, Women's Advisory Committee.

1940, the Federation surveyed the results and found that more than 1,000 women were elected to office that year. It is my hope that a survey made after the elections next November will show that at least 2,000 women have been elected to offices in Federal, state, and local

units of government. In 1940, 140 women were elected to state legis-
latures and, in addition, 863 were elected to county and local offices,
New England having elected a greater number than any other section
of America. Women have made a successful invasion and have broken
many lines of prejudice and discrimination, but we are far from hav-
ing won the battle for full equality of opportunity and equal participa-
tion in the affairs of government.

I truly believe that this moment tonight is D-day and H-hour for
the women of America, who have given so much for so little, to as-
sume full and equal partnership in this, our America, in order that we
may finally become "the kind of people we want to be in a world we
want to live in."

15 Peace Conference Address

Clare Boothe Luce

MANY WORRIED AND DISILLUSIONED AMERICANS are beginning to look
forward to the coming peace conference as a bored audience
looks forward to the third-act curtain of a bad play.

These Americans have come to suspect that the peace conference
will not be the last word in the last war, but only a meeting to draw up
the contracts for a return match. They have read the writing in the
headlines and drawn the conclusion that the only possible good thing
about the peace conference is that it will mark the end of hostilities
and the probable return of most of the American soldiers now on duty
overseas.

Disillusionment about the terms of peace has begun to set in years
before the drawing up of that peace. Blood poisoning has anticipated
the wound.

If the sensible idealists of this nation—the people with their feet
on the ground and their eyes on the stars—give way to defeatism and
despair, the shrewd, hard men who make no distinction between a poker
table and a peace table are certain to draw up a treaty with five aces
and plenty of jokers.

After the last war and during this one, we reaped the harvest of
disillusionment, coming closer to defeat than we yet dare to realize
because the people were suspicious of the motives of their govern-

Peace Conference Address, 1944. Clare Boothe Luce Papers, Box 677, Peace
Conference [1944], Manuscript Division, Library of Congress, Washington, DC.

ments and their leaders and skeptical about the real causes of the second great conflict. Briefly, that doubt was allayed by the solemn vows of the Allied nations that from this war a better and a saner world would emerge. It seems to many people now that the promise of a better world was broken as soon as the leading statesmen realized that it could be kept.

At this point, then, there is a need for some spectacular gesture on the part of the United Nations to demonstrate that beyond the old familiar grubbing for gain and bickering over borders there is actually a new spirit in the world, that the plans which were laid in the darkness of despair will be hatched in the brightness of victory.

Some sign must be given to show that this peace conference will be different, that there is within the governments as well as within the common people a consuming desire to draft a peace which bids for eternity.

Such a sign would be an announcement by the United Nations that the women of the world will be represented at the peace conference by full-fledged delegates of their sex.

It is easy enough to under-estimate the effect of such a gesture, but in point of fact it would be worth more than a hundred ambiguously worded charters or declarations or resolutions. A peace conference which included a large number of women cannot be cynical or careless or short-sighted because women will not be cynical or careless or short-sighted about such matters as preserving peace or averting war. With women present it will not be a waltzing conference or a smoke-filled room conference, but one which promptly gets down to the business of building a healthy peace at whatever cost and sticks to that business.

The people—the saddened, suspicious, worried men and women of the United States and the United Nations—know this and would be comforted by an announcement that their governments meant to make use of the inspired pacifism of women.

No one, even the most narrow anti-feminist, can deny the right of women to be represented at any peace conference which even pretends to be democratic in spirit and ideals. How can any gathering which overlooks one-half of the human race be called representative? How can it make decisions which must be accepted by all humanity?

Moreover, the great departure from past history which took place in this war was the voluntary or enforced participation of women. They have been under fire in Warsaw, in London, in Rotterdam, in Manila, in Stalingrad and, for that matter, in Berlin. They have been bombed and shelled and starved. They have served in the auxiliaries of the armed forces, doing vital and often dangerous work and doing it well.

They have even manned guns and taken part in battles as actual combatants.

At home on the production line they turned the tide of battle from the monotony of defeat on all fronts to the surge of great offensive drives into the enemy's territory.

Those who are prepared to oppose this idea will find it useless to drag out the old specious arguments to bar women from the peace conference. The assertion that war and peace are the business of men and men only does not hold now that women have donned uniforms and become subject to military discipline. It became impossible to bar women from a role in the peace when it became impossible or inconvenient to bar them from a role in air-raids, in the burnings and famines which accompany every phase of modern warfare.

Therefore, the point to consider is: What would be the immediate result of a pledge by the United Nations that each participating government will include at least one woman among its delegates to the peace conference? The immediate result would be a news story which would show good and noble intentions on the part of the Allies when so many headlines betray intentions which are selfish and petty.

Aside from the immediate morale value, there are other and deeper reasons why women should be represented and well-represented at the peace table.

Since formal peaces first began to conclude formal wars, men have never succeeded in drafting a lasting and durable and equitable peace to maintain friendship among nations. This centuries-long record of failure necessarily exerts a certain psychological pressure on any man who sits down at a peace table. Women delegates, starting anew, without the handicap of such a dismal record, will have no preconceived doubts about their chances of success. A new broom sweeps clean—a fresh approach, an intense desire to make good can often more than compensate for inexperience.

Whatever men may say, it is women who hate war with all their instincts as well as their hearts and minds. Men have demonstrated that they are willing to baste up a shabby, patchwork peace which includes all the necessary ingredients for another war. Men have shown that they are willing to take any gamble with posterity for the sake of adding a few acres of disrupted land to a national boundary or snatching a cannibal island in some lonely corner of the Pacific. Rather than lose face in a diplomatic dispute, men have shown themselves willing to lose a whole generation.

Women, on the other hand, shoppers by tradition and practice, know the difference between a bargain and a swindle. They know that war is

too high a price to pay for a piece of land. They are not too vainglorious to talk things over or work out a compromise to avert bloodshed.

It cannot be denied that many women have a pronounced weakness for uniforms as such, but no woman was ever at heart a militarist. Men know this, even those men who will not admit it.

Twenty-three hundred years ago, Aristophanes, the Greek dramatist, wrote a play in which a frightful war was quickly ended with an agreeable peace when women took a hand in the matter. His heroine, Lysistrata, and her followers on both sides of the conflict used the direct and highly effective method of deserting their husbands en masse and refusing to return to their homes until the peace was concluded.

Lysistrata's method would be impracticable in a war of the present magnitude—especially since even she found it hard to hold her followers to their plan—but Aristophanes' play reveals that even the ancients believed men's wars could only be ended permanently when women decided to end them.

Even aside from fiction and drama, it is not unusual, as it may seem at first thought, for women to enter the field of international diplomacy. Women of many countries, including England, Russia and our own, have served and are serving in high diplomatic posts in their Foreign Offices and State Departments and even as ambassadors and ministers.

Four women in particular, Elizabeth and Victoria of England, Catherine the Great of Russia and Maria Theresa of Austria, achieved brilliant success in the conduct of foreign relations. That they were not outstanding pacifists may be attributed to the fact that theirs were not pacific times.

At least they—centuries before the emancipation of their sex— more than held their own with men in a man's game, discrediting for all time any notion that diplomacy is beyond the intellectual powers of a mere woman.

There is one living woman whose name conveys special significance and special hope to all who yearn for a better world and have faith in their dreams. I refer, of course, to Madame Chiang Kai-shek of China.

She most certainly should be a delegate to the peace conference, whether or not women as such are represented. She would attend not just as a spokesman for China but for the people of all nations who want a peace constructed of durable material and on a firm foundation. Among all the men and women who have played a major part in world politics and government in the last decade, she is the one who best expresses in thought and deed the highest political and social aspirations of mankind.

She is the one who said in a speech during her recent visit to the United States: "There must be no bitterness in the reconstructed world. No matter what we have undergone and suffered, we must try to forgive those who injured us and remember the lesson gained thereby."

If we really intend to reconstruct the world, spiritually as well as physically, Madame Chiang has given us in these two sentences the text which the builders must follow.

If Madame Chiang Kai-shek is not present at the peace conference, her absence will be noted and regretted for dreary years to come. A denial of her wisdom, her humanitarianism and her broad outlook will be a denial of all these qualities as they exist in mankind in favor of the vindictiveness and greed which have brought us to the present pass.

It may be too much to hope that the United Nations have reached that stage of enlightenment which will permit them to disregard the moldy customs of the Victorian era and give women a voice and a job in the making of the peace. If the ideas of the Nineteenth Century prevail at the peace conference, we cannot expect it to draw up a program suitable for the Twentieth Century.

Then post-war disillusionment will really set in, with all its moral and spiritual stagnation, to remain with us until the bigger and faster bombers, the mightier guns, the higher explosives of the next world war go into action.

Someday women will sit down at a peace table on an equal footing with the men to add their determination, their devotion to peace, their vision of a better world to the practical experience of older diplomats.

That happy event may not take place after this world war or even after another one, but, provided humanity survives the great fires and blood-lettings, one-half of the population cannot be expected to endure indefinitely and in silence the tragic blunders of the other half and pay the certain reckoning for those blunders.

There is enough of the spirit of Lysistrata in the modern woman— enough revulsion against wars and peaces that breed wars—to make it inevitable that women will be represented in the drafting of some future peace, represented with or without a formal invitation from the men.

V What Kind of World
Do Women Want?

The movement for the inclusion of women at the peace table took on even more significance when the *New York Times* sponsored three major conferences on women and postwar planning. Organized by Natalie Wales Latham, director of women's programs at the *Times*, these conferences occurred between April 1943 and December 1944. Document 16 provides the texts of the speeches given at the first *New York Times* conference held on April 7, 1943. Each of the twelve women speakers, who included high-ranking government officials, lawyers, business executives, writers, educators, and a diplomat, addressed the question, "What Kind of World Do We Want?" In a front-page news story, published on April 8, the *New York Times* reported that the women "agreed that they wanted a world where international cooperation will take the place of war, and within that economic and social security for the family, the home and the individual."

Intertwined in many of their speeches was the notion that essential gender differences strengthened women's qualifications to serve as participants on postwar planning councils. At the same time, the speakers asserted that women, as citizens of the United States and the world, had the right and responsibility to participate on an equal basis with men in the construction of the postwar world. These women, and most of their contemporaries, had little difficulty in advocating both gender differences and equality when calling for representation on postwar planning councils.

16 *New York Times* Symposium: "What Kind of World Do We Want?"

Secretary of Labor Frances Perkins

To SECURE A FREE WORLD and to give some reality to the hope that it be a better world we must build upon foundations which already exist and which we understand. And so when you ask me tonight to say what kind of a world do I want, I say boldly that I want and believe we can have a world in which individuals have both liberty and security on the basis of the extension of already known patterns and habits of social cooperation.

Legislation as an instrument for social cooperation among the politically free has been effective for many years with us and with our British brothers. Social legislation alone will not be enough to support and maintain the aspirations of the people of this country and the people of the world.

The recently released reports of the Committee on Economic Development are most challenging and encouraging. They point out not only the desirability but the possibility of maintaining economic activity which will require the steady employment of ten million more persons than were gainfully employed in 1940. This means a total of 56 million people gainfully employed in the United States, which presupposes production and distribution of more than 140 billion dollars worth of goods and services.

Would Expand Public Activity

Certain types of public activity will need to be extended usefully in most countries, certainly in our own.

The extension of special provisions for child welfare—assuring all children a freedom from oppressive child labor, access to suitable educational opportunity and vocational preparation, health assistance, and whatever assistance in conserving home life or providing special protection their needs may require, will clearly be part of useful public activity.

A large measure of public responsibility for the establishment of steady employment is undoubtedly to be expected. It should be pos-

New York Times Symposium: "What Kind of World Do We Want?" *New York Times*, April 8, 1943.

sible to reduce the suffering due to unemployment, which might follow industrial and military demobilization (1) by extension of the Social Security program, (2) previously planned public works (such as bridges, roads, housing, etc.), and (3) the retraining of men and women for peacetime occupations.

Adoption of an expanded Social Security program in the near future so as to provide enlarged benefits covering all major hazards of wage earners would give the United States a curb on inflation now and a brake on deflation later. It would also mitigate many demobilization difficulties in the post-war period.

Sees Social Security Aid

If wise and practical extension is undertaken now the Social Security program will be able correspondingly to provide to all wage-earners and to such self-employed people as care to buy into the system, unemployment benefits, retirement, or old age benefits, a retraining benefit, a benefit in periods of disability due to illness or accidents, and maternity benefits to wives in insured families, funeral benefits, and a survivor's benefit to the widows and dependents of those who do not live to collect their old-age benefit and a modest hospitalization benefit.

In addition a strong and developed Employment Placement Service for use not only in wartime but in the period of demobilization and thereafter can be of inestimable value. The sense of security which returning soldiers and sailors will have because their families are protected as well as themselves, if such a system is put into its beginning operations now, will do much to stabilize our political and social development in the future.

Such extensions should include appropriations of Federal funds to aid States in public assistance to the aged not covered, to dependent children, to the handicapped, etc., in inverse proportion to the taxable income of the States.

The demobilization of those now employed in the wartime industries and their reassignment to peacetime production would be cushioned against the doubt and uncertainty with which today many persons view that period.

There can be no question of our ability to pay for an adequate system of Social Security at this time. Indeed, we can hardly envisage an equally propitious time to introduce a plan of postponed spending. The funds paid into Social Security contributions now will flow back in the future to those who pay them to the social improvement of the whole of society.

Payroll Tax Is Suggested

The cost of such a system at the outset could be covered by a tax of 10 percent of payrolls, shared equally by employer and employee, with eventual equal three-way contributions, the government sharing the burden as total annual cost increases from increased old-age retirement payments. Decreased need for public assistance may be expected to counterbalance a large part of such projected government share.

The carrying out of such a program as I have outlined would certainly go far toward achieving for the American people the freedom from want which from the economic and social standpoint is one of the most important elements in our common aspiration for the future.

In this connection we should realize that public responsibility must express itself both in the national and in the international sphere. All nations must stand ready at the conclusion of this war to make many resources available in the reconstruction of the world. How those resources are to be made available must still be determined. Temporary grants on the basis of need, in cases of suffering with future adjustment, may be necessary.

Stable economic society exists not on the basis of free grants of assistance but rather on the basis of mutually advantageous exchanges of goods and services. The world is rich, but every nation that must depend upon its own resources alone is poor. Economic as well as personal and social cooperation of the many for the welfare of all may be the key to a dynamic and orderly world in the next fifty years.

Concept of Free World

The free world which we want to emerge from the war needs to be a world designed to produce security and minimum comfort for the ordinary man, the wage earner, the farmer, the merchant, the teacher. He must have opportunity to earn his livelihood in useful contributory pursuits. He needs to live in a world which makes provision for the disadvantaged groups of the community: the young, the old, the sick, those without adequate bargaining power, those whose family resources make it impossible for them to develop fully their innate capacities. In a free world the resources of science, of management, of organizing capacity and of statesmanship can be harnessed to produce a constantly rising level of living.

Finally, in the economic society in which he lives, man needs flexibility, variety of pattern, free choice, opportunity to experiment, to bargain with others, to risk, to be responsible for himself, to develop his moral judgements, to grow in spiritual stature, to realize and expe-

rience the sanctity of his very manhood. Liberty and underlying security can be attained together in a modern world with machinery and knowledge as tools. With the human will and Divine assistance, men should enjoy freedom of association, freedom to choose those who shall represent them and their interests. Free men must have opportunity to differ and to settle their differences by compromise. This is growth.

Freedom is an essential condition of social progress. Only as men are free to express their personal convictions and aspirations, only as men are free to experiment and learn from their mistakes, only as men are free to differ and to compromise their differences, only as men share the means of life with each other, only as men grow in unselfishness and in pity, does their freedom have eternal worth and significance.

Judge Camille Kelley

The program of today's citizenship will no more fit the man who returns from the battlefields of conflict than the civilian suit he laid away for his uniform. He walked away from the old clothes and packed many plans and desires carefully away for a great new purpose. But when he comes home he will be broader perhaps, and taller, and the style and the color of the suit will be out of date. He will have outlived old designs of citizenship.

We want to think and work toward building a good world for those loved ones to come back to, and we must use the best material that the human heart and mind can design for this job of building.

The social and economic structure of this new world must be built on a rock of security, for after the baptism of blood for freedom the new citizen will demand a baptism of sincerity and purpose, that freedom may be a permanent heritage.

We should now set up a council for research that will go into the planning for a program after the war, with the same intelligence and seriousness that we are devoting to the study of military procedure—not just the appointing of another committee, but a serious, intelligent study, a conference table ranking in importance with the peace table.

Every State should set up a council, and each State should select one or two persons to be on a national conference. These delegates should be men and women familiar with the citizenship of the respective States, their industries and natural resources, transportation and communication development, their politics and social program, and should be able to know by the simple movement of a pencil on a map how the rich fertilization deposits of one State could be transported to

the washed-away lands of another; how the oil of Oklahoma would meet the fuel demands of Virginia, the sugarcane of Louisiana add luxury to the breakfast of the New Yorker. Educational opportunities should be developed to suit the citizenship of that locality.

Behavior—of the new world—will be as important as economics or education, and there will be as much study by experts as to how to fit a boy or girl into life for full expression of his or her talents as is given by the agriculturist now studying the adaptability of the soybean to the soil.

We are advanced in education and progressive in industry. We are stabilizing in economics, but behavior must be the steel framework upon which we will build a new world.

Dr. Margaret Mead

Most of the clues around which we now arrange and organize society and fight wars, or develop educational systems, are false. You can count all the people of the world regardless of race or sex or previous condition of servitude or previous position in the social register as raw material for building a good world.

But there are differences that do matter. To be reared in one culture, in one society, makes one irrevocably partake of that culture. There are differences between Germans and Englishmen, Russians and Frenchmen, Americans and Chinese, Japanese and Japanese-Americans which are very deep and very important.

Traditionally, we have lived in a country where everyone was scrambling to forget his old ways and learn ours. This had brought us to the conceited past of believing that our way, our political forms, our religious forms are superior to all others, and that it is our mission in the post-war world to offer them, like a combination of Lady Bountiful, school teacher and psychiatric nurse, to the rest of the world.

This attitude of ours, this willingness when we wish to cooperate with all other nations at all to go the whole hog and help them be just like us, may well prevent a balanced and fruitful post-war world development.

We need to show the American people the adventure that lies before them in cooperating, not with a set of their own images, a little pale and distorted because they are Czechs or Serbs or Norwegians, but with a set of countries, each of which has its own special contribution to make to a post-war world more varied than any we—or any country left to itself—could dream up.

My second point stems directly from what women have specially to offer. There is one field in which women have more experience than

men, that of developing human beings and conducting smooth human relations within the family in such a way that individual growth is possible. Women have had aeons of experience in bringing up good human beings and now is the time to use that experience. Women know that if you are to develop good human beings, then you must leave them free, feed their bodies, guard their footsteps, protect their paths, give them materials and books and words and let them develop toward their own goals.

So, let us take this knowledge of women and insist that social science make the necessary inventions to set the world's feet on the right path but leave the next generation free.

What we need is a sense of direction, a minimum behind which we will not retreat, a star high enough to guide us but undefined enough so that the future is left untrammeled. For this, inventions are necessary. Women must demand that those inventions be made. They must insist that our society place back of the social scientist the same resources that have been placed back of natural science, to outlaw the bad intention of war, just as the inventions of the automobile and the airplane have outlawed the poor invention called the horse and buggy.

Women must insist that the job of building a world in which war will be as outmoded as dueling is a technical job, and see that the technical inventions are made. As human beings we have a moral desire for a better world, as women we have experience in how best to leave development free, as citizens we must demand the tools to work with.

Edna St. Vincent Millay

I have found it impossible to imagine—to say nothing of describing— the kind of world I want, except in terms of its difference from the world which, whether I want it or not, is at present my habitation. Therefore the first thing I did when I was asked to be a speaker at this conference was to stand as far away as possible from the world in which we live, and take a good look at it.

Regarded from this distance, I saw at once how shockingly out of plumb our present dwelling is—a structure sagging here, bulging there, new patches nailed onto old patches, and new patch and old patch working loose together, dragging their rusty nails out with them; the front of the house freshly painted, the stoop scrubbed spotless, and the brass polished bright; and behind the sparkling glass of the clear windowpanes bowls of skillfully fashioned artificial flowers.

But in the rear of the house, the old, discolored paint was curled and peeling, lying in small, brittle curls on the dirty boards of the

shaky, garbage-strewn porch, and the cracks in the cloudy, fly-specked windows were stuffed with rags.

Two glances, one at the front, and one at the rear—and I knew beyond any doubt how badly in need of a brand-new house is the wretched, hopeless, hopeful human race.

But immediately following this strong conviction that human beings deserved and must have immediately a far more dignified dwelling place than this—there came to mind the question, "Who built this house anyway?" And the answer, of course, was "Human beings."

I looked at the building again: an architect's nightmare, an atrocity . . . viewed from the front, pretentious, flashy, false, a lie of a house; seen from the rear, an honest degradation, relaxed, resigned.

From the moment I could not think of the kind of world I wanted, except in terms of the kind of creature which would inhabit it.

"Whatever we build," I reflected sadly, "no matter how handsome, how capacious, no matter how straight and strong the dwelling we erect for him, in two years' time—in ten years at the most—he will have made of it a horror just like that."

Over a period of many years we have been growing steadily more and more lax in our deportment, both private and public; more and more slovenly in our ethics. Those of us who do not commit crimes, condone them in others. Those of us who are honest in our business dealings receive in our houses men whom we know to be dishonest in theirs.

We should not do this. It is this which is killing our country. But how can we put a stop to it?

Only one thing can be done and only the women can do it. And the women must do it, if our country is to be saved from utter and abysmal degradation, out of which nothing can ever lift it to decency again. The women, who have always been the arbiters of taste, of manners, and of morals in the community in which they live; the women, who have always decided what is delicate and what is indelicate, what is honorable and what is dishonorable; and what sort of person may properly be received and entertained in their homes, and what sort of person shall never cross their thresholds. Never mind, if your husbands fail to put over the deal; never mind, if somebody else gets the contract. The price you have been paying for these things all these years is much too high.

I have been speaking of morals, of ethics. I have not yet spoken of religion. But now, at the end of what I have to say, I wish to speak of religion. Our grandfathers, our great-grandfathers, our sires of different nationalities who founded this country, those of them who wrote our Constitution, were deeply religious people.

We live today in what is, predominantly, a Christian country. We call ourselves Christians.

Are you a Christian? Do you call yourself that?—Then you know what to do to please Christ. You know the kind of person to be, to make Him feel less sad. Be, then, the kind of person of whom He could be proud. Do, then, the things which would please Him.

Fannie Hurst

Through all their war-harassed centuries women have functioned in behalf of peace by way of lip service rather than action. Let's face that, evaluate it for what it is worth, which is not very much, and dedicate ourselves to a war-proof future. That, women of America, is a high mission, as high as human happiness and human decency and all the elements that go to make life worth living for you and yours.

The greatest unreleased power in the world today is womanpower. The Muscle Shoals and the Boulder Dams that will utilize that power reside in the determination of the women themselves.

If you stop to think about it, there has been no great organized woman-push throughout history. It will be interesting a couple of centuries from now, after women have long been inducted into those departments of society which now discriminate against them, to see to what extent our feeble representation in the enduring arts was responsible for the circumscribed lives that women have been living for centuries.

How few immortal women authors, for instance, there have been compared to men! How few women poets between Sappho and Millay! How many women Beethovens and Mozarts have come down to us through the ages? How many women Rembrandts? These fields have always been open to women. What circumscribed conditions have inhibited us? You believe and I believe the answer is that we have remained the creatively languid sex for environmental reasons.

And now we have come to the crossroads and are face to face with the most realistic moment in our long history.

What do we want and how are we going to set about getting it? Those are concrete factual considerations.

Let's not fool ourselves. We need more functional power in government than we have yet achieved. We need more woman-push, organization, and capacity to work together. We need to break down women's inhibition against women.

And even more than that, there is an overtone; a more important dimension than any of the concrete ones mentioned, that we women need and want in our post-war world.

Not for one moment has this been a mere discussion of more jobs for women, equalization of their citizenship rights, extension of their home interests, wider economic independence, and a more active participation in the machinery of government.

These assets, important as they are, are scarcely worth the candle unless they achieve for us by way of wider horizons of intellect and experience a release of the spirit, a richer capacity to stand at the center of the home, a more intelligent capacity for wifehood, motherhood, citizenship.

Pearl Buck

I do not propose now to urge women to do the things that are already being asked of us. I feel it is more important to urge them to do the things that are not being asked of us. It is important that women today not only get into uniforms of the fighting forces and of industry but it is even more important that, whether they wear these uniforms or whether they are still homemakers only, they apply themselves to the job of understanding our times and of determining to take their share of the responsibility of winning the war and establishing the terms of peace.

Their brains must be put to work on the vast tasks which men cannot do alone, the job of making this war count for a better world. I have said before and I say it again, that unless women realize their responsibility for the kind of world we must have, and unless they think about it, plan it and work for it, we shall simply go on having these devastating, heart-breaking, ruinous wars.

The wife and mother has an equal responsibility with all other citizens in a democracy for intelligent knowledge and action.

Are women ready for today? Yes, in the major jobs of thinking and knowing and resolutely sharing in the planning and carrying out of the shapes of national and international relations and administration, which can by the very shapes they are now taking mean peace or else inevitably mean another war within ten years, or, at most, twenty. I say this with the utmost seriousness: if the present shape of the post-war world goes on in the designs at this moment being planned, we will have another war in less than a generation. Your sons and mine now under 10 years old will have to fight it.

What can we do to make ourselves ready for today?

In the first place, we can mend our gross ignorance. We can and ought and must try to find out what sort of people we have to deal with. We must try to find out what they want and why they want it and whether what they want and what we want can be adjusted and made

into a practical possibility. We are not ready, we men and women of America, either for today or tomorrow because we don't know enough about other peoples. We live in mental isolation, and that isolation has got to be broken down somehow.

We can learn by simple reading and some study, some basic knowledge we lack about even our own allies, Russia and England and China, so that we know what sort of people they are and what the conditions of their present life are and what they want.

Mrs. J. Borden Harriman

Once again we are to come to one of those periods in history when momentous decisions have to be made by the people. There is a fork in the road ahead. One way leads to world cooperation, the other to world chaos.

Let me outline briefly something of the task as I see it. First, we must clearly understand the nature of the opposition. No one is opposed to world cooperation or world peace, but there are many who put their own interests first and these vital matters second. These people are opposed to changes in what they call our traditional American way of life. They look upon all attempts to regulate private enterprise as an interference in the American scheme of things.

And they are right. But there must be interference. Of course, there can be no world cooperation unless measures are taken to prevent the exploitation of the underprivileged peoples and unless the smaller nations are guaranteed free access to raw materials. This means that the right of private enterprise to form huge international cartels, thus controlling for its own benefit materials essential to the people's welfare, must be abolished.

It seems quite obvious that what we need now is political action. The question of international cooperation is going to be decided by Congress. We must let every Congressman know where we stand, and we must insist that every Congressman, every member of our State Legislatures and every important person in public life stand up and be counted on one side or the other.

Is not the immediate constructive task before us a long-range program of popular education? There are immediate decisions which have to be made and I think that every effort should be made at once to force a decision on the Ball resolution. I hope that every woman here who has not already done so will write at once to Senator [Tom] Connally, chairman of the Senate Foreign Relations Committee, and to the Senators who are sponsoring the Ball resolution.

It is of the utmost importance that we mobilize every man and woman behind a program to make this the last war. It ought to be quite clear that the responsibility rests squarely on citizens like you and me. The job of the armed forces is to win the war. We are dodging our responsibilities if we ask them to win the peace. We know that our government is waiting for public opinion to crystallize. If in this moment you and I and the millions of other Americans cannot make up our minds that we want world organization and the peace and order which come with it, we shall richly deserve all the misery and chaos and deep damnation that the future holds in store for us.

Mrs. Walter H. Beech

I have been asked by the *New York Times* to put into words a résumé, so to speak, of my type of thinking. This is a very difficult thing for me to do, as I deal in works, not words. My double role of homemaker and business executive does not include that of public speaker.

I come from a part of the country that still possesses the pioneer spirit. The essence of that spirit is self-reliance. To me the pioneer spirit could be interpreted to mean a complete willingness to accept the full individual responsibility for all one's words and deeds. This sort of spirit will be needed by our people in the future. We must accept responsibility for the work and expense that will be involved in protecting the peace that we shall have purchased with our blood, tears and treasure.

Because there are not enough able-bodied men to fill both our armed forces and our productive plants, it has been found necessary to depend upon the assistance of women in all sorts of new ways. Women have proved themselves to be expert welders; they are operating machine tools, rivet guns, punch presses and all other types of machines. They are assembling aircraft, boats and tanks and other complex mechanisms. They are acting as draftsmen and designers, pilots, technicians, chemists and in a hundred other capacities and are fulfilling their duties capably.

It is my opinion that no serious problem will be created in the post-war period because of the necessity of displacing some of the women in industry by the returning men. Women, like men, vary each from the other and have a thousand different motivations. A great many of them will be glad to resume the important profession of homemaking when their men return. In fact, many today are playing the double role of war worker and homemaker. Others who are less well adapted for industry will be displaced by fair competition with men.

Still others who are well suited to the demands of industry will retain their places and progress upward in the scale of responsibility to positions of importance. Those who remain in industry will have justly and fairly earned the right to full and equal participation in its fruits.

We shall be faced with tremendous problems of readjustment from war to peace. We, the people, must make our individual contributions of work and effort. We all have had personal experience with the inequities, injustices and stupidities that are inherent in the present government-managed economy or in any bureaucratically operated system of extensive control. We are patient with these shortcomings because we believe that patience is our rightful contribution to the war effort. When the peace is won, our patience will have reached its limit.

Very little has been done to teach us the value of individual responsibility as a vital contribution to the post-war period. Americans respond nobly to a challenge to their initiative and ability. The war production program has proved that beyond a doubt. If they are turned loose upon the post-war program within the very minimum framework of government control they will conquer the problems of that era with the same verve and spirit.

Margaret Culkin Banning

As the United States was sobered by war and began to detach itself from frivolities and ephemeral values, the family unit began to stand out as something to tie to. Tired of rattling around in the wide and undefined spaces conjured up by phrases about a "better world," people began to pin their minds to the family unit as a place to begin.

Let us think, for a minute or two, of the differences the family may expect for itself after the war.

First of all, the family will be physically safe again, except for normal risks. But it will be a long time before the home feels as safe as it has in the past, if ever. Families will know now that if the world is not safely governed there is not real remoteness from the bomber and the flame thrower and no permanent safety for women and children except as international cooperation replaces war.

Second, the family will be encouraged to increase itself because, as every nation knows now, there is grave danger of a falling birthrate.

Third, the family should be able to have a better and more comfortable home. Abilities now preoccupied with war material will turn to better housing, to supplying comforts and conveniences for everyone.

Fourth, the family will have more earning capacity than before because in many instances the wife as well as the husband, the girl as well as the boy, has learned a new trade during the war.

Finally, as I think we all know, there will be a danger of reaction from the present emotional drawing together within the family, from the nobility of purpose and from the establishment of real values which we feel exist today.

We should encourage in every possible way the increase of families in accordance with government wish and human desire. But we should insist that government sees to it that there are no neglected children and no vitiating childhoods in the whole breadth of this country, and no burdens on mothers which make them unfit for their jobs. These things go together. I have known in my life few people who didn't want children, who did not think it was their human and sacred duty to have them. There will be no open protest if society in the future does not do its share in helping motherhood, but there will be definite absenteeism from motherhood.

My great hope for the post-war family is that it will apply what it has learned and waste nothing.

Frieda S. Miller

What is it we want for those of us who must and those who want to continue to work? There are two sets of standards to be considered, industrial standards and social standards.

Under industrial standards, the first and foremost are decent standards of working conditions. These have in part been surrendered for the sake of the war production output. They must be returned to a day's rest in seven, reasonable hours per day, rest periods, adequate time for meals, seats available for relief from fatigue, safe equipment and sanitary surroundings.

Next, there must be a continuance of training provisions for women. Training, whether by educational or governmental agencies, or within industry itself, must be offered, not on the basis of sex but to the individual.

Then, women must be free to participate in workers' organizations, both as members of unions and as representatives of their fellow-workers and as officers. And there must be equal pay for equal performance.

As to the second group of standards, social standards, here I refer primarily to the standard of those services the community can offer. Many communities are offering such services now, and they will in increasing numbers.

There are, on the one hand, those services which assure the woman who must or who chooses to work that her home concerns are cared for. Foremost are the nursery and play schools, and supervised recreation for older children after school hours. Then, special transportation facilities are being furnished in some localities and these, it is hoped, will continue into the post-war period, to reduce the loss of time between a woman's home cares and her job and the fatigue of prolonged hours.

There are, on the other hand, women whose choice it will be to work in their own homes. For many the choice will not be possible unless we recognize the economic contribution their work is to the community, a contribution, the Beveridge report emphasizes, heretofore greatly undervalued. Certainly, earlier experience with mothers' pensions or mothers' assistance offers evidence that many women prefer full-time care of their homes and children to industrial employment if even minimum economic provision is made for their assistance.

Judge Dorothy Kenyon

We have heard a great deal lately about the Four Freedoms, all essential, all correlated, all forming parts of a whole, the synthesis of which makes the kind of society and the kind of individual within that society which all true lovers of democracy seek and without which life would not be worth living.

But there is, it seems to me, another freedom, which I like to call the fifth freedom, without which these others cannot possibly be considered complete. My fifth freedom is a very simple one. It is simply freedom for women, or for anybody, to decide for themselves what they shall do in the world, to exercise freedom of choice in the disposition of their lives, to enjoy the same kind and degree of opportunity to exercise their diverse talents, whether in rocking the cradle or ruling the world, that every other human being has.

A world which freely utilizes the brains and capacities of its women is a complete and rounded world in the sense that a world which keeps its women in purdah and swathed in veils up to the eyes can never be.

All this seems fairly clear to us, I think, and in our complacent way we American women think we have it. Our short hair, our short skirts, and our freedom of locomotion generally give us the illusion that we are free to enter every portal. But as a matter of fact we are not free like that.

The very simple and elementary struggle which the women doctors are going through right now, for instance, to obtain recognition of their skills as doctors, not as women, a struggle that is still going on,

although I believe our efforts are soon to be crowned with success, is
an illustration of what I mean. No, we American women still have a
long way to go before our fifth freedom becomes an accepted part of
the public consciousness.

But even if we had it, these last few years have taught us that free-
dom for ourselves is not enough. We know now that the basic free-
doms must be worldwide. Not only this nation, but the world, too,
cannot exist half slave and half free. So, if we think of this fifth free-
dom of ours in world terms, as we must, it is clear that we have a
mighty task before us.

Dean Virginia Gildersleeve

Facing a probably hard and certainly uncertain future, what shall we
teach the young women to want? I think it is fairly clear that there are
four things, and the first is work: training to do and to have a chance
to do some work of a kind they can do fairly well for their own satis-
faction, probably for their own support and as part of some large end
and hope.

The second thing we should teach them to want is human relations
with other human beings. It may be with husband and children, and it
may not be, but to teach them the importance and the sacredness of
human relations and to want human relations with husband and chil-
dren; failing that, at least with their families and with friends. Human
relations can be a deep emotional satisfaction even without marriage
if that proves impossible, and human relations must be carried out
with wisdom and loyalty and with generosity.

The third thing that they should be taught to want and prepare for
is recreation; the refreshment and exhilaration of the spirit which comes
from contact with beauty in the arts, music, sculpture, painting; prac-
tice, if possible, to appreciate and enjoy them at all events. Reading, a
form of recreation which sometimes seems in danger of disappearing,
games, sports, the simple joys of country walks, of gardening, of dogs—
all of those forms of recreation and refreshment and happiness which
would be possible even if the factories still continued to make other
things than motor cars and radios.

The fourth thing to teach them to want and to get is citizenship so
that they understand the country's past and its present problems and so
that they want to take some part in improving somehow the well-being
of all citizens of the country they love. And also, so that they want to
help their country play its part, and a worthy part, in the affairs of all
the world, when there is no hope for them of that security which would

enwrap the home and the husband and the children to whom they look forward.

Feeling and playing some part, however small, in a great whole working toward some great end, I think, will enrich the personal happiness of our young people in the years to come if they are so fortunate as to achieve some measure of personal happiness. If they do not, then this can fortify them against sorrow at their failure.

I believe very strongly that the best chance a young woman has for happiness in this uncertain world of today is to throw herself wholeheartedly and unselfishly into the great currents of her own time.

VI White House Conference: "How Women May Share in Post-War Policy Making"

The national dialogue on women's participation in postwar planning reached the highest levels of government when a special White House Conference, "How Women May Share in Post-War Policy Making," was convened on June 14, 1944. Document 17 includes an appeal by First Lady Eleanor Roosevelt, published in the April 1944 issue of *Reader's Digest*, that women participate in all councils and meetings addressing postwar problems. In response to the growing demand that women take part in postwar planning, Charl Ormond Williams, director of Field Service for the National Education Association (NEA) as well as former president of both the NEA and the National Federation of Business and Professional Women's Clubs, joined with Eleanor Roosevelt in organizing the June 1944 White House Conference. A native of Tennessee, Williams had served as the chair of the ratification committee when Tennessee became the thirty-sixth state to ratify the Nineteenth Amendment in 1920. Documents 18 and 19 include the Program and Report.

Document 20 contains the texts of the speeches of the nine women and one man who addressed the 230 distinguished women, including leaders of seventy-five women's organizations, in attendance at the Conference. All of the women who addressed the White House Conference had participated in international councils concerned with postwar issues. Several of the speakers used maternalist arguments, with their emphasis on gender differences, to justify women's participation in postwar planning. Yet carefully integrated into these maternalist ideas was the belief that qualified women, as citizens of the United States, had the right and the responsibility to participate fully in postwar planning.

The Conference Summary Statement, including the call that women "share in the building of a post-war world fit for all citizens

—men and women—to live and work in freely side by side," makes up Document 21.

Absent from the White House Conference was Carrie Chapman Catt, but Catt's role as the leader and elder stateswoman of the twentieth-century woman's movement did not go unnoticed. Before adjourning, the 230 women in attendance passed a resolution instructing Charl Williams to send a telegram of appreciation and good wishes to the ailing Catt at her home in New Rochelle, New York. Document 22 reprints this telegram.

The Committee on the Participation of Women in Post War Planning was one of the seventy-five national women's organizations to take part in the White House Conference. In a June 29, 1944, letter to members of the CPWPWP, Emily Hickman reported on the work of the Conference. Document 23 reproduces that letter.

17 Women at the Peace Conference

Eleanor Roosevelt

N^O PEACE CONFERENCE SEEMS TO BE confronting us at the moment, but when and if there is one I am confident that we will see women not only in the United States delegation but also from other countries. The interests of women who are fighting this war alongside the men cannot be ignored in any decisions for the future.

Through the years men have made the wars; it is only fair to suggest that women can help to make lasting peace. Women are, because of their natural functions, the great conservers of life; men spend it. Men are now giving up, though rather reluctantly, their ancient prerogatives of deciding, without feminine assistance, the great questions of public policy.

Queen Elizabeth, Mrs. Winston Churchill, Lady Reading and many other British women stand out today as having prepared themselves during the war to face the problems of the postwar world. Certainly, Queen Wilhelmina and Princess Juliana [of the Netherlands] have been doing the same. From Madame [V. M.] Molotoff down, every woman in Russia has been taking her part in assisting the armed services. Madame Chiang Kai-shek is never far away from her husband's side. In every country there are women ready to think in terms of postwar developments on a world scale.

Eleanor Roosevelt, "Women at the Peace Conference," *Reader's Digest* (April 1944): 48–49.

As each future conference of the nations meets, women should be among the delegates, no matter what the subject under discussion. This is not only a question of the recognition of women, it is a question of education for citizenship.

If women do not sit side by side with men and hear the arguments as they develop, decisions will be made without the proper basis of knowledge, decisions which cannot be carried out unless the majority of the women in every country cooperate in making them successful. News travels fast through women's clubs; such organizations would help greatly in spreading information if some of their members sat in important councils with men.

I was proud that our nation had women present at the Food Conference, and was glad that on our delegation at the United Nations Relief and Rehabilitation Conference we had not only women delegates but several women as observers. The observers were women with interests in special fields; they brought up points that otherwise would not have been given adequate consideration. I hope that, as more conferences are called, we will see an interesting number of women take their places with the men.

All nations are ruled primarily by self-interest, and women are not going to be different from men in that respect. But the men often think that our self-interest lies in reaching out for more power through force or through trade. Isn't it conceivable that women may think our self-interest lies in giving all the world a chance to envision something a little better than has been known before? That conception does not exist because women are more unselfish; it is because women value the conservation of human life more highly than the acquisition of power. Women will try to find ways to cooperate where men think only of dominating.

You will say that my thesis cannot be proved—and I will agree with you. Yet in the past, whenever women have shared in the councils of the mighty, there have been shining examples among them. Queen Elizabeth and Queen Victoria gave their country good leadership. Queen Wilhelmina is doing so today.

I can remember when women first began to be a factor in politics in this country, when it was generally said that "politics is no place for women." Men took off their coats and smoked big black cigars and put their feet on the tables and drank liquor and insisted that their political gatherings would offend the ladies. (The ladies seem to be surviving, however!)

Perhaps women haven't accomplished all they might have in politics, but there is a good deal more social legislation than there ever was before women had the vote. When a question comes up which

really arouses the women of this country, believe me, the men know that women are now a real factor in politics.

My plea is not for women at a peace conference only. It is for women in every meeting which deals with postwar problems; more women among our state legislators, in our city governments; more women in Congress; more women in high appointive positions of responsibility. They will not be there to oppose men, but to work with men, to have a share in shaping the new world which, whether we want it or not, is going to confront us some day. Men and women will have to live in this new world together. They should begin now to build together.

18 White House Conference Program

Morning Session—10:00 A.M.

I. OPENING THE CONFERENCE—Eleanor Roosevelt

II. WOMEN'S RESPONSIBILITY IN WORLD AFFAIRS
 Lucy Howorth—10 minutes
 Member, Legal Staff, Veterans Administration

III. WOMEN'S EXPERIENCE ON RECENT INTERNATIONAL COUNCILS
 1. Josephine Schain—10 minutes
 Delegate to the Food Conference of the United Nations,
 Hot Springs, Virginia, May 1943
 2. Ellen S. Woodward—10 minutes
 Member, Social Security Board
 Adviser to U.S.A. Member, Council of the United Nations
 Relief and Rehabilitation Administration Conference,
 Atlantic City, November 1943
 3. C. Mildred Thompson—10 minutes
 Dean of Vassar College
 Delegate to the Conference of Allied Ministers of
 Education, London, April 1944
 4. Margaret Chase Smith—10 minutes
 Congressman from Maine
 Technical Adviser to the delegates of the International Labor
 Organization Conference, Philadelphia, April 1944

White House Conference Program. Charl Ormond Williams Papers, Box 7, Folder, White House Conference, "How Women May Share in Post-War Policy Making," Memos and Records, Manuscript Division, Library of Congress, Washington, DC.

5. Frances Perkins—10 minutes
 Secretary of Labor
 Chairman, U.S. Government delegation to the International
 Labor Organization Conference, Philadelphia, April 1944
6. Elizabeth A. Conkey—10 minutes
 Member, Board of Commissioners, Cook County, Illinois
 Adviser to U.S.A. Member, Council of the United Nations
 Relief and Rehabilitation Administration Conference,
 Atlantic City, November 1943
 Discussion—20 minutes
Recess for Luncheon
Afternoon Session—2:15 P.M.
IV. FUTURE OPPORTUNITIES IN NATIONAL AND INTERNATIONAL
 POLICY-MAKING
 1. G. Howland Shaw—20 minutes
 Assistant Secretary of State
 2. Helen Rogers Reid—15 minutes
 Vice-President, *[New York] Herald-Tribune*
 3. Ruth Bryan Rohde—20 minutes
 Former Ambassador to Denmark
 Discussion—20 minutes
V. BUSINESS OF THE CONFERENCE—45 MINUTES
 A Summary Statement of the Conference
 Roster of Qualified Women
 The Continuation Committee
 Resolution of Appreciation
VI. CLOSING WORDS—Eleanor Roosevelt

19 White House Conference Report

HISTORY—MRS. ELEANOR ROOSEVELT and other prominent women have made many appeals to women to prepare themselves to serve in the post-war. They have called attention to the responsibility, opportunity and need for women in post-war planning.

On May 11, Dr. Minnie Maffett, president, National Federation of Business and Professional Women's Clubs, Dr. Kathryn McHale, general director, American Association of University Women, Mrs. La Fell

White House Conference Report. Charl Ormond Williams Papers, Box 7, Folder, White House Conference, "How Women May Share in Post-War Policy Making," Memos and Records, Manuscript Division, Library of Congress, Washington, DC.

Dickinson, president, General Federation of Women's Clubs and Charl Ormond Williams, director of Field Service, National Education Association, invited ten other women to meet with them to consider the question of women's participation in national and international commissions and find ground for common action. Mrs. Roosevelt invited this group to meet with her at the White House. The recommendation of this group, who later called themselves an operating committee, was a meeting of the presidents of national women's organizations and other leaders—the meeting that was held at the White House, June 14.

People are important and so before I tell you what happened, I want to tell you about some of the people who were in attendance. I believe it is evidence of the significance of the Conference:

Mrs. Roosevelt, who opened and closed the meeting and participated informally in all discussions.
The Hon. Frances Perkins, speaker and participant.
Among the wives of the Cabinet Members in the audience: Mrs. Cordell Hull and Mrs. James Forrestal.
Congress was represented, among others, by Margaret Chase Smith (speaker), Mary K. Norton, Frances P. Bolton and Winifred Stanley.
The two former women Ambassadors, Mrs. J. Borden Harriman and Mrs. Ruth Bryan Rohde.
I cannot recall a woman's national organization that was not represented—in almost every case, by the president herself.
Among other women who helped to make this a distinguished meeting by their presence were: Judge Dorothy Kenyon, Josephine Schain, C. Mildred Thompson, Dean of Vassar; Mrs. Ogden Reid, Vice-President, *Herald-Tribune*; Genevieve Forks Herrick, and others, the list being very long.
All government bureaus sent representatives.
And men watched the results! The President of the United States, the Members of the Cabinet and independent agencies sent observers. Judge Samuel I. Rosenman and Jonathan Daniels attended for the President.

What was the Program—In the morning session of the Conference six women who have recently been appointed to international councils told their experiences: Food Conference of the United Nations (Josephine Schain); Council of the United Nations Relief and Rehabilitation Administration (Ellen S. Woodward and Elizabeth Conkey); Council of Allied Ministers of Education which met in London (C. Mildred Thompson); International Labor Organization Conference (The Hon. Frances Perkins and Representative Margaret Chase Smith).

The reports of their experiences were very interesting but revealed simple reasons for the need of a conference of this nature:

1. While there may be some who argue that war is man's business, there is no one who does not admit today that the social and economic planning necessary to establish a better world in which to live is woman's business—and women are particularly qualified to participate intelligently.

2. In most cases, the executive heads of government departments responsible for the appointment of people to international conferences can quickly name or learn about men who are qualified to fill the appointments. They admit they are not averse to appointing qualified women, but they do not know or know about women.

3. There is need in Washington for a roster of qualified women so that when the situation arises they can be considered along with men on the same basis. Some women who have come to public attention are known—but there are women in every state who may not have come to national attention but who can make valuable contributions. If an organization sends in the name of only one, it has made a real contribution. (I see no reason why two organizations might not recommend the same person if she needs and merits support.)

In the afternoon session we were given the opportunity of hearing about some of the future opportunities in national and international policy making. Perhaps the most significant speaker was G. Howland Shaw, Assistant Secretary of State (the only man speaker) because his presence indicated the endorsement of the State Department to the plan.

This is an outline of action taken:

1. Adoption of a Summary Statement of the Conference, from which I quote . . . [see Document 21].

2. Presentation of facts on the organization of International Conferences and of the form on which qualified women are to be recommended (copies attached). Note: If you wish to recommend more than one, you are free to copy this form.

The recommendations are to be sent to Miss Charl Williams because she has graciously taken the responsibility to see that the names are routed to the proper authorities.

No permanent organization was formed. The Conference approved unanimously a motion that the original operating committee meet again and report progress.

A few significant facts:

This is a positive program. The question in this case is not whether men or women are to be appointed but how qualified women can be made known to the people responsible for making appointments.

This was a one-time meeting—not a permanent organization. It was not called contrary to the objectives of any other organization on post-war planning. The Committee endorsed the objectives of other organizations and invited their chairmen to attend.

During the meeting many of us thought of the great need to have qualified women participate in local and state planning. The people who planned this meeting are well aware of the importance of doing a job on the local and state levels, but they urge our support of this project which can be so significant in establishing a better world order. I think in your search for women to participate in national and international conferences, you may also discover some who don't meet this standard but who can serve you well on local and state levels.

The meeting was planned, organized and conducted better than any conference it has ever been my privilege to attend. Each delegate was charged with the responsibility of carrying the message to the leaders and through them to the members of her group. This is graphic evidence that women are a potent force in public opinion.

Mrs. Roosevelt called attention to this fact: "It takes two nations to make a war. It isn't enough that we help the men of our country establish a way to avoid wars. We must set examples to women of other countries to go into politics and do public jobs in the spirit of public service."

One of the delegates made a significant point: "We do a lot of talking about our ideals, but how many of us will stick our necks out for a cause? It's time we step forward with the courage of our convictions and tackle our jobs unafraid."

20 White House Conference Addresses

Women's Responsibility in World Affairs

Lucy Somerville Howorth,
*Senior Attorney, Veterans Administration**

*Lucy Somerville Howorth, "Women's Responsibility in World Affairs," *Journal of the American Association of University Women* (Summer 1944): 195–98. Reprinted by permission of the American Association of University Women.

W E ARE MET IN A ROOM hallowed by great events. We are met in a time of solemn urgency.

We must project ourselves to the time when we shall no longer be united by impending danger, no longer be sobered by the shadow of personal sorrow.

Women of the United States from Revolutionary days have had a high tradition of courage and steadfastness under the shock of war. With tenderness and pride in our hearts, we pay tribute to the wives and mothers of men on the bitter sands of Normandy, the peaks of Italy, the jungles of New Guinea, on and over and under the oceans.

World conditions demand even more of women today. Those new demands have brought us to this Conference. You are the voice of multiplied thousands of women in the homes and kitchens, in fields and factories, in cloistered college and public ways. It is for you not only to think and act, but to stir those whom you can reach to thought and action.

Consider these facts:

On June 3, the Census announced that adult women outnumbered adult men in the United States for the first time. Many jokes will result from that announcement, but seriously, it is most significant. It will highlight the power and failures of American women.

American women are strong and healthy, their life expectancy is greater than that of men.

American women own, it is said, more than 50 percent of the property in this country.

American women work in every profession and nearly every occupation. In the Army alone, members of the Women's Army Corps fill 239 categories of jobs.

American women vote, they hold office, they speak their minds freely on public issues.

High schools and colleges, nearly bereft of boys, are crowded with girls.

An avalanche of problems is moving down upon us and all the world. If planning is done in the United States to meet that avalanche, it must be done by women, older men, and men disqualified for military service. Most of these men are engrossed in war work. Women are the natural planners of the human race. The "little woman" plans and plans, sometimes to the annoyance of all the family. That same quality, if translated into action in world affairs by this group here today, may well save the world blood, sweat, toil and tears tomorrow.

Look at these facts, thus:

If down the ages, after each war, women had been haled before a judgement bar and asked: "What have you done to make an enduring

peace?"—they could have said: "We had no vote, we had no money, we had no strength after the day's work was done, we could only do our daily tasks and hope and pray. There is no guilt upon us."

If after this war that same question were to be asked, would we have to answer: "We could vote, we could hold office, we were rich in money and goods, our bodies were strong, our minds were trained, well informed, we could speak with voices reaching every land, yet we did nothing to cure this world sickness"?

Surely the richly gifted women of this Conference will not permit such an answer to be the only one that can be made.

Our consciousness is split these days. Our hopes and fears are across the seas. Our job is here, our minds must be centered here.

There is unfolding in the midst of battle, an approach to the problems of the world. It is becoming clear that there are to be a series of general international [and] technical conferences. Senator [Elbert] Thomas of Utah said in the Senate: "The aim of such conferences is to put together the fragments of a broken world. . . . Events seem to suggest that the forthcoming peace settlement will be built on a broad, firm base, with dozens of minor, technical matters talked out and thought out before the great political issues are settled and agreed upon."

The *Washington Star* states: "As matters stand today, sources high in the Administration do not expect a full-dress peace conference on the Versailles model to follow the surrender of Germany."

Four such conferences have been held: the Food Conference at Hot Springs, the Conference on Relief and Rehabilitation at Atlantic City, the Philadelphia meeting of the International Labor Organization, the Conference on Education in London. An International Monetary Conference will convene on July 1, and the press reports a Conference on International Aviation is in contemplation.

The functioning of international conferences should be understood. As in every home and office, there are two kinds of responsibility: responsibility for policy and responsibility for work. In the family, mother and father are responsible for policy; they generally do the work also. In larger institutions these functions are separated. Organizations, such as those represented here, have elective and appointive officers to shape policies and staffs to do the work. Exactly the same division of responsibility for policy and work exists in government and world affairs.

International conferences held to date have had two groups of policy-making representatives: official delegates and official advisers. The technical and general secretariat compose the non-policy-making representatives. In government agencies the policy-making positions

are the heads of departments, members of boards, and assistant administrators. Officials of lower rank may obstruct policies; they do not make policies. This may seem elementary to you, yet these simple matters of government structure are a puzzle to many otherwise well informed people. It is part of our duty as leaders to make such matters clear.

So remember, while it is fine for young Mary Jones to take a CAF 1 job in the government, she will not, and the thousands like her will not, shape the destiny of the nation, unless they push and shove themselves into policy-making positions.

It is well to pause here. This meeting is too important to be misinterpreted. While thousands of our beloved husbands and sons are fighting and dying to free the world, we must not be portrayed as grasping for special favors. This Conference is dedicated to what we may call the "new humanism," to adapt a phrase from Josiah Royce. It is dedicated to humanity, to solving the world's problems in terms of human rights and human needs.

With our philosophy stated, let us spade the ground a bit. How do women, or men, get appointed to policy-making positions? The process is not secret, it is not draped in mystery, it can be outlined in three short steps:

1. Names—names of individuals, not groups or classes of people —must be given to the appointive authority, with a short biographical sketch for each.
2. The appointive authority must be convinced that the person recommended can do the job.
3. The person recommended must not only be qualified for the job, but must not be obnoxious to the public, or that part of the public concerned with the position sought. It is preferred that the persons recommended have some assurance of public support.

Organizations and individuals here today can assume a definite responsibility in each of these steps.

First, a roster should be made up of the names of able, intelligent, personable women, qualified to serve in conferences to come, remembering the different requirements for policy-making and staff positions. Organizations represented here today are national, with units in every state; if they will comb their rolls, no capable woman will be overlooked.

Second, organizations and individuals must unite to convince the appointive authority that the women recommended can do the job.

This is where we strike a sharp snag. Organizations, some of them at least, have rules. The purpose of the rules is worthy. But there comes

a time when rules must be changed or exceptions allowed. Somehow, some way, the transition from the general to the particular must be made.

Picture this scene: A committee of distinguished women from this Conference confers with a cabinet member about a forthcoming international conference. One of the committee, in her most agreeable manner, says: "Mr. Secretary, we ask that you appoint several women delegates to this conference." Mr. Secretary replies: "I shall be glad to do so, if suitable persons are brought to my attention."

"Oh," say the committee, "we never recommend individuals, but we hope, if you do find a woman to appoint, she will be properly qualified."

I think you did not come here today for any such inanity.

The times demand that we be broad enough, bold enough, generous enough, patriotic enough to rally behind suitable women without fear of disunity, without fear of stirring factional strife within our ranks. I, for one, believe we can do it.

There was the day, not so long ago, when most women's organizations would take no positive stand on legislation. That day is happily gone. And no organizations were wrecked; the sailing might have been rough at times, but they made port.

Third, organized women particularly can rally public support to aid and uphold the aims of women appointed to national and international policy-making positions. This technique is well understood. It does not need discussion here.

If there comes out of this Conference a determination to take these three steps, then this Conference will indeed be history-making.

This Conference meets under favorable auspices. The prestige of the great lady who is our hostess supports our endeavors. Our government is friendly to our cause; able women have been appointed as delegates to international conferences and we feel sure others will be appointed in the future; women leaders in other lands are urging that women have voice and vote in the making of the peace. Surely we will not be paralyzed by timidity, tradition, and taboo. Instead, let us here highly resolve to go bravely forward, using the talents God has given us, in service to our country and humanity.

Women Should Share in Government

Josephine Schain, Delegate to the
*United Nations Conference on Food and Agriculture**

**Josephine Schain, "Women Should Share in Government." Charl Ormond Williams Papers, Box 7, Folder, White House Conference, "How Women May*

There is no issue of greater interest to women than the establishment of world order based on law with justice. All the things that women care most about are endangered by war. Women are the conservers of life and therefore naturally react against the terrible destruction that is brought about by hostilities. Women have no pride of authorship concerning the war system, so, as a whole, they are not inhibited in their belief that a more effective method can be found for settling disputes between nations.

Women are citizens and should have a share in government. They should have a voice in making decisions that mean as much to them as the issues that are involved in war and peace. Citizenship with its privileges entails responsibility. Women are asking to share with men the responsibility of working out peace machinery to take the place of the old war machine. The best results are generally conceived by men and women working together, for men's ideas, approach and convictions plus women's ideas, approach and convictions make a unified whole. A society in which the voice of women is discounted is out of balance.

Women have come of age since World War I. For the past twenty-five years women's organizations throughout the country have been intently studying international problems. Many women have gone beyond a superficial study and have become experts; thus they have a contribution to make that would be of benefit to society as a whole.

We want women represented in the future in the places where decisions are being made. This means we want them included in delegations to international conferences, advisers on committees and commissions planning for such meetings, women in policy-making positions in the State Department and in other departments in the government where planning is being done, women on the Foreign Relations Committee and other committees in Congress which deal with matters of war and peace.

My Experience at the UNRRA Conference

*Ellen S. Woodward, Member, Social Security Board**

Share in Post-War Policy Making," Memos and Records, Manuscript Division, Library of Congress, Washington, DC.

*Ellen S. Woodward, "My Experience at the UNRRA Conference." Charl Ormond Williams Papers, Box 7, Folder, White House Conference, "How Women May Share in Post-War Policy Making," Memos and Records, Manuscript Division, Library of Congress, Washington, DC.

This meeting today is a very hopeful sign—a sign that the *unity* of *purpose* which characterizes our women's organizations throughout the country will find more effective expression in unity of action.

Our immediate purpose is to determine ways in which women may have greater opportunity to participate in weaving the pattern of the post-war world. You will notice that I have said *"greater opportunity"* since we are all aware of the historical fact that the door has already been opened for women in the post-war program. In fact, beginning with the early war days, a woman served on the National Defense Council with six men. That woman, who is still helping to make policy in war and post-war programs as Director of the Women's Division, War Finance Committee, is Dean Harriet Elliott, who is here today.

I further call your attention to the fact that there are also present today women who were appointed members to the Food Conference, to the UNRRA [United Nations Relief and Rehabilitation Administration] Conference, to the recent London Conference on Education, to the I.L.O. [International Labor Organization] Conference, and I understand that a woman has been appointed to the Monetary Conference which meets in July 1944. So, in the language of the times, I might say that we have already established a "beachhead." Now we must go forward and widen that "beachhead" by rallying our forces in *united action* to assure the appointment of more women to other important conferences which will make post-war plans and policies.

You want to know whether or not women who are appointed have an opportunity to make a contribution at international conferences. I will tell you briefly about my experience as a member of the UNRRA Conference at Atlantic City.

I was appointed an official adviser to our United States member of the Council, the Honorable Dean Acheson. I advised him in the field of my experience—welfare. The work of the Conference was carried on through four over-all committees, one of which was Welfare Services, composed of representatives of 44 nations. I served as the United States member of the Committee on Welfare Services and helped to formulate the policies which were adopted by the Council.

A five-member "working committee" screened the flood of policy material for the large Committee on Welfare. I was one of the five members who did the screenings.

Because of the magnitude and complexity of the problems confronting UNRRA and the necessity for continuing effective guidance, the Council established Standing Technical Committees in five fields, one of which is *Welfare*. On this continuing Welfare Committee, composed of representatives of 22 nations, I was appointed the United States member.

A development of this continuing committee is a Studies Subcommittee, which has been set up to assist the Welfare Division of UNRRA by obtaining and analyzing certain materials necessary to the planning of Welfare Services in the various countries when liberated. There are three members of this Studies Committee—a representative of the National Committee for French Liberation, a representative from Russia, and a representative from the United States. I am serving as the United States representative.

As you see, I have had the opportunity for full participation at the UNRRA Conference and in its continuing activities; and I am deeply conscious of the great responsibility that goes with full participation.

No one doubts that this is the most critical period in world history. At this high moment, we, a group of American women, are meeting here in the White House in our nation's capital—inspired by the unfailing interest and courageous leadership of Mrs. Roosevelt—declaring that women are prepared to assist in reconstructing a broken world and in helping to build a better civilization. We say this because we believe it to be true—because we have tremendous faith and confidence in American women. And we are also saying that women are ready and able to assume such responsibilities.

It is with sober determination that we say this, for we know that the policies and plans adopted in the post-war planning conferences will affect human life for centuries to come.

With this in mind, I am compelled to add a word of caution—we must be more than careful in building our roster of recommendations. We should constantly consider and remember the distinction which Judge Howorth has made between those prepared to serve as technical experts and those qualified to contribute to policy determination. Unless we keep this distinction in mind, we cannot possibly make the best recommendations.

With so many potential women leaders in various fields it is difficult for some to understand why women have not participated more fully in world planning. Certainly they have proved their ability. I think I can see two possible causes. One—apathy on the part of a great many women—a disinclination, whether conscious or unconscious, to repudiate the customary and traditional role assigned in the past to women. Two—failure to unite in the common purpose of obtaining greater participation for women in international affairs.

Today's meeting is tangible evidence of our determination to overcome those obstacles. We must transmit this determination to the millions of American women who are looking to us for guidance and assistance in thinking through those difficult problems.

In conclusion, therefore, may I say that recommending members to conferences is not the end, but the beginning, of our work. Because we have long memories, our minds go back to another post-war period. We know that misunderstanding and ignorance in that post-war period contributed to the confusion in public thinking concerning ways and means to achieve world peace. There must be developed a strong public opinion if the policies and plans of the conferences are to be really effective and if women are to understand what each can do in her own community to work for a lasting peace.

Conference of Allied Ministers of Education in London

C. Mildred Thompson, Dean, Vassar College*

Education has long been the profession in which women have taken the largest part. In recent years any activity for the planning for peace has engaged the interest and the devotion of women. Therefore a conference, the purpose of which was to aid education in the countries to be liberated as a means toward building peace, would naturally fall within the province of women's interests and qualifications.

The Conference of Allied Ministers of Education in London was engaged in a two-fold activity: (1) the inquiry into the needs which the allied countries may have for material equipment, for the opportunities for the training of personnel and for the restoration of library, archival and art resources; and (2) the United Nations as a whole. Both of these activities were largely concerned with work in which women have both special concern and trained equipment to offer. If I had not myself had the good fortune to be appointed by the State Department to join the five distinguished and highly qualified men already appointed as the American delegation, it would have given me satisfaction to know that a woman was to serve for such work as the Conference was charged to undertake. There are indeed many women whom I might have named, all highly qualified for this important work toward post-war planning.

From my experience, going as I did to join the Conference at London on three days' notice, I received nothing but the fullest and most friendly cooperation from everyone with whom I dealt—from the various officers of the State Department who were responsible for the appointment and direction of the delegation, from my five colleagues who accepted me as an equal without question, and from the members

*C. Mildred Thompson, "Conferênce of Allied Ministers in London, April 1944." Charl Ormond Williams Papers, Box 7, Folder, White House Conference, "How Women May Share in Post-War Policy Making," Memos and Records, Manuscript Division, Library of Congress, Washington, DC.

of foreign delegations at the Conference who showed no signs of surprise or displeasure at having a woman injected into their midst. Even the army transport plane which brought me home seemed to suffer no marked distraction on the part of the crew or the military passengers from the unaccustomed presence of a woman.

We must insist that qualification for the job be the sole test for the privilege and the duty to serve our country in post-war planning. I would not urge appointment of women because they are women but because many women have capacities and skills needed by our government in the big task ahead. Full employment is our directive—the employment to the full of well-qualified women, as well as men, in all the important commissions to serve our government in the weeks and months ahead.

The Need for Qualified Women on Policy Making Bodies

*Margaret Chase Smith, Representative in Congress from Maine**

If post-war planning was ever academic, it certainly has become a realized necessity since D-day, June 6. Now that the second front has been established and the liberation of Europe started, there is less time for post-war planning. This is the real beginning of the end, which is not so distant that we can leisurely prepare for post-war problems.

With this in mind, this particular meeting should be aimed at having women at the peace table and at the many important conferences of the future. Women should be at these conferences from a standpoint of practical necessity rather than the insistence of a fair share of influence. The desire of women to help solve these problems is much deeper than self-interest.

In the past, women's rightful participation has been denied through sex discrimination. This war has exposed the fallacy of such discrimination, for women have filled innumerable jobs traditionally occupied by men.

Women should be called in to assist in post-war planning—not just because they are women, but because of the knowledge and understanding that they have of certain problems.

As a member of the House Naval Affairs Subcommittee on Congested Areas, I have had an opportunity to observe personally the accomplishments of women everywhere. I have been amazed to learn the high percentages of women workers. I saw them in hospitals, in

*Margaret Chase Smith, "The Need for Qualified Women on Policy Making Bodies." Charl Ormond Williams Papers, Box 7, Folder, White House Conference, "How Women May Share in Post-War Policy Making," Memos and Records, Manuscript Division, Library of Congress, Washington, DC.

shipyards, aircraft plants, torpedo factories, and many other war activities all over the country. All of this has made an indelible impression upon me. Many of these women have become experienced and skilled workers and have replaced men who are fighting the war.

There will be the problem of readjustment when these people return from the congested war areas to take up normal activities, all looking for work which will not be of a war nature. This presents a very difficult problem.

Time is short. We cannot be leisurely in finding a solution for these complicated problems. As the men who have been fighting the war return, there will be some inevitable conflicts as to whether the jobs are to be retained by the women or returned to the men. In order to approach the solution of such a problem with proper balance and equity it will obviously be necessary to have representatives of women as well as men to make final decisions.

It has been my privilege as a member of the House Naval Affairs Committee to visit naval establishments over the country, to see the work of the women in the services—the WAVES, the SPARS, the MARINES, the WACS, and the nurses. Here, again, is a problem—the orderly demobilization of these women from the services and their return to civilian life.

It was my recent work at the I.L.O. [International Labor Organization] Conference which gave special emphasis to my study of post-war problems. While I was greatly honored in being the only Representative from the House, it was a greater satisfaction to me to see proper recognition given to women. Women from several nations were representing government, industry and labor.

I believe that splendid progress was made not only in crystallizing the rights and duties of labor, but in maintaining the right of women to equal opportunity and reward, and in cementing the international friendship that comes from personal meeting between people of different countries.

Actually, it was a conference attended by officially appointed representatives of each member government, and each country's organized workers and organized employers. The I.L.O. was founded in Washington just twenty-five years ago, and its purpose has been to standardize and improve protection which can be given by local and national legislation to workers, especially women and children.

The Philadelphia Conference went into new territory and recognized the importance of international cooperation to meet the common, social, and economic problems of ordinary people—all men, women, and children in this country and all over the globe.

An I.L.O. recommendation of great importance deals with the organization of employment in the transition from war to peace. It directs attention to the problems involved in the redistribution of women workers in each national economy which has been disrupted by the war.

This broad recommendation is intended to promote full employment with a view of satisfying the vital needs of the population and raising the standard of living throughout the world. It points out that the redistribution of women workers "should be carried out on the principle of complete equality of opportunity for men and women in respect of admission to employment on the basis of their individual merit, skill, and experience, and steps should be taken to encourage the establishment of wage rates on the basis of job content without regard to sex."

As a primary responsibility in carrying out the objectives set up at the Philadelphia Conference, it is our duty to see to it that women have a share in transmitting these ideals into practical action. Our women have shown that they can make valuable contributions in setting up the program. It ought to be obvious that the execution of the program needs their thought and action.

The foundation on which the peace will be built is being laid in these international conferences: the I.L.O. at Philadelphia, the Food Conference at Hot Springs, the Monetary Conference to be held in Bretton Woods, New Hampshire, in a few days, and others.

The presence of women at all of these conferences illustrates the increasing participation which women are taking in the planning of a post-war world. More than that, they are evidence of a recognition that women have much to contribute to that planning.

The recommendations and plans made at these conferences can be translated into positive action only through the legislative and executive branches of the various governments of this world. Obviously such recommendations and plans will include problems best understood by women. Because of this it is of the utmost importance that women be adequately represented in Congress and in the Executive Department.

We shall need women who have been trained in special fields to sit on decisive bodies, and that is where a list of women whose backgrounds fit them for various services will be helpful. At least this would eliminate the excuse that appointing officials didn't know where to find competent women.

There are many varied fields in which women's influence should be felt, and there are many qualified women in these fields. While qualifications gained from training and education are of great value, it

is experience in the field of human relations that is the most valuable asset of women.

Most women are wives and mothers, and their great demand is for a nation and a world in which their families may be prosperous and live happily. That demand should be represented at every meeting in which decisions are made—but the demand should be made by women of intelligence, courage and experience or their cause is lost to sentimentality.

It is not enough to have the desire to help. Women must be qualified to serve well, because unqualified and incompetent women forfeit their own opportunity and discourage the appointment of other women.

We must be constructive in our cooperation, and as we continue to urge recognition we must at the same time realize that we are asking for jobs that carry with them tremendous responsibility. Women are ready and willing to accept the resulting burdens along with the privileges of authority.

Contribution of Women at the International Labor Conference

*Frances Perkins, Secretary of Labor**

American women today do not make their claim to positions of responsibility and trust because they are women. They will be used successfully only as they are patriotic, trustworthy, responsible citizens of demonstrated ability. I am sure that there are many qualified women who can and will be used either as technical advisers or as responsible political representatives of the United States in those most important conferences for agreement on the details of different phases of peace.

An important example of women's contribution to making the peace was the recent Conference of the International Labor Organization at Philadelphia, where 16 women were full members of the Conference. These 16 women were from 10 nations and were there in one of three capacities: either full government delegates, government advisers or advisers to labor delegates. Several of them were members of parliamentary bodies, a number were officials of government ministries and two were trade unionists.

*Frances Perkins, "Contribution of Women at the International Labor Conference." Charl Ormond Williams Papers, Box 7, Folder, White House Conference, "How Women May Share in Post-War Policy Making," Memos and Records, Manuscript Division, Library of Congress, Washington, DC.

The Constitution of the I.L.O. requires that women shall be among the delegates to conferences when any matter affecting women particularly is on the agenda, and there have always been women at the Conference. The U.S.A. delegation has always included women—sometimes several—since the beginning of our membership. These women have done their full share of the hard, grueling details of committee and subcommittee work; have entered difficult negotiations with members from other nations and have comported themselves with intelligence and goodwill as well as with a practical eye for their country's welfare. Women in the Conference from many nations have become real friends and have won the respect and fellowship of other members.

This recent Conference was difficult and complicated, but it resulted in important progress—the Philadelphia Declaration of social purpose and intent among 41 nations and the wording of an explicit treaty to implement this Declaration in detail suitable for adoption (after consideration) by the plenipotentiaries and heads of state who will sign the final agreements.

Women have done their work well in the I.L.O Conference—have contributed to the great sense of solidarity with which this recent Conference ended. Seventeen committees, ten or twelve languages, tensions born of war and political uncertainties, new faces—all were complicating factors and yet it came off well. The technique of international conferences and affairs must be studied, meditated about and practiced humbly. After all, any international conference is an assembly of men and women given certain representative and/or plenipotentiary powers which they seek to use first, for the purpose of the conference; second, to protect their own country; and third, to further the peace and welfare of the world as they understand it.

Contribution of Women to International Policy Making

Elizabeth A. Conkey, Adviser to the
*United States Member, Council of UNRRA Conference**

Women will make a contribution to international policy making provided that they are equipped with certain attributes. It is agreed that they must have acquired the training, background and experience which qualifies them for the task to which they may be assigned.

*Elizabeth A. Conkey, "Contribution of Women to International Policy Making." Charl Ormond Williams Papers, Box 7, Folder, White House Conference, "How Women May Share in Post-War Policy Making," Memos and Records, Manuscript Division, Library of Congress, Washington, DC.

International policy making functions directly between governments and governmental agencies. However, governments and governmental agencies are only the agents of the individuals, the human beings, that they represent. Therefore it is mandatory that women chosen to assist in international policy making possess much more important attributes, if they are to be helpful. It is imperative that they be endowed with the innate, inherent characteristics that will make them stalwart advocates of justice in all deliberations. They must carry within their souls a lofty honesty of purpose, shorn of all unfair bias, prejudice, intolerance and self-interest. Their one and only purpose always and ever must be the welfare of the human beings for whom they are legislating, regardless of race, creed, nationality or previous condition. For the moment they are their brother's keeper—a grave responsibility. Honesty of purpose—that is the imperishable rock upon which the peace and happiness of the human race must be built. No other will endure.

We are grateful and proud in the knowledge that the United States of America gives the world this type of woman. In the past many have undertaken most successfully the burden of international policy making. There are many women present this morning who have rendered this service with distinction. At Atlantic City it was the speaker's privilege to observe Ellen S. Woodward, adviser to the United States Member, Council of the United Nations Relief and Rehabilitation Administration, and member of the Social Security Board. Mrs. Woodward contributed most successfully to the policy-making of that body. Through her comprehensive knowledge in the field of public welfare and her perseverance, she was able to have policies adopted which will redound to the welfare of distressed men, women and children throughout the war-stricken areas.

The women of the United States must participate in international post-war policy making. The harassed, hungry and humiliated women bearing the actual brunt of war are crying out across the seas for assistance. We have a moral obligation to respond to that call. We shall do it. America is blessed with women who are experts, women who have potential for service in every field—relief, health, rehabilitation, food, agriculture, labor, employment, care of veterans and government. When victory comes and Divine Providence gives us an opportunity, once more, to try for sound world peace, it is hoped that every woman in the nation will advocate, and demand, if necessary, that women participate.

There are innumerable women throughout our nation who could and would distinguish themselves and the great country they represent in that capacity. In the speaker's opinion, based upon the observa-

tion of a decade, no woman is better qualified in any nation than Mrs. Roosevelt, our hostess on this occasion. Mrs. Roosevelt's vast and varied experience, her courage and wisdom, her deep understanding of problems between nations and her honesty of purpose in trying to help those who cannot help themselves especially prepares her for service at the Peace Conference. Mrs. Roosevelt knows how to suffer for a just cause. She is a great leader of women in her own country and has undoubtedly set the pattern for women leaders in other nations. Above all, she possesses that spiritual quality without which no peace deliberation will be successful or permanent. For lack of it our last Peace Conference failed.

Opportunities for Women in the Conduct of International Relations

*G. Howland Shaw, Assistant Secretary of State**

At the outset I am going to make an assumption which I know is a safe one; namely, that you are not concerned with the conception, which happily is ever more narrowly held, that women as such constitute something in the nature of a national minority for which representation should be secured on all governmental projects. It may once have been tactically expedient to promote that somewhat restricted view in the process of obtaining general recognition to the simple fact that the women of this country are likewise members of the body politic. But that fact is certainly now beyond dispute.

Today we in the government who are engaged in the selection of individuals for the performance of the multitude of tasks which confront us both here and abroad are concerned only with the competence of the potential government servant or representative. Nevertheless, to those of you who recall that June day twenty-five years ago when what became the 19th Amendment to the Constitution of the United States received the approval of the Congress, there must indeed be a source of satisfaction in the knowledge that today the women of the nation are playing an active, a vital and an indispensable role in every line of American endeavor from assembly line to the President's

**G. Howland Shaw, "Opportunities for Women in the Conduct of International Relations." Charl Ormond Williams Papers, Box 7, Folder, White House Conference, "How Women May Share in Post-War Policy Making," Memos and Records, Manuscript Division, Library of Congress, Washington, DC.*

cabinet. And those women are there, not because they are women but because they have what it takes.

This afternoon I would like to speak briefly about the role of women in the conduct of our international relations which, as you know, is the province of the State Department. In so doing, I risk being charged with trying to divide into meaningless categories the people who serve their country in the international field. It might perhaps fairly be said that it would be almost as meaningful for me to devote a discussion to the work in this field of all persons who bear the name of Smith. Yet because of the history of the emancipation of women, perhaps such a segregation is not totally lacking in significance to this gathering.

As you know, our foreign relations are conducted through the complementary channels of a home office—the Department of State; and a field staff—the Foreign Service of the United States. I am going to speak first about the home office—the Department of State.

Of the persons engaged in administrative and professional work in the Department, more than 300, or over one-third, are women. This figure does not, of course, include the many highly valued women who are employed in the essentially important field of secretarial and stenographic work. In the administrative and professional classifications, to which I just referred, women are receiving base salaries of from $2,000 to $8,000 per year. While war conditions are in part responsible for the increased ratio of participation by women in government affairs, those war conditions are *not* responsible for the professional and technical competency which is being outstandingly demonstrated by the women who have recently joined the State Department. I think some of you who have participated in the past in government activities can take at least partial credit for the high quality of the work now being performed by women in the various activities of the Department. For, with the example before them of your own successful contributions to the operations of the government, young women in their college days have in recent years prepared themselves with more assurance that suitable outlets for their talents will be found.

I think these women who are working with us are happy in the knowledge that they are more than carrying their share of the burden and that they are regarded by their fellow workers not as stop-gap or makeshift employees—necessary evils "for the duration"—but as full-fledged and expert technicians capable of doing the best possible job. It was interesting to me to hear the comments of a competent research worker—a woman known to many of you here—who recently joined the staff of the Department. Said she, "I have been impressed by the attitude or rather lack of attitude toward women in the Department." I

thought that was a very apt way of saying that the presence of women as officers of the Department has now become commonplace.

So far as concerns the Foreign Service, or the Career Service as it is sometimes called—I will state quite frankly that the situation at least in the past has been different. These people serve abroad in many lands and under extremely varied circumstances. It is no reflection on our friendly neighbors in other parts of the world, but rather a manifestation of pride in our own standards to say that the position which women hold in the United States is not always understood by the peoples of some of the other countries of this world. Moreover, the living conditions, not merely the physical surroundings but the sociological settings, differ in many foreign posts to a very large degree from those found in our own country. I personally believe that time will bring a change in this situation and that in the future there will be more opportunity for women in our Foreign Service. However, in spite of these factors and in spite of the fact that Foreign Service officers must be selected on the basis of their being able to serve anywhere in the world at any time, there are now included in our regular Foreign Service seven women as Foreign Service officers. Five others have at one time or another been members of the regular Service but have either resigned or retired. In addition, as you know, two women have served as Chiefs of Mission: Mrs. Ruth Bryan Owen Rohde as Minister to Denmark and Mrs. Florence Jaffray Harriman as Minister to Norway.

During the war the regular Foreign Service has been supplemented by an Auxiliary Foreign Service made up of people sent abroad to serve in special capacities connected with this emergency period. Twelve women are officers in this auxiliary service. It may be expected that the complexity which characterizes our present-day foreign relations will, even at the conclusion of the present emergency, require us more and more to attach to our embassies and legations abroad specialists on temporary assignments in fields in which women have shown themselves outstandingly qualified, such as labor relations, welfare work, cultural relations, economic relations and so on.

So much for the Department of State and the Foreign Service of the United States. There is, of course, another area of international activity in which women have and will continue to take an active part; namely, those international conversations, conferences, and commissions in which this government participates through American delegations. The speakers this morning dwelt at some length upon the role which women have played in these special assignments. By way of summary, the following constitute a list of recent international

gatherings at which women have been members òf the American delegations:

The United Nations Conference on Food and Agriculture at Hot Springs, Virginia, in May and June 1943

The first Council Meeting of the United Nations Relief and Rehabilitation Administration at Atlantic City in November 1943

The Meeting of the International Labor Organization at Philadelphia in April 1944

The Conference of Allied Ministers of Education at London in April and May 1944.

As the war approaches the final decision we can, of course, expect that numerous other occasions will arise for consultations between representatives of the United Nations on international problems of mutual concern. Many of these problems will be of a highly technical character. It is inevitable that those selected to represent this government in such consultations or deliberations will, as in the past, continue to be chosen on the basis of their technical qualifications. The record of participation by women in the conferences and meetings which I have just listed clearly demonstrates, if there ever was a doubt, that the desired technical qualifications are to be found among women as well as men. From this it may be concluded that women will continue to find themselves taking part in future meetings of this character. And, of course, the same must be true of those international consultations and conferences which will follow the termination of hostilities.

In the selection of those persons who will make up the American representation in these ad hoc international consultations, it is obviously desirable that full information be available as to potential selectees, particularly with respect to their professional or technical qualifications. This information is not always at hand in the files of the State Department or of other government departments. In this connection I may say that we in the State Department are aware of the fact that groups of private citizens are capable of rendering valued assistance by assembling data as to technically qualified persons—and I emphasize the element of qualifications—who might constitute something in the nature of an informal panel from which appropriate selections can be made at opportune times.

In summary, whether it be to serve in the State Department, in our Foreign Service or on special commissions, we are looking for the best in the land. I can assure you that those who possess preeminently the requisite qualifications will be chosen, whether they be men or women.

The Need for Women in Public Service

Helen Rogers Reid, Vice-President, New York Herald-Tribune*

The topic on the program under which I am supposed to talk is the Future Opportunities in National and International Policy Making for Women. It seems to me that the opportunities have been admirably covered by the speakers at the morning session. At least their experiences have been a fine illustration of the possibilities for further work by women after the war. What I would rather comment on now are some of the needs. The ideal objective, of course, is that government should have the benefit of citizens who will be chosen to represent the country because of what they can contribute, not because they are either men or women. But a great deal of groundwork must be done before this ideal is realized, and responsibility rests with the women to change the established practice. They can only blame themselves for the present situation.

Unfortunately, trained women in America have been unambitious for public service and too content to do subordinate work. They dislike pushing themselves. They need to apply their theory of self-confidence to effort that will enable them to go to the top. Mr. [G. Howland] Shaw has told us of the opportunities that are available in the State Department. This is fine and more than we perhaps realized, but the positions are all in the category of assistants. Women will have to care more about going further before they can arrive.

We all know that old habits, old patterns of thought must sometimes be interrupted, and there is bitter medicine in having this accomplished through war. But the records of today show that women have arrived as full partners in much of the present horror. Of course, they are not serving directly at the front, but they are proving of immeasurable value to military forces behind the lines. Our enemies, however, have placed them in their front lines of attack, whether through bombing them in their homes or mowing them down on the roads of France when they fled as refugees. Cold blooded as this has been, I believe there is benefit in the fact that women have been made to suffer equally with men. By making war complete against the human race, its true values of no glamour and crass stupidity have gripped all people who are civilized. In past wars, women have been made to suffer in the loss of their men. For the first time this war has caused men to suffer

*Helen Rogers Reid, "The Need for Women in Public Service." Charl Ormond Williams Papers, Box 7, Folder, White House Conference, "How Women May Share in Post-War Policy Making," Memos and Records, Manuscript Division, Library of Congress, Washington, DC.

for the loss of their women and children. And grief can be a potent force for progress.

In England, as you know, women who have been drafted for anti-aircraft work in the Home Defense are performing all types of service in attacks on the enemy—with the one exception of pressing the lever to fire the guns. They plot and plan the operation, do the arithmetic and higher mathematics, train sights and handle everything up to the final act. They can be fired on, of course, but through a quaint bit of old law, they may not fire back. They do not perform the ultimate.

It is a major tragedy in my judgment that women have not been drafted in America for whatever war service they could perform. All of us here today no doubt feel badly that more women have not volunteered, and probably some of us wish that we were not beyond the age for doing so, but I wonder how large an army of men would have been mustered and how long it would have taken if that process had been left entirely to a voluntary system, even though all tradition and general acceptance were on the side of men serving when war became inevitable. Presumably a national service act including women will not now be passed. There is too much general psychology of the war being nearly over, even though it has just begun for many of us, and even though there still exists a tremendous need for girls and women in every branch of the Armed Services.

But perhaps the men who have opposed women sharing the hardships of warfare will see the wisdom of drafting them for work that may be a means of preventing war. The fact is that government is being run by only half of the human race. This power is in the hands of men, and they will not discover by themselves that something more is needed by the world. Our obligation is to convince them that all the best of mankind should be utilized.

Probably the brain contribution which women would bring to this future work would not be very different from that of men because there is no proof that mental capacity is different in men and women. The only kind of a mind that counts is a good mind, a trained mind, and this is neither male nor female. What is true is that women have a certain kind of imagination and endurance which prevents their becoming defeatists. You do not hear them say that war will always be inevitable. They believe that the seeds of it can be destroyed if only enough effort is used. Their work with the young has given them great patience and the will to try many methods. Their traditional job of bringing life into the world and preserving it has developed will power for the future. Qualities and experience like these, when combined with other abilities, are needed for government. But our qualities as women are only our plus, not the reason for our gaining the opportu-

nity to serve. I agree completely with what was said this morning about the special assets that we have, but men have theirs too and we have to prove our fitness for work on the basis of what a given job requires.

There is another reasons for women serving in public life—a completely altruistic one. They are needed for the sake of saving men from a horrible fate of Olympic egotism. The conservation of men's best efforts may well be one of our most important jobs. Power too long in the hands of one division of mankind can lose its effectiveness. Certainly it is an established fact that where men and women work normally together they stimulate each other and produce creative results. They have been successful in producing children together; why is it not time for them to produce brain children in work for the world? When they work shoulder to shoulder, with a comparable responsibility, the record shows that romance has not been a disturbing factor. Ideas are born—not children.

The first step, it seems to me, for accomplishing our objective about women's contribution to government following the war is to get more of them into public office now—not just because they are women, but because among them is an untapped supply of ability. We should have more women in the House of Representatives and far more of them in the Senate—not as successors to their husbands, but as people in their own right. They should go into local governments. This can only be accomplished through women deciding on those who are capable and then undertaking campaigns to elect them to office. Men will not initiate this and we cannot complain of the fact. Tradition and habit are all against it, but many of them will help if we take the lead. The opportunity for women's organizations is tremendous. In the past they have often dissipated their power on worthy educational projects of one sort or another, but it seems to me the time has come for them to show their force by putting able women into positions of responsibility and action. The challenge is ours. We will not be successful in demanding the presence of women in world machinery unless we get more of them into important work on the home front. America has been outdistanced by England in the number of women in the House of Commons and other important posts. They have one of the most able women in the world at the head of the Welfare Division of UNRRA—Craig McGeachy.

Incidentally it is estimated that well over 50 percent of the ballots this fall will be cast by women *if* they go to the polls. In addition, and because of military requirements, it is important to realize that far more women than men are being graduated from college. Twelve years ago more girls were finishing high school than boys. Probably the figure is even higher now. The result will be that, for a time anyway,

young women will be better educated and more of them trained professionally.

To sum up:

1. America needs women in local, state and national government.
2. The world needs them.
3. Men need them.

Many people are watching this meeting. Before it ends, I wish that action on two counts could be taken:

1. I wish a protest might be registered that women have not been drafted for war service and a call might be sent forth to those available to volunteer at once.
2. I hope we shall ask that the best trained experts among our younger women particularly be drafted after the war, to share with men the building of a world organization that will maintain order and prevent future wars.

Some of you might say that the first suggestion has nothing to do with the purpose of this meeting—that it has no concern with mistakes of the past. But my conviction is that the work of women during the war has everything to do with their opportunities after the war. The two fields are inseparably linked together. Women are needed now. What we do for our country in a time of great national crisis may well be a test of what we will have a chance to do for the world.

How Women May Share in Post-War Policy Making

*Ruth Bryan Rohde, Former Minister to Denmark**

It is appropriate that this Conference in the interest of the wider participation of women in the planning and construction of our post-war world should meet with the encouragement of a President who has done more to open opportunities to women than any President our country has had, and that the Conference should have been called by that gracious lady who has by her own example and effort set a new standard for women's service and women's recognition.

There is an encouraging change of approach in the matter of women's participation in public affairs. In the early suffrage days, places

*Ruth Bryan Rohde, "How Women May Share in Post-War Policy Making." Charl Ormond Williams Papers, Box 7, Folder, White House Conference, "How Women May Share in Post-War Policy Making," Memos and Records, Manuscript Division, Library of Congress, Washington, DC.

were demanded for women with the emphasis on women's rights to have such posts. Now there is emphasis on the government's right to have the special service which women are qualified to give. There are certain fields in which women by temperament and training and experience have something significantly their own to contribute. All that concerns the home and the child is woman's special domain.

Some of the most vital post-war problems deal with just these matters—homes to be rebuilt, children to be clothed and fed. To omit women from leadership in these phases of post-war planning would be uneconomical and impractical.

Education, with its close relation to the child's welfare, has been woman's province to an extraordinary degree. The great majority of our teachers are women, and what a valiant army they are! One would gather from attending the Parent-Teacher Association meetings, that parenthood was an exclusively feminine business. It is the mothers and teachers, for the most part, who have carried this work forward.

Education is a major problem of the post-war world. The rebuilding of ideals is more important than the rebuilding with brick and mortar, and it would be a costly oversight to omit from leadership in this field those who best know the mind of childhood and how it may be "led forth."

But women's specialized interests are wider than home, child and education. After a mother has studied the child and given him in home and education all that she feels will fit him for manhood, the time may come when government puts its hand into the home and takes the finished product onto the battlefield. Women should have a place on all councils which decide questions of war and peace between nations.

21 White House Conference Summary Statement

T HE TASKS OF WAR, OF PEACE, of nation-planning must be shared by men and women alike. No part of the citizenry holds a greater stake in the democratic way of life, in plans for the reconstruction of an ordered world, than the women of the nation. Women have been called upon to share the burdens of war, to stand side by side with men

White House Conference Summary Statement. Charl Ormond Williams Papers, Box 7, Folder White House Conference, "How Women May Share in Post-War Policy Making," Memos and Records, Manuscript Division, Library of Congress, Washington, DC.

on the production line and to complement men in the fighting ser-
vices. So women must share in the building of a post-war world fit for
all citizens—men and women—to live and work in freely side by side.

Eloquent appeals to women to prepare themselves to render the
greatest possible service to society in national and international coun-
cils have recently been uttered by women leaders here and abroad.
They have urged that women should participate in any decisions for
the future, now or later.

So far, very few women have shared in the councils of national and
international policy-making bodies. Yet, there are women in every coun-
try who are qualified and ready to contribute. We note with encour-
agement the recent appointments of women as United States delegates
to the Food Conference, the United Nations Relief and Rehabilitation
Conference, the Conference of Allied Ministers of Education in Lon-
don, and the International Labor Organization Conference.

Current developments make this the crucial moment for women
and women's organizations to press for the inclusion of qualified
women as United States delegates and advisers to international con-
ferences and as members of national policy-making bodies. Therefore,
we, a group of 200 representative women, meeting in Washington at
the White House on June 14, 1944, express our conviction that women
should take definite action now in order to implement the significant
statements of women leaders the world around, to see that women have
a share in national and international planning, to see that women's
proper contributions are made "in giving all the world a chance to
envision something a little better than has been known before."

*We therefore resolve that we will take every step within our power
to further the active participation of qualified women in positions of
responsibility pertaining to the conduct of public affairs, national and
international.*

22 Telegram, Charl Ormond Williams to Carrie Chapman Catt

Mrs. Carrie Chapman Catt
120 Paine Ave.
New Rochelle, N.Y.

Telegram, Charl Ormond Williams to Carrie Chapman Catt, June 14, 1944.
Charl Ormond Williams Papers, Box 7, Folder, White House Conference, "How

THE 200 WOMEN AT THE White House Conference on "How Women May Share in Post-War Policy Making" by unanimous vote deputed me to express their abiding appreciation to you for the dynamic forces you set going for the advancement of women and for the great help you have been to their generation and to send you best wishes for a speedy convalescence.

<div align="right">

Charl O. Williams
Chairman

</div>

Women May Share in Post-War Policy Making," Invitations, Manuscript Division, Library of Congress, Washington, DC.

23 Letter, Emily Hickman to CPWPWP Fellow Member

Dear Fellow Member:

THERE ARE THREE MATTERS which I wish to call to your attention:

First: Legislation is under consideration to provide two additional Assistant Secretaries of State, making a total of six. One of these should be a woman. The Committee is suggesting the appointment of Anne O'Hare McCormick. Data concerning Mrs. McCormick is enclosed. Will you please write at once to President Roosevelt and to Secretary [of State Cordell] Hull urging her appointment as an Assistant Secretary of State as soon as the new Assistant Secretaries are provided for.

Second: The Inter-American Technical Economic Conference has been postponed until next year. Nominations you have sent to Mrs. James Irwin, 5805 Chevy Chase Parkway, N.W., Washington 15, D.C., will be held until nearer that time. The general International Economic Conference has not been postponed. If you have not sent your nominations for delegates to that Conference, will you please do so at once.

Third: On June 14th there was held at the White House an all-day conference on the subject of the appointment of women to governmental commissions and boards dealing with the planning of policy

Letter, Emily Hickman to CPWPWP Fellow Member, June 29, 1944. Records of the National Council of Negro Women, Series 5, Box 28, Folder 414, Post War Planning Committee of NCNW, 1944 June–December. National Park Service, Mary McLeod Bethune Council House National Historic Site, Washington, DC.

for the post war world. There were representatives of seventy-five national women's organizations present with delegates from all sections of the country. The Sponsoring Committee was composed of Miss Charl Williams, Field Secretary of the National Education Association; Dr. Kathryn McHale of the American Association of University Women; Dr. Minnie Maffett, President of the National Association of University Women; and Mrs. La Fell Dickinson, President of the General Federation of Women's Clubs. The Conference decided to compile a roster of qualified women, circulating blanks to be filled in for the purpose.

The Committee on the Participation of Women is cooperating in this by asking each of its members to fill in ten blanks with names and achievements of highly qualified women in different fields. We are asking that you fill these blanks in duplicate, returning them all to the office of Miss Helen Raebeck in July.

You will all be glad to know that Dr. Mabel Newcomer has been appointed to the delegation of the United States at the International Monetary Conference. Dr. Newcomer was one of three women whom we as members of the Committee on Participation of Women in Post War Planning endorsed to the President and Secretary Hull as well qualified for this appointment.

The work of the Committee grows steadily. I think the importance of the work also grows. The Committee can be effective only as the members painstakingly answer the calls upon them. We are all busy, but we all believe this effort should be made. Therefore, we must each do our share. Some of you sent me copies of the supporting letters you wrote the President and Secretary of State. I appreciate that. You will understand if I do not acknowledge them.

Faithfully,
Emily Hickman, Chairman

Emily Hickman, founder and chair of the Committee on the Participation of Women in Post War Planning, led an aggressive campaign to guarantee the proper representation of women on postwar planning councils. *Courtesy Division of Rare and Manuscript Collections, Cornell University Library, Ithaca, New York*

The Aframerican

WOMAN'S JOURNAL

Reveille For Humanity—Justice—Freedom

ANNUAL WORKSHOP—CONVENTION ISSUE
1943

Throughout the wartime years, the *Aframerican Woman's Journal*, the official journal of the National Council of Negro Women, featured articles that urged women to assume a leadership role in the creation of a postwar world that would provide equal rights and responsibilities for all, regardless of gender, race, ethnicity, or social class. *Courtesy National Park Service, Mary McLeod Bethune Council House National Historic Site, Washington, DC*

R O S T E R O F Q U A L I F I E D W O M E N

prepared under a resolution of

T h e W h i t e H o u s e C o n f e r e n c e

on

"How Women May Share in Post-War Policy-Making"

June 14, 1944

by

The Continuation Committee:

Miss Charl Ormond Williams, Past President and Director of Field
 Service, National Education Association — Chairman
Dr. Minnie L. Maffett, Past President, National Federation of
 Business and Professional Women's Clubs, Inc.
Dr. Kathryn McHale, General Director, American Association of
 University Women
Mrs. Lucy J. Dickinson, President, General Federation of Women's
 Clubs
Miss Elizabeth Christman, Executive Secretary, National Women's
 Trade Union League of America
Mrs. Charles W. Sewell, Administrative Director, The Associated
 Women of the American Farm Bureau Federation

and presented to

The President of the United States

January 3, 1945

With the support of First Lady Eleanor Roosevelt, a national White House Conference, "How Women May Share in Post-War Policy Making," was held on June 14, 1944. One important outcome of the Conference was the preparation of a Roster of 260 women qualified to serve on postwar planning conferences. Charl Ormond Williams Papers, Box 8, Folder, White House Conference, "How Women May Share in Post-War Policy Making," Roster, Manuscript Division, Library of Congress, Washington, DC. *Courtesy Library of Congress, Washington, DC*

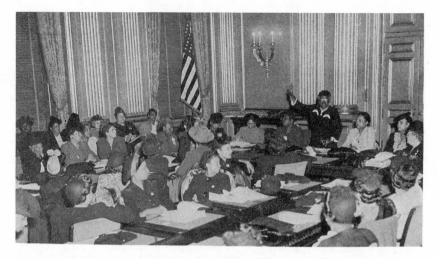

Mary McLeod Bethune, founder and president of the National Council of Negro Women, presides over the NCNW's 1944 Annual Workshop, "Wartime Planning and Post-War Security." *Courtesy National Park Service, Mary McLeod Bethune Council House National Historic Site, Washington, DC*

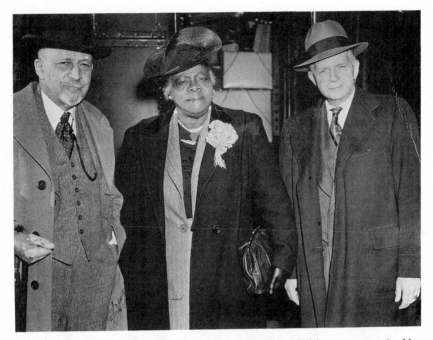

W. E. B. Du Bois, Mary McLeod Bethune, and Walter White represent the National Association for the Advancement of Colored People at the April 1945 United Nations Conference in San Francisco. Although at first rebuffed in her efforts to serve as a consultant at the UN Conference, Bethune eventually found her way to San Francisco as a representative of the NAACP. *Courtesy National Park Service, Mary McLeod Bethune Council House National Historic Site, Washington, DC*

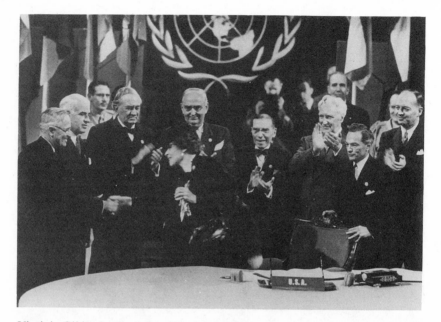

Virginia Gildersleeve, dean of Barnard College, was one of the eight U.S. delegates appointed to the UN Conference. She is pictured here shortly after signing the UN Charter, June 26, 1945. *Courtesy Barnard College Archives, Columbia University, New York, New York*

VII White House Conference: Press Coverage

Newspapers and journals throughout the United States devoted significant time and space to the White House Conference. Many women who read these reports sent clippings to Charl Williams. Documents 24 through 28 represent accounts from mainstream urban newspapers, religious journals, regional publications, and reports from professional women's associations, all of which are located in the Charl Ormond Williams Papers at the Library of Congress.

24 Women Ask Place in Peace Councils

WASHINGTON, JUNE 14—Two hundred women, representing seventy-five organizations, voted at a White House conference today on "How Women May Share in Post-War Policy-Making" that "we will take every step within our power to further the active participation of qualified women in positions of responsibility pertaining to the conduct of public affairs, national and international."

They adopted a resolution saying that women had been called upon to share the burdens of war, and adding:

"Women must share in the building of a post-war world fit for all citizens to live in and work freely side by side. Current developments make this the crucial moment to press for the inclusion of qualified women as United States delegates and advisers to international conferences and as members of national policy-making bodies."

"Women Ask Place in Peace Councils," *New York Times*, June 15, 1944. Reprinted by permission of the *New York Times*.

Mrs. Roosevelt Hails Move

Mrs. Roosevelt, closing the session, called this move a "first step in setting our house in order that we may be able to do the things that need to be done."

"No matter what we do here in the United States, it is not enough," the President's wife said. "If we hope to build peace in the future, we have to do it in cooperation with other nations. We have to know the women of every part of the world and work with them in a spirit of friendliness and of understanding of other people's problems. We have to include all groups."

The conference adopted a blank form which women would fill out in recommending other women for appointment as official delegates, official advisers, technical advisers or staff members to international conferences or as members of national policy-making bodies.

Seventeen women have thus far been appointed to peace-building international conferences. Most of these women were present and all six who had been actual delegates reported their conference contributions. They were Josephine Schain, Hot Springs Food Conference of May, 1943; Ellen S. Woodward and Elizabeth A. Conkey, United Nations Relief and Rehabilitation Administration, Atlantic City, November, 1943; C. Mildred Thompson, Allied Ministers of Education, London, April, 1944; and Secretary Frances Perkins and Representative Margaret Chase Smith, International Labor [Organization] Conference in Philadelphia in April.

Monetary Experts Named

The names of three women believed to be qualified to take part in the coming international monetary conference have been submitted to the Department of State, and it was reported here today that one of these had been selected.

A continuing committee was appointed to receive and compile names for the Federal departments to use in making up a roster of women recommended to help in post-war building.

G. Howland Shaw, assistant secretary of state, told the women that groups of private citizens could render much assistance by assembling data on technically qualified persons. He said those in government who make appointments "are concerned only with the competence of the potential servant and representative."

To this Ruth Bryan Owen Rohde, former Minister to Denmark, took exception, saying:

"If that were more than a theory we would not be here today—it is like outlawry of war—not worth much unless implemented."

Mrs. Conkey, the UNRRA delegate, said she thought no woman was better qualified than Mrs. Roosevelt to sit at the peace table, but the chairman, having received a note from Mrs. Roosevelt, said such remarks were outside the field being considered at the meeting.

25 Postwar Role Demanded at White House Parley

"IT'S A MAJOR TRAGEDY THAT WOMEN have not been drafted into war service," Helen Rogers (Mrs. Ogden) Reid, vice president of the *New York Herald-Tribune* Forum, declared when 200 outstanding feminine leaders gathered at the White House yesterday to muster forces for women's participation in postwar councils and to draw up a roster of qualified women.

"There probably won't be such a service act because there's too much feeling that the war is won—yet it's hardly begun," explained Mrs. Reid. She did, however, ask the women to register a protest for not having been drafted and to issue a strong call for volunteers. She also suggested that women experts be drafted after the war to share with men in rebuilding the world.

The speaker said that women had been content with subordinate work too long and blamed it on their own lack of interest. She called upon them to make their force and power felt in local, national as well as international fields.

Discussing opportunities for women in the State Department, and how they may share in postwar policy-making, G. Howland Shaw, Assistant Secretary of State, pointed out that jobs would be filled on citizens' qualifications, rather than upon sex.

Mrs. Rohde Disagrees

Dynamic Mrs. Ruth Bryan Rohde, former United States Minister to Denmark, took exception to Mr. Shaw's statement that sex doesn't enter into appointments. "If this were more than theory, that citizens are

Genevieve Reynolds, "Postwar Role Demanded at White House Parley," *Washington Post*, June 15, 1944. © 1944 by the *Washington Post*. Reprinted with permission.

chosen on their qualifications," she asserted, "we wouldn't need to be here now."

She pointed out that women have special assets in certain fields that should be emphasized to obtain representation on important policy-forming committees and peace councils. Specifically, she referred to the welfare, educational and rehabilitation phases of the postwar world.

"Some of the most vital postwar problems deal with just these matters," she said, "homes to be rebuilt, children to be clothed and fed. To omit women from leadership in these phases of postwar planning would be uneconomical and impractical."

The conference was opened by Mrs. Roosevelt at 10 A.M. yesterday in the East Room of the White House. Judge Lucy Somerville Howorth, lawyer, former Mississippi legislator, now a member of the legal staff, U.S. Veterans Administration, struck the keynote of the conference in her opening address when she stated, "women, organized and unorganized, can and should rally public support for women appointed to national and international policy-making positions."

Calls for Action

"Able women have been appointed delegates to international conferences held already," she said. "Mrs. Roosevelt urges women to take responsibility, so the women of this conference should take definite action in planning their full responsibility in world affairs. These times demand that they accept responsibility of rallying behind suitable women without fear of causing disunity."

Judge Howorth suggested the following procedure for securing appointments: 1, submission of names of qualified persons; 2, convincing the appointive authority that the person can do the job; 3, public support for the applicant.

Miss Josephine Schain, delegate to the United Nations Conference on Food and Agriculture, explained the function of the food conference and the part women played on committees.

"If women want it and are willing to organize and work for it," said Miss Schain, "they have a chance to participate in postwar parleys."

Secretary of Labor Frances Perkins, another speaker at the morning session, pointed out that "American women today do not make their claims to positions of responsibility and trust because they are women. They will be used only as they are patriotic, trustworthy, responsible citizens of demonstrated ability."

As an important example of women's contribution to making the peace, the Secretary cited the recent conference of the International

Labor Organization at Philadelphia, where 16 women were full members.

Ellen S. Woodward, member of the Social Security Board, adviser to USA member, Council of UNRRA, called for greater unity of purpose among women's organizations.

Representative Margaret Chase Smith of Maine is another who called upon women to stick together to make their force felt.

Other speakers included the dean of Vassar College, C. Mildred Thompson, delegate to the Conference of Allied Ministers of Education; and Elizabeth A. Conkey, member, Board of Commissioners, Cook County, Ill., and adviser to USA member, Council of UNRRA conference in Atlantic City.

Miss Charl Ormond Williams presided and introduced speakers. Mrs. La Fell Dickinson, president of the General Federation of Women's Clubs, offered a resolution of appreciation to the President and Mrs. Roosevelt for their cooperation and interest in the advancement of women.

Others participating in the forum included: Representative [Mary T.] Norton; Miss Katharine F. Lenroot, chief of the Women's Bureau; Miss Minnie Maffett, president of the Business and Professional Women's Clubs.

The President of the United States, members of his Cabinet and five independent agencies and establishments sent observers to this conference.

Observers representing the President were Judge Samuel I. Rosenman, special counsel to the President; and Jonathan W. Daniel, administrative assistant to the President.

26 A Preferred List of Women

ONE REASON WOMEN HAVE NOT MADE more rapid progress in public life is that too often they don't stick together. Many women don't trust members of their own sex to hold office, even when they have the qualifications.

Mary Hornaday, "A Preferred List of Women," *Christian Science Monitor*, June 14, 1944. © 1944 by The Christian Science Publishing Society. For permission to reprint, fax your request to 617/450-2031 or e-mail to copyrt@csps.com. All rights reserved. Reproduced with permission.

Many women talk vaguely about the desirability of women at the peace table when they haven't been willing to back women for policy-making jobs at home where women can get experience in thinking in terms of the public good.

Today at the White House an unusual and history-making meeting took place. With the President's wife as hostess, 200 women, members of the 75 largest and oldest organizations of women in the United States, came together in an effort to get more women on national and international policy-making boards.

The women didn't just talk. Each carried away a blank form on which she is to list women she knows [who] would make valuable contributions in such jobs. This roster will be made available to the White House, State Department, and all Government agencies to select from when they have a policy-making job to fill.

President Roosevelt has heard about the scheme from his wife and assigned two of his assistants, Judge Samuel I. Rosenman and Jonathan W. Daniels, to attend.

The invitations that went out signed by Charl Ormond Williams, Director of Field Service for the National Education Association and former President of the National Federation of Business and Professional Women, billed the meeting as "an historic milestone in women's contribution to society."

How did all this come about? As one who in this column has been critical of the personal type of influence wielded by Mrs. Roosevelt in the selection of women who have represented the United States at international conferences to date, it is a pleasure to point out that the inspiration for this general meeting came indirectly from the President's wife, and she has not only cooperated but pushed wholeheartedly the plan which will mean that women will be chosen not necessarily from Democratic ranks nor from among her Hyde Park neighbors in the future.

What happened was this. Laid up with a fractured ankle, Miss Williams read some of Mrs. Roosevelt's writings on women's participation in the peace. She dropped a note to the President's wife, asking if the women's organizations could be of help in furthering the appointment of women to the various international conferences at which the peace is now being written. The two agreed that an exploratory committee should look into the subject, so Miss Williams called two of her friends, Miss Minnie L. Maffett, president of the National Federation of Business and Professional Women's Clubs, and Miss Kathryn McHale, director of the American Association of University Women. Together they prepared a list of women who met at the White House for a luncheon on May 11.

After they had eaten, Mrs. Roosevelt went around the table asking the women's views on how to proceed. They were unanimous in their conviction that the time has come to bestir themselves and decided that the most practical contribution they could make would be the formulation of a roster like that started at the White House today.

The women whose names will make the roster will not necessarily belong to any organization, but because the groups invited to the conference do have branches all over the country, they are in a position to note the work of women locally.

Naturally there will be some organization politics involved. Members of the General Federation of Women's Clubs at their recent convention, for instance, put forth their outgoing president, Mrs. Sara Whitehurst, as their candidate for the peace table.

The movement has already grown to proportions, Miss Williams says, she never dreamed of. Just the same, she has hopes that it may sow the seeds of a broad new awakening of American womanhood resulting in not only women at international conferences but in greater feminine participation in the elections, in local conferences on housing, child welfare, and other social subjects and in every phase of public life.

This may be a man's world, but, as Miss Williams and her friends figure, [at] this moment it is a pretty dark one into which women need not be timid about shining their light.

27 White House Conclave Seeks to Put Women at Peace Table

TWO HUNDRED WOMEN, representing millions throughout the country, did not talk "peace" when they held a conference at the White House Wednesday. Instead, they took the importance of peace for granted as they discussed "how women may share in postwar policymaking." At the beginning, the chairman, Miss Charl Ormond Williams of the National Education Association, explained that the conference had one object only—the inclusion of qualified women as United States delegates and advisors to international conferences and as members of national policy-making bodies.

Elinor Pillsbury, "White House Conclave Seeks to Put Women at Peace Table," *Oregon Journal*, June 15, 1944. © 1945 by the *Oregon Journal*. All rights reserved. Reprinted with permission.

The session was opened and closed by Mrs. Franklin D. Roosevelt, who declared that "the service we can render must always come first" with women and that recognition for service should come second.

Ex-Ambassador Speaks

After hearing the morning program dealing with "women's responsibility in world affairs," and "women's experiences on recent international conferences," Mrs. Ruth Bryan Rohde, former ambassador to Denmark, who was among the afternoon speakers, said:

"If we can see this thing in proportion, we are going to give the government a chance to have qualified women in commission after commission. If it were more than a theory that qualified women are given such opportunities, we would not need to be here today.

"The ideas presented have been so practical, so easily translatable into action, and so welcome, that this is a significant occasion. It will be an historic occasion if we choose to make it so. I believe women belong in the councils of government where war and peace are to be discussed among the nations."

Mrs. Ellen S. Woodward, a member of the Social Security Board, said in referring to recent international councils which have included women:

"We have already established a beachhead. Now we must rally our forces to the appointment of more women to national and international conferences. Here we are, a group of American women, meeting in the White House, because we believe that women are ready and able to assume the responsibilities we are asking for."

Called "New Humanism"

The conference was called "a meeting in behalf of the new humanism" by Judge Lucy Howorth, member of the legal staff of the Veterans Administration, who pointed out that women should "push their way to policy-making positions," as it becomes clear that a series of international technical conferences will be necessary to put together the fragments of a broken world. "Women must step forward," she said, "and persist in sharing in policy-making."

The necessity for women in such places is far greater than any reasons of self-interest, it was asserted by Mrs. Margaret Chase Smith, Congresswoman from Maine, who stated: "A roster of qualified women, as proposed by this conference, eliminates any excuses by appointing officers that they don't know where to go to find competent women. Furthermore, we must not overlook that if women are appointed who

are not qualified, they forfeit their opportunities and also discourage other women."

Delegates' responsibilities were stressed by Secretary Frances Perkins who said women must study the "technique of international conferences."

Declaring that American women have demonstrated their ability as well as their patriotism, she said: "They must serve without self-consciousness and with humility in all negotiations," adding that "to live according to international agreement is of great importance."

Want Definite Action

The summary statement adopted at the conference expressed the "conviction that women should take definite action now to implement the significant statements of women leaders the world around, to see that women have a share in national and international planning."

28 Conference on Women's Share in Post-War Planning

ON JUNE 14 THIS ASSOCIATION [the American Association of Medical Social Workers] took part in a conference at the White House to discuss women's share in post-war planning. The outgoing president, Miss Bartlett, represented the Association at the meeting. The conference was called by the National Education Association, the General Federation of Business and Professional Women's Clubs, and the American Association of University Women, with the interest and support of Mrs. Eleanor Roosevelt. About 200 women representing seventy-five organizations attended. The presiding officer was Miss Charl Ormond Williams of the National Education Association. Women who had participated in recent international commissions told about their experience, while other prominent women in Congress and the diplomatic service also spoke. Mrs. Roosevelt gave an opening and closing address and participated throughout the discussion.

The purpose of the conference was to stress the contribution that women might make to post-war planning. So far, very few women have shared in the councils of national and international policy-making

"Conference on Women's Share in Post-War Planning," *American Association of Medical Social Workers* (September 1944).

bodies, yet there are women in every country who are qualified and ready to contribute. Current developments make this the crucial moment for women and women's organizations to press for the inclusion of qualified women as United States delegates and as members of national policy-making bodies.

The participating organizations passed the following resolution at the end of the conference: "We resolve that we will take every step within our power to further the active participation of qualified women in positions of responsibility pertaining to the conduct of public affairs, national and international." As a first step toward this objective, organizations were asked to send to Miss Williams at the National Education Association in Washington suggested names of women qualified as experts to participate in such planning.

There is to be no formal organization to carry on this program but it is hoped that as a result of the White House meeting the participating organizations will feel a greater interest in women's responsibility in world affairs. The national office of this Association will welcome any suggestions from our members and local groups as to ways in which our professional group might appropriately further the objectives of this conference.

VIII Regional "White House" Conferences

The enthusiasm generated by the June 14, 1944, White House Conference provided the impetus for conferences at the state and regional levels on the participation of women in local, state, regional, national, and international postwar planning councils. Documents 29 and 30 provide information about a Texas "White House" Conference held in Austin on September 7, 1944. Document 31 is a September 29, 1944, memorandum from the American Association of University Women (AAUW) urging state AAUW affiliates to organize "White House" conferences modeled after the Washington and Texas meetings. Document 32 is a report of a South Carolina "White House" Conference, published in the March 1945 issue of *Independent Woman*. Documents 33–35 contain information about a large Midwestern conference, "Women's Share in Postwar Planning," attended by three hundred delegates at the Palmer House in Chicago on February 22, 1945.

29 Texas "White House" Conference Report

T HE WASHINGTON WHITE HOUSE CONFERENCE, held on June 14, 1944, was the inspiration and model for a Texas "White House Conference," held in the chamber of the House of Representatives, in Austin, September 7.

An exploratory meeting was held the middle of August, with eleven organizations represented by their state presidents or representatives, to determine the feasibility of a conference, the object of which would be to consider How Women May Share in State Government. The plan

Texas "White House" Conference Report. Charl Ormond Williams Papers, Box 8, Folder, White House Conference, "How Women May Share in Post-War Policy Making," Post Conference Materials and Correspondence, Manuscript Division, Library of Congress, Washington, DC.

was approved and an arrangements committee appointed, consisting of the president of the Texas Federation of Business and Professional Women's Clubs, the president of the Texas Congress of Parents and Teachers, the president of the Texas Federation of Women's Clubs, the immediate past president of the National Federation of Business and Professional Women's Clubs, and Judge Sarah T. Hughes, national chairman, Committee on Economic and Legal Status of Women, AAUW.

Invitations to the Texas White House Conference were sent to about twenty-five women's organizations, to individual women, and to state officials. More than two hundred women from all parts of the state were present when the conference gathered. State officials and the press were likewise well represented.

Dr. Mattie Lloyd Wooten, who is chairman of the Committee on Economic and Legal Status of Women of the Texas Division, AAUW, as well as president of the Texas Federation of Business and Professional Women's Clubs, opened and closed the meeting, which was presided over by Judge Hughes. The program followed the plan of the White House Conference, but was on the state rather than the national level. The [Texas] Secretary of State, Sidney Latham, welcomed the members of the conference and Dr. Maffett gave the keynote address on Women's Responsibility in Government.

The rest of the morning session was devoted to Women's Experience in Government; women who were or had been in public office were the speakers. They were a former Secretary of State, former State Superintendent of Public Instruction, two former Regents of state colleges, a member of a local school board, and a State Representative. Each discussed how she was elected or appointed, how she was received by her colleagues and the public, and what she accomplished in office.

In the afternoon the Future of Women in State Government was discussed by Dr. Homer P. Rainey, president of Texas University; Dr. Minnie Fisher Cunningham, candidate for governor in the recent Texas Democratic primary election; and Dr. Robert B. Sutherland, Director of the Hogg Foundation. Following the speaking program there was discussion from the floor.

In the business session, which concluded the conference, a summary statement was first adopted. It emphasized the past contribution of women in state government, the need for the government's making full use of all its resources, and the failure of officials in the past to fully utilize the abilities of women. In the resolving clause, expression was given to the desire of women to have a greater share in shaping the policies of the Texas State Government in order that the full use might be made of the woman power of the state. Action was likewise

pledged to take every step to further the active participation of qualified women in positions of responsibility pertaining to the conduct of public affairs, state and local.

The whole tone of this conference on the part of speakers and participants was not one of criticism, but of the need for making use of all the state's resources and the responsibility of women to participate in government policy-making.

Following the summary statement the conference adopted a blank form to be used in recommending qualified women for appointive positions in the Texas State Government.

Attached to the blank form was a list of the present appointive boards with the number and terms of members. A continuation committee, consisting of the women who composed the arrangements committee, was appointed, whose duty it will be to compile the list of qualified women and to present it to the Governor. Terms of many board members expire in January 1945, and the plan is to have the list compiled by October 15 and presented to the Governor shortly afterwards. At the present time, with more than fifty appointive boards, there are women on less than one third. Among the most important having no women are the Board of Education, the boards of two colleges, the Prison Board, the Board of Health, and the Board of Public Welfare.

In appraising the conference there is no doubt that September 7, 1944, will go down in Texas history as a milestone in the active participation of women in state government. With so many qualified women in the state and so few being appointed, the need for such a conference to spotlight women—their abilities and responsibilities—was apparent. With the compilation of the best of qualified women, no longer can appointing officials in Texas say they did not know any women to appoint.

Sarah T. Hughes
AAUW National Chairman, Committee
on Economic and Legal Status of Women

30 Texas "White House" Summary Statement

S INCE DECEMBER 7, 1941, women have been called upon in increasing numbers to share the burdens of war, to stand side by side with

Texas "White House" Summary Statement. Charl Ormond Williams Papers, Box 8, Folder, White House Conference, "How Women May Share in Post-War Policy Making," Post Conference Materials and Correspondence, Manuscript Division, Library of Congress, Washington, DC.

men on the production line and to serve in essential capacities in the military branches.

Occasionally, in the past, women have served on state policy-making boards and in appointive offices. Always, when appointed on their qualifications, they have served with distinction and made valuable contributions to the policies of the office.

So far, few women have had the opportunity to use their talents and abilities for the welfare of their communities and state in appointive governmental capacities. Yet there are many women who are qualified through native ability, education and experience to make a real contribution to their country.

Today, with the end of the war almost in sight, the problems of the peace loom large. The returning service man and woman, the industrial war worker, youth in school and coming of age, are the responsibility of women as well as men. In these critical times government should make full use of all its resources. Women as well as men are ready and willing to contribute their services to their state.

Therefore, we, a group of representative Texas women, meeting in Austin on September 7, 1944, wish to give public expression to the desire of women to have a greater share in shaping the policies of the Texas state government, in order that full use may be made of the womanpower of the state.

And we therefore resolve to take every step within our power to further the active participation of qualified women in positions of responsibility pertaining to the conduct of public affairs, state and local.

31 Memorandum, American Association of University Women

TO STATE PRESIDENTS AND TO STATE chairmen on economic and legal status of women:

On September 14, the AAUW national Committee on Economic and Legal Status of Women, meeting in Washington, heard the Chairman, Judge Sarah T. Hughes of Dallas, Texas, describe the Texas "White

Memorandum, American Association of University Women, September 29, 1944. Charl Ormond Williams Papers, Box 8, Folder, White House Conference, "How Women May Share in Post-War Policy Making," Post Conference Materials and Correspondence, Manuscript Division, Library of Congress, Washington, DC.

House" Conference on How Women May Share in State Government held on September 7. Judge Hughes had been largely responsible for initiating the conference and presided during the sessions.

Impressed by the success of the conference and by the enthusiasm with which it was met by women in the state, the national Committee recommended unanimously that AAUW state chairmen in other states be urged to initiate similar state "White House" Conferences. Judge Hughes reported that she received letters from women all over Texas expressing keen interest and saying that the time was long overdue for a conference of this kind.

We are therefore transmitting the recommendation to you in this memorandum in order that you may consider the suggestion as it might be put into effect in your own state. Enclosed you will find papers showing in detail how the Texas conference was organized. And information on the national White House Conference held in Washington on June 14, which may be taken as the original pattern for state conferences, is given in the Summer 1944 Workshop *Journal* (pp. 195–198, 247) and in the August 21, 1944, *General Director's Letter*. A news release based upon the national Committee's recommendations, including news of the Texas conference, is being mailed to all branches at this time.

> Yours very sincerely,
> Frances Valiant Speek (Mrs. P. A.)
> Secretary to Committee on Economic and
> Legal Status of Women

Copies to:
National Board
National Committee on Status of Women
National Committee on Social Studies
State Chairman on Social Studies

32 South Carolina Holds Its "White House" Conference

S ECOND OF THE STATES TO hold a White House Conference at the local level is South Carolina.

"South Carolina Holds Its 'White House' Conference," *Independent Woman* (March 1945). Reprinted by permission of Business and Professional Women/ USA.

Called together by the South Carolina Federation of Business and Professional Women's Clubs and the South Carolina Division of the American Association of University Women, some one hundred representatives of women's organizations throughout the state gathered in January [1945] at the Jefferson Hotel in Columbia to formulate plans for the preparation of lists of women qualified to hold policy-making posts on state and local boards.

From its inception, the undertaking had the cordial support of the governor, other state and local officials, and numerous citizens prominent in state and local affairs, many of whom were present, and some of whom spoke at the meeting.

After greeting the delegates to the conference, Mrs. Joe P. Lane, president of the South Carolina Federation of Women's Clubs, introduced Governor Ransome J. Williams, who got the discussion off to a favorable start by asserting that the participation of women is necessary to good government and that the help of women is now urgently needed.

Various speakers pointed out that at present the special abilities of women are not being adequately used in the local and state government. The general assembly, it was stated, is one hundred per cent masculine. Although the student body is forty-five per cent feminine, there is not a single woman on the board of trustees of the University of South Carolina. Although there are women prisoners in the state penitentiary, there are no women on the penitentiary board. There are just as many girls as boys in schools, yet there are few women on the district school boards. On county boards and commissions, there are only sixty-six women as compared with 534 men, and on city boards and commissions, twenty-five women as compared with 266 men.

At the end of the meeting a resolution was passed urging full use of womanpower in shaping the policies of the government of South Carolina. Each one of the organizations participating was asked to submit names of women qualified to serve in policy-making posts to their executive committees, which committees will, in turn, select the ten best qualified for submission to a continuing committee of the group which called the conference. This group will then prepare a list to place on file with government authorities.

The discussion at the morning session was led by Mary E. Frayser, chairman of the Committee on Education and Vocations of the South Carolina State Federation of Business and Professional Women's Clubs. At the luncheon which was held betweeen the morning and afternoon sessions, Faye Fuller, first vice president of the State Federation of Business and Professional Women's Clubs, presided in the place of Emma

Davis, president of the state federation, who was unable to be present, but sent a telegram of greeting. The discussion of the afternoon session, which was devoted to a consideration of the experiences of women in administrative and policy-making posts, was led by Mrs. T. C. Wooten, director of the South Carolina Children's Bureau. Women holding such posts who related their experiences were Mrs. Cordelia Schroder, personnel director of the Charleston Navy Yard; Ann Agnew of the South Carolina Department of Labor; Will Lou Gray, state supervisor of adult education; and Elizabeth Eldredge, a Columbia attorney.

33 Memorandum, Altrusa Club of Chicago

How Women May Share in Local, State, Regional, National and International Post-war Planning

Conference—November 20th, 8:00 P.M.
Place—The Cordon Club
410 S. Michigan Avenue, Chicago.

A CALL FOR INTER-CLUB, inter-group cooperation in the Midwest:
 The question of how best to serve, is stirring the hearts and minds of women leaders in every women's organization in the City of Chicago and the Midwest region.
 The answer does not lie in the hands of individuals or individual groups. We must have over-all planning.
 The Altrusa Club of Chicago, assisted by the Altrusa Clubs of Illinois, Wisconsin and Indiana, is sponsoring the bringing of Charl Ormond Williams to Chicago on November 20th, to advise women's organizations of this region on holding a Midwest Conference concerning women and post-war planning.
 Charl Ormond Williams, Director of Field Service, National Education Association of the United States, presided at the White House Conference held last June on How Women May Share in Post-War

Memorandum, Altrusa Club of Chicago, November 1944. Charl Ormond Williams Papers, Box 8, Folder, White House Conference, "How Women May Share in Post-War Policy Making," Post Conference Materials and Correspondence, Manuscript Division, Library of Congress, Washington, DC.

Policy-Making, and is chairman of the Continuing Committee. She has followed the activities of the several state and local conferences which have been held since that date. She will be with us to answer questions which are receiving the attention of practically every women's organization seeking the way to make woman-power most effective in meeting the great responsibilities of the peace which is to follow victory.

Elizabeth Conkey, member of the Board of Cook County Commissioners, who was the only woman from this district to attend the White House Conference, and who had previously served as adviser to the U.S.A. member of the Council of the U.N.R.R.A. at Atlantic City, in November, 1943, will be present at this Round Table.

Out of the Conference of November 20th, there will come a Continuing Committee which will stimulate, assist, guide and direct activities in the Midwest. With the cooperation of all women leaders in this community, plans will be carefully laid for a regional conference based upon the White House Conference, to which will be invited representatives of government—city, county, state, and nation—and representatives of women's groups in this territory.

34 Radio Interview, Charl Ormond Williams, *National Farm and Home Hour*

INTERVIEW ON *National Farm and Home Hour*, Monday, November 20th (77 stations on Blue Network—coast to coast) between Charl Ormond Williams and Kay Baxter:

Bradley [announcer]: Will there be a woman—or women—at the peace table? Two hundred women meeting at the White House in Washington last June say—yes—that the tasks of peace-planning must be shared by men and women alike. Kay Baxter's guest today is the woman who presided over the sessions of that now historic White House Conference, and who is chairman of the committee appointed to compile a

Radio Interview with Charl Ormond Williams, *National Farm and Home Hour*, November 20, 1944. Charl Ormond Williams Papers, Box 8, Folder, White House Conference, "How Women May Share in Post-War Policy Making," Post Conference Materials and Correspondence, Manuscript Division, Library of Congress, Washington, DC.

list of women who are qualified to serve on peacetime planning committees. She is Charl Ormond Williams, director of field service for the National Education Association of the United States. Kay, you officially welcome our distinguished guest.

Baxter: Charl Ormond Williams—we bid you welcome to the *National Farm and Home Hour*. It is a real privilege to have you with us.

Williams: Thank you. It is a privilege to be here.

Baxter: I understand that you are in Chicago to help organize a White House Conference for the women of the middlewest.

Williams: That's right, Miss Baxter. The Chicago Altrusa Club, a member club of Altrusa International, an organization of executive and professional women, is taking the lead in organizing all the major women's groups in the middlewest. I am here to act in an advisory capacity at the big inter-organization planning meeting being held in Chicago tonight.

Baxter: What will be accomplished through such a meeting?

Williams: Well, qualified women will be brought to the attention of government representatives and it is hoped that this action will result in their being given an important role in organizing the peace. As Mrs. Roosevelt said at the White House Conference, the heads of government agencies haven't known where to look for qualified women, and have no means for finding out who they may be.

Baxter: I wonder, Miss Williams, whether you could take a moment here to give us a brief review of the White House Conference— just to bring us up to date on this nation-wide effort to find a place on postwar planning committees for women leaders.

Williams: I'll be glad to. Last June, 200 women leaders were invited to attend a conference at the White House to determine how best to strengthen the participation of qualified women in international, national, and community postwar policy-making. They were invited by the heads of four organizations, which are: National Federation of Women's Clubs, American Association of University Women, General Federation of Women's Clubs and the National Education Association. Sessions were held all day on June 14th. Women leaders expressed their views on the part women should play in forming the peace. In the audience, paying careful attention to the proceedings, were representatives of the President, of the President's Cabinet, and of various agencies and establishments.

Baxter: Who were some of the women leaders who spoke?

Williams: Margaret Chase Smith, congresswoman from Maine; Helen Rogers Reid, vice-president of the *New York Herald-Tribune*, C. Mildred Thompson, dean of Vassar College; Frances Perkins,

Secretary of Labor; Elizabeth Conkey, from Chicago, member of the Cook County Board of Commissioners.

Baxter: Somehow the expression—peace table—conjures up a picture of a big round table with the heads of nations scowling at each other in deep thought.

Williams: (chuckle) That is a popular conception—or rather, misconception. There'll doubtless be much scowling—but there'll be many peace conferences at many so-called peace tables.

Baxter: Just how can women serve?

Williams: I'll answer that by quoting Ruth Bryan Rohde, former minister to Denmark. She said, at the White House Conference, "Women ought to be represented on all councils working toward international peace. All the problems to be solved are those related to woman's work; namely, getting folks back into the home, clothing the naked abroad, and feeding the starving."

Baxter: When you say qualified women—what qualifications do you have in mind?

Williams: There are women whose special vocations qualify them for service on peace-planning committees. Language specialists, medical technologists, top home economic women, leaders in education—in short, women who are extremely expert in the various fields essential to improved living will be considered.

Baxter: I suppose you already have thousands of names on file.

Williams: Organizations throughout the nation have been very cooperative in sending in names. The problem now, of course, is to see that action is taken on the names submitted. The inter-group meeting called by the Altrusa Club is a step in this direction, to see that middle-western women will serve.

Baxter: The main job then, as I see it, is to convince the men in charge of forming postwar planning committees that qualified women can intelligently share the load of peacetime planning.

Williams: That's a major goal to be achieved. And as we resolved at the close of the June White House Conference—we will take every step within our power to further the active participation of eligible women in positions of responsibility pertaining to the conduct of public affairs, national and international. Women can start in their own communities, organizing local, state and regional women's club groups. For it doesn't matter which group gets the credit. The important thing is to see that woman is given her rightful job in helping to set the world house to rights.

Baxter: I am certainly in accord, Miss Williams, and I want to thank you for bringing us this inspirational picture of what women are doing toward planning tomorrow's world.

35 Women Urged to Aid in Postwar Planning

WOMEN IN HOMES, SCHOOLS, CLUBS, industries and on the farm must assume greater responsibilities in the policies and economics of the world. This was the collective opinion of speakers representing the above classifications of women yesterday morning at the Women's Share in Postwar Planning Conference at the Palmer House [in Chicago]. If women do assume their share of administration there will be world co-operation and full employment.

These were the opinions of leaders. Stumbling blocks in securing these conditions are the reluctance on the part of great numbers of women to see beyond their homes and their failure to stand by other women.

The purposes of the conference, explained by Mrs. Stella Ford Walker, chairman, to the 300 women, members of some 40 different organizations, are "to secure participation of women in postwar planning bodies and to a greater extent in government." The policy of the continuing committee, expected to grow from yesterday's conference, is to survey government agencies for the number of women serving in them, to maintain a roster of qualified women who might serve and to secure their recognition.

List of Qualified

Mrs. La Fell Dickinson of Keene, N.H., president of the General Federation of Women's Clubs, reported that a list of 260 highly qualified women, selected by other women over the country, has been filed with the State Department for use in national and international appointments. This was the result of several White House Conferences of women's groups of which she was a member.

Today is possibly woman's last chance to work for humanity, according to this club leader. She urged that women work for the principles of the Dumbarton Oaks Conference. "Unless we have the kind of civilization it embodies, ours will die," she asserted.

Coming from a farm in Iowa, Mrs. Raymond Sayre, vice-president of the Associated Women of the American Farm Bureau, spoke for co-operation with other nations and an expanding national economy.

Neola Northam, "Women Urged to Aid in Postwar Planning," *Chicago Sun*, February 23, 1945. Reprinted by special permission of the *Chicago Sun-Times*, Inc. © 1999.

"Problems do not have gender," she asserted in her arguments that women will have to learn that they are involved in world problems. "The grime of the community can be dragged in on their clean floors unless they do community housecleaning," said Mrs. Sayre. Farm women have long been their husbands' partners in business. "As representatives of great productive roots of this country they should have their place in postwar planning," she asserted. Her organization approves of Dumbarton Oaks, Bretton Woods and international food agreements.

In postwar industry women should have their share of wage earners and supporters of families, according to Miss Mary V. White, president of the Illinois State Women's Trade Union League. She declared that 16 million of the more than 18 million women now employed will remain on the labor market of the country after the war. In order not to take jobs away from returning servicemen, Miss White advocates that enough jobs be provided to take care of all who wish to work. "The 60,000,000 goal is not just a figure—that number of jobs are needed," she asserted. She believes that women should share all responsibilities in industry—collective bargaining, support of minimum wage, maximum hour and equal pay laws and well-organized departments of labor.

Inequalities Condemned

Inequalities in the teaching profession were condemned by Mrs. Edna Siebert, vice-president of the Illinois Education Association. Discriminations and the general low pay of teachers are to blame for the shortage of teachers which left 10,000 schoolrooms without instruction this fall. "One out of every five teachers is paid less than $1,200 a year," she said.

Women legislators were represented at the afternoon session by Mrs. Lottie Holman O'Neill and Mrs. Bernice T. Van der Vries. The former asked that "women find out the truth of how countries get into war." Mrs. Van der Vries based her call for more women in government on the fact that in 1944 there were 573 men in policy-making agencies of the federal government and only eight women. "There is a great place for women to use their capabilities on local boards, in city and state government," asserted Mrs. Van der Vries.

The importance of healthy and wisely directed recreation for youth was stressed by Mrs. Vivian Carter Johnson of the Girl Scouts and Mrs. Gwen Heilman Griffin of the Camp Fire Girls.

Summing Up

Summing up the all-day session, Miss Harriet Vittum, head resident of Northwestern University Settlement, said that the boys in the service expect and deserve on their return better housing conditions, protection of childhood from exploitation and wider educational opportunities. "We must be ready for this armistice," said Miss Vittum.

By vote of attending club delegates, the Women's Share in Postwar Planning Committee was continued to further the purposes outlined by Mrs. Walker. She will remain as chairman and Miss Florence M. Meves will act as treasurer.

IX The Roster of
Qualified Women

In order to help ensure that qualified women be appointed to postwar policy positions, delegates to the June 14, 1944, White House Conference endorsed a suggestion made by Lucy Somerville Howorth in her keynote address that a roster of qualified women be compiled. A six-person Continuation Committee, headed by Charl Ormond Williams, was appointed to oversee the creation of the roster. Serving with Williams on the Continuation Committee were representatives of the NFBPWC, the American Association of University Women, the General Federation of Women's Clubs, the National Women's Trade Union League, and the Associated Women of the American Farm Bureau Federation.

Document 36 is a December 11, 1944, letter from Williams to the Continuation Committee that provides a detailed history of the Committee's activities. Documents 37–39 pertain to the presentation of the official "Roster of Qualified Women," which consisted of 260 names, to the Secretary of State in January 1945. The complete Roster, with names and positions, is located in the Charl Ormond Williams Papers, Manuscript Division, Library of Congress, Washington, DC. The announcement of the Roster to the public occurred on January 22, 1945, at Eleanor Roosevelt's press conference. The First Lady told reporters that "now no man can ever say he could not think of a woman qualified in a particular field. It is not that men do not want to use women on various commissions, but it is because they forget." Document 40 contains a January 23 *New York Herald-Tribune* report of this press conference.

36 Letter, Charl Ormond Williams to Continuation Committee

1201 Sixteenth Street, N.Y.
Washington, 6, D.C.
December 11, 1944

Dear Member of the Continuation Committee:

AT LONG, LONG LAST, I have a report to make to you concerning the one task left to us by the June 14 White House Conference on "How Women May Share in Post-War Policy-Making." At the request of the American Association of University Women, the time to receive the names for the Roster of Qualified Women was extended first to September 1, and then to October 1. Even if the time had not been extended, I could not have begun work on the Roster earlier than I did because of the October 3–5 White House Conference on Rural Education.

To date, about 750 names have been submitted from every corner of the nation. The idea of building this Roster caught the imagination of the women of the country and was received enthusiastically by the women of the press. How to cope with this problem was vexatious, to say the least, since no one of us on this committee had a qualified staff at our disposal which could be assigned to this task.

On two occasions during the fall, Dr. Maffett was in Washington, and she and I conferred at length as to procedure. She proposed to me—and later to you in a letter—that the organizations represented in the White House Conference be asked to contribute to a fund to be used to employ an expert with secretarial help to handle this Roster. Not having proposed this in the call to the Conference, or to the delegates who were present, I was reluctant to make this proposal to them at such a late date. We learn from experience, and all of us, I feel sure, will avoid such an error in judgment in any future undertaking of this kind.

Fortunately for all of us, a friend of the committee volunteered to study and classify the 750 names sent in to my office. Judge Annabel Matthews, a lawyer and formerly a member of the U.S. Board of Tax Appeals (not Tax Court) as well as a participant in two international

Letter, Charl Ormond Williams to Continuation Committee, December 11, 1944. Charl Ormond Williams Papers, Box 8, Folder, White House Conference, "How Women May Share in Post-War Policy Making," Post Conference Materials and Correspondence, Manuscript Division, Library of Congress, Washington, DC.

conferences, had just retired from government service and was ideally situated to undertake this important piece of work. About the middle of October, the members of our committee who were in Washington met with Miss Matthews and decided on the procedure to be followed. She and I conferred several times later on.

Soon after the June Conference adjourned, I received a letter from the National Roster of Scientific and Specialized Personnel of the War Manpower Commission, offering to help in any way possible in building our Roster. At my request, Miss Ann Taylor of this agency conferred with Miss Matthews and gave her several excellent suggestions. She volunteered to check our list with the National Roster and to give us the file numbers of any of our women on their list. The National Roster of the WMC has a file of more than twenty thousand women with extensive information concerning their preparation and experience. This offer made by Miss Taylor was exceedingly valuable and has now been carried out.

Soon after she began her work on the list, Miss Matthews conferred with Dr. Richard W. Morin, one of the observers sent to the June meeting by the State Department. He also gave some helpful advice.

After several weeks of study and work on the list, Miss Matthews had a typed list of names to submit to the full committee for their consideration. Accordingly, the available members of the committee met on November 27 and made final plans which in the main were as follows:

1. No names on the Roster of Qualified Women would be given to the press, though publicity would be given to the Roster as a whole.
2. The name, title, address, and field of work would be recorded for each person; also whether found in *Who's Who in America*; also file number if found in the file of the National Roster.
3. A copy of the Roster of Qualified Women would be submitted to President Roosevelt and to the State Department with a letter of transmittal to each by the chairman.
4. No copies of the list would be given out.

Miss Ann Taylor attended this meeting at my invitation and listened with great interest to Miss Matthews's report. When she heard that Mr. Morin had asked for names of women qualified in the field of commodities, Miss Taylor volunteered to "run the cards" in their extensive file—quite a piece of work. She produced nine names of women who specialize in sugar, rubber, synthetic rubber, petroleum, etc., as well as marketing. These names, now added to our list, increase considerably its usefulness.

After this second committee meeting, I called at the offices of the National Roster WMC and the State Department to find out the best form in which to submit our list of 259 and to learn what further use could be made of the approximately 470 names submitted to our committee but not included in our Roster. A typed, alphabetical list will be made for the President and the Secretary of State in accordance with points 2 and 3 decided by our committee.

The WMC Roster will be glad to receive all the names submitted to us to be "processed" for their file. After this work is completed, the entire list of questionnaires submitted to us will be deposited in the State Department for further information desired concerning any of the names either in our Roster, or omitted from it. The State Department also agreed that our Roster would be available to the other Cabinet officers or to the heads of the five independent agencies who sent observers to the June Conference. At the proper time, I shall send an appropriate letter to each of these officials.

The list of women to be submitted to the President and to the Secretary of State is now being typed in my office.

At the time of the June Conference, the four organizations listed below contributed $25.00 each for postage and incidental expenses incurred in holding this June conference:

The American Association of University Women
The General Federation of Women's Clubs
The National Federation of Business and Professional Women's Clubs, Inc.
The National Education Association

An account of the expenditure of this $100.00 fund to date, kept by my secretary, Mrs. Lucile Ellison, is submitted for your information. All other clerical work was contributed, without cost, by these organizations.

I am sorry that I cannot recount to the entire Conference our great indebtedness to Judge Matthews for her invaluable work on the Roster. She consented to do the work for us on one condition—that no publicity would be given to her part in this undertaking. We must and shall respect her wishes in that matter. There are others who also were very helpful in committee meetings and they, too, wish to remain anonymous:

Mrs. Frances Valiant Speek, Secretary of the Committee on Economic and Legal Status of Women, American Association of University Women
Judge Lucy Howorth, Member, Legal Staff, Veterans Administration

Mrs. James W. Irwin, Delegate from the National Board of the YWCA on the Women's Joint Congressional Committee

Dr. Esther Caukin Brunauer, Division of International Organization and Security, State Department, Washington, D.C.

When our work is finished, I shall write a letter of appreciation to each of them.

I have had opportunities to talk with individuals of the committee from time to time—all except Mrs. Sewell, with whom I conferred briefly only once. It would have been helpful if the members had been near enough for frequent meetings, but their busy lives, to say nothing of the expense for two of them, made these meetings inadvisable. However, we have proceeded according to their views as far as they have been made known to me—and through me to the members who could attend these meetings. If you do not concur in the procedures followed in building this Roster and in disposing of it, will you please phone or wire me immediately? For your further information, I should like to add that my name will not be included in the Roster, even though a number of people proposed it.

You do not need to be told that I shall be happy beyond words when this task is completed, and our committee goes out of existence. To have been associated with you in this historic enterprise has been a satisfying and memorable experience.

Yours sincerely,
Charl Ormond Williams

37 Letter, Charl Ormond Williams to the Honorable Edward R. Stettinius, Jr.

The Honorable Edward R. Stettinius, Jr.
The Secretary of State
Washington, D.C.

Dear Mr. Secretary:

FOR THE FIRST TIME IN HISTORY, 230 women from all parts of the country came to the White House on June 14, 1944, to take part in a

Letter, Charl Ormond Williams to the Honorable Edward R. Stettinius, Jr., January 17, 1945. Charl Ormond Williams Papers, Box 8, Folder, White House Conference, "How Women May Share in Post-War Policy Making," Post Conference Materials and Correspondence, Manuscript Division, Library of Congress, Washington, DC.

Conference on "How Women May Share in Post-War Policy-Making." This Conference was called by representatives of four of the leading national organizations of women and was inspired by a statement made six months previously by Mrs. Roosevelt that "women should serve on all commissions that are an outgrowth of this global war."

The influence of this conference has already been widespread. Similar conferences have been organized in cities, and plans are made for conferences on a state and regional basis. The immediate tangible result of that meeting was the creation by unanimous vote of a Continuation Committee whose duty was the preparation and compilation of a Roster of Qualified Women in various fields of activity, to be submitted to the President, to the Secretary of State, and other high governmental officials for their use when the appointment of such commissions is under consideration.

The idea of building this Roster caught the imagination of the women of the country and was received enthusiastically by the women of the press. During the past six months, the names and records of 730 women have been sent in from all parts of the country for study and analysis by the Continuation Committee, the members of which are:

Dr. Minnie L. Maffett, Past President, National Federation of Business and Professional Women's Clubs, Inc.

Dr. Kathryn McHale, General Director, American Association of University Women

Mrs. Lucy J. Dickinson, President, General Federation of Women's Clubs

Miss Elizabeth Christman, Executive Secretary, National Women's Trade Union League Of America

Mrs. Charles W. Sewell, Administrative Director, The Associated Women of the American Farm Bureau Federation

Miss Charl Ormond Williams, Past President and Director of Field Service, National Education Association—Chairman

The committee has had expert help in building this Roster of Qualified Women and wishes to acknowledge especially its indebtedness for assistance by officials in the State Department as well as the National Roster of Scientific and Specialized Personnel of the War Manpower Commission.

On behalf of this committee, I take pleasure in submitting to you the names of 260 women qualified to serve in many and varied fields such as international law and relations, the mathematical and social sciences, medicine, and education and the arts. Dozens of more specialized qualifications appear—examples: market analyst; plant pa-

thologist; specialist in rubber, in petroleum, in sugar; metallurgist; cellulose chemist; civil engineer; anthropologist; neural anatomist.

We appreciate the cooperation of the State Department in making this Roster of Qualified Women available to all members of the Cabinet and the heads of the five independent agencies who sent official observers to the June Conference. I think you will be interested to learn that all the questionnaires sent in to this committee will be reviewed by the WMC Roster for inclusion in their file of any names on our list that are registrable. When this study has been completed, the 730 questionnaires will be deposited with the State Department for further study and use.

We wish to record our appreciation of the interest you, and your predecessor, Secretary Hull, manifested in our Conference and of the support you gave to it by sending two of your executive assistants as observers. Your example was followed by every member of the President's Cabinet and the heads of five independent agencies who also were invited to send observers to this meeting.

It is the profound hope of the women who gathered at the White House upon invitation of Mrs. Roosevelt—and of many thousands throughout the country—that one or more qualified women, regardless of whether they are listed in this Roster, be appointed to serve on all commissions looking toward the establishment of peaceful relations in this war-torn world.

Yours sincerely,
Charl Ormond Williams
Chairman of Continuation Committee
of the June 14 White House Conference
on "How Women May Share
in Post-War Policy Making"

38 Press Release, Department of State

[Press Release] No. 58

THE DEPARTMENT OF STATE TODAY received from Miss Charl Ormond Williams, Chairman of the Continuation Committee of the White

Press Release, Department of State, January 22, 1945. Charl Ormond Williams Papers, Box 8, Folder, White House Conference, "How Women May Share in Post-War Policy Making," Post Conference Materials and Correspondence, Manuscript Division, Library of Congress, Washington, DC.

House Conference on "How Women May Share in Post-War Policy-Making," a roster of 260 American women qualified to serve in many fields of specialized activities. The roster is designed as a list which government departments and agencies may consult in the selection of qualified persons to serve on Government Commissions concerned with the re-establishment of a peaceful world.

The roster, which will be held available in the Department of State for consultation by all government authorities, was prepared by the Continuation Committee created at the White House Conference in June, 1944.

39 Letter, Acting Secretary of State Joseph C. Grew to Charl Ormond Williams

M y dear Miss Williams:

IT GIVES ME PLEASURE TO ACKNOWLEDGE the receipt of your letter of January 17, 1945 with its enclosure, the Roster of Qualified Women prepared by the Continuation Committee of the White House Conference on "How Women May Share in Post-War Policy-Making." The Roster represents a splendid and most useful undertaking. It will be filed in the Department of State and interested officers will be notified of its availability.

Following your suggestion, the Roster will be open to officials of the other Departments and Agencies of the Federal Government on their request. We shall also be glad to have for further study the questionnaires from which the Roster was compiled, as soon as you find it convenient to turn them over to the State Department.

At your Conference last June, former Assistant Secretary [G. Howland] Shaw pointed out that a considerable number of women, specialists in many fields, are serving as officers in the State Department. I believe that your Conference program took note also of the fact that women have been appointed members of United States delegations to almost every recent international conference. The Department is gratified that able women have been ready to represent the United States on these occasions.

Letter, Acting Secretary of State Joseph C. Grew to Charl Ormond Williams, January 31, 1945. Charl Ormond Williams Papers, Box 8, Folder, White House Conference, "How Women May Share in Post-War Policy Making," Post Conference Materials and Correspondence, Manuscript Division, Library of Congress, Washington, DC.

There will undoubtedly be conferences and commissions in the future at work on many matters of international concern. They will cover a wide range of interests and activities, and the Government will need to call on persons qualified in many different subjects. Thus, in seeking out women of special training and attainments and in making them known to the officials of the Government, the women's organizations have performed a valuable service. Please convey to the members of the Continuation Committee the Department's appreciation of the project and the cooperative spirit in which it has been carried through.

As of possible interest of the Committee, I am enclosing a copy of the statement about the Roster released to the press by the Department.

Sincerely yours,
Joseph C. Grew
Acting Secretary

Enclosure:
Press Release no. 58

40 260 Women Designated to Aid in Shaping Post-War Policies

THE CAMPAIGN FOR INCLUSION of qualified women on war and post-war commissions was advanced today by the presentation to the State Department of a roster of 260 women, but their names were withheld from the press by the continuation committee of the White House conference on how women may share in post-war policy making.

The fact that the roster, almost eight months in preparation, is now complete and is accessible to high officials of each government department was announced by Miss Charl O. Williams, chairman of the continuation committee, at Mrs. Roosevelt's press conference. Miss Williams is field service director of the National Education Association. President Roosevelt had given the roster advance billing at his Jan. 16 press conference by saying an announcement would be made on it today at his wife's press conference.

Ann Cottrell, "260 Women Designated to Aid in Shaping Post-War Policies," *New York Herald-Tribune*, January 23, 1945. Reprinted by permission of the *New York Times*.

When Miss Williams arrived at Mrs. Roosevelt's conference, she did not issue the names as expected, explaining that the committee had thought "a long, long time whether to make the names public, but decided not to do so" for their own reasons and on the advice of the State Department and the War Man-Power Commission.

She justified the decision by saying that the release of the names would have placed "too much emphasis on personalities and might start campaigns for certain women." She also claimed that "newspapers would not use 260 names" and "that it wouldn't be fair to use just a few names," adding that the list is yet incomplete as it is hoped that other names will be added from time to time.

Mrs. Roosevelt, who had nothing to say about the publication of the names, remarked that the value of the roster lay in the fact that "now no man can ever say he could not think of a woman qualified in a particular field." She said: "It is not that men do not want to use women on various commissions, but it is because they forget."

Mrs. Roosevelt seemed not the worse from her Saturday experience of standing in line shaking hands with more than 3,500 people attending the inaugural luncheon and reception [following the swearing-in of her husband for his fourth term as president]. She said that her right hand fared all right but that her feet hurt from standing so long.

The compilation of the roster from the names of 730 women submitted by individuals and women's clubs officials all over the country was inspired by Mrs. Roosevelt last May, Miss Williams recalled.

Mrs. Roosevelt met with thirteen women, representing national organizations, on May 11 and they decided to hold the June 14 White House conference on how women may share in post-war policy making, which was attended by 230 women. As a result of this conference a continuation committee was appointed, headed by Miss Williams.

X Dumbarton Oaks: No Women Need Apply

The pivotal Dumbarton Oaks deliberations, held in Washington, DC, from August 21 to October 7, 1944, led to the proposals that provided the outline for the United Nations organization. Much to the dismay, if not horror, of American women, they were excluded from the Dumbarton Oaks meetings. Congresswomen Clare Boothe Luce, Edith Nourse Rogers, and Margaret Chase Smith issued strong statements of condemnation to the press. Their statements were reported in a *New York Herald-Tribune* article on August 21, 1944. Document 41 reprints this article.

Prompted by the exclusion of women from Dumbarton Oaks, the *New York Herald-Tribune* produced a list of fifty-six women whom they regarded as eminently qualified to hold positions in future international parleys. Twenty-four of these women were introduced at a *Herald-Tribune* forum held on October 18. Documents 42 and 43 contain the *Herald-Tribune*'s coverage of these events.

Document 44 gives the incredulous response of Emily Hickman to the exclusion of women from Dumbarton Oaks.

41 Women Absent at Four-Power Peace Sessions

THE TOTAL ABSENCE OF WOMEN among the representatives of the United States, the United Kingdom, the Soviet Union and China attending the conference on post-war peace and security at Dumbarton Oaks prompted several women members of Congress to inquire today

Ann Cottrell, "Women Absent at Four-Power Peace Sessions," *New York Herald-Tribune*, August 21, 1944. Reprinted by permission of the *New York Times*.

if there were no women in these countries qualified to take part in the conversations.

Although China's representatives were absent from the conference table today due to the fact that the European phase of the war was to be discussed with the Soviet group, no women are included in the Chinese delegation. The only women in the music room of the Dumbarton Oaks mansion today were newspaper reporters and a few private secretaries and stenographers.

Informed of this fact, women members of the House of Representatives expressed hope that the omission of women in this first of the peace conversations was not prophetic of future conferences. Representative Clare Boothe Luce, Republican, of Connecticut, said that the inclusion of women should be viewed not from the standpoint of sex but from that of the qualification of an individual.

Mrs. Luce commented: "I believe women should be chosen not because they are women but as qualified individuals. It is difficult to believe there are no women with the qualifications needed at Dumbarton Oaks."

Representative Edith Nourse Rogers, Republican, of Massachusetts, was in agreement with Mrs. Luce, but she also had another grievance—the failure to invite members of Congress to observe at the conference. Mrs. Rogers told the House that "for the future ratification of any agreements by this country it is only good judgement and fair play to invite the most direct representatives of the American people to listen in at least to part of the conferences."

Remarking on the failure to include women in any of the delegations of the four nations, Mrs. Rogers said: "I believe that many women have made a great study over a period of years of post-war security, and I should think that the conferees would welcome such persons."

The news that no women are taking part in the planning at Dumbarton Oaks also brought a note of disappointment from Representative Margaret Chase Smith, Republican, of Maine. Mrs. Smith said that "qualified women expect to serve and have a right to serve in international groups and take part in international conversations." Mrs. Smith then asked, "Where are they at Dumbarton Oaks?"

All women interviewed today on why members of their sex had been omitted were of the opinion that qualified women should seek such posts and should receive the support of other women in obtaining them. A member of a committee which called a meeting at the White House on June 14 to discuss "how women may share in post-war policy making" declined to comment on the failure to include women in this conference.

42 Fifty-six U.S. Women Nominated for Peace Parleys

PROMPTED BY THE EXCLUSION OF WOMEN from the post-war peace and security discussions at Dumbarton Oaks, ten women distinguished in political and public life named for the *New York Herald-Tribune* today a total of fifty-six American women they believe qualified to participate in any future post-war planning and peace conferences.

Leading the list of women mentioned most frequently in this informal survey are Representative Edith Nourse Rogers, Republican, of Massachusetts; Representative Mary T. Norton, Democrat, of New Jersey; Mrs. Florence Jaffray Harriman, former Minister to Norway; Mrs. Anne O'Hare McCormick, of "The New York Times"; Miss Frances Perkins, Secretary of Labor; Mrs. Vera Micheles Dean, research director of the Foreign Policy Association; Miss Dorothy Thompson, newspaper columnist; and Mrs. Ogden Reid, of the *New York Herald-Tribune*.

Participating in the poll were Representatives Rogers and Norton, Representative Clare Boothe Luce, Republican, of Connecticut; Representative Winifred Stanley, Republican, of New York; Representative Jessie Sumner, Republican, of Illinois; Miss Perkins; Miss Frieda Miller, director of the Women's Bureau of the Department of Labor; Mrs. Ruth Bryan Rohde, former Minister to Denmark; Miss Margaret Hickey, president of the Business and Professional Women's Clubs; and Mrs. La Fell Dickinson, president of the General Federation of Women's Clubs.

All-Male Conferences Assailed

Although several of the women participating in the survey were aware that the American group at Dumbarton Oaks was chosen from the State Department—where there are few women—they pointed out that the pattern of all-male conferences should not be established now. Some regretted that women have not reached greater eminence within the State Department, thus qualifying themselves for such a conference as is now taking place. The opinion expressed by Mrs. Luce, Mrs. Rogers

Ann Cottrell, "56 U.S. Women Nominated for Peace Parleys," *New York Herald-Tribune*, August 31, 1944. Reprinted by permission of the *New York Times*.

and Representative Margaret Chase Smith, Republican, of Maine, in the *New York Herald-Tribune* on Aug. 22, that women wish to be included not just because they are women but because they are qualified, was echoed by other persons involved.

The argument that the Dumbarton Oaks conference is made up of diplomats and technicians was countered by Miss Hickey, in a telegram from St. Louis, asking why Mrs. Harriman, Mrs. Rohde or Mrs. Dean had not been considered, if such were the case. Miss Hickey, who is also chairman of the women's advisory committee to the War Man-Power Commission, cited the conference as "another example in the long history of failure to appoint women." She added that many women are qualified "not because they are women but by demonstrated leadership."

Other women mentioned by more than one of those interviewed included Mrs. Rohde, Mrs. Franklin D. Roosevelt, Miss Virginia C. Gildersleeve, dean of Barnard College; Representative Frances Bolton, Republican, of Ohio; Miss Pearl Buck, novelist and authority on China; Dr. Minnie L. Maffett, of Dallas, Tex., physician and surgeon and former president of the National Federation of Business and Professional Women's Clubs; Judge Florence Allen, of Cleveland, judge of the United States Circuit Court of Appeals.

43 Twenty-four Women Leaders Introduced as Qualified for Peace Talks

TWENTY-FOUR WOMEN DISTINGUISHED in political and public life, and deemed qualified for participation in the peace conference, were seated on the Forum platform last night as special guests of honor. These were among the fifty-six women selected last summer for the *Herald-Tribune* by a jury of twelve national women leaders, following a White House conference at which feminist dissatisfaction was registered against the absence of women from the Dumbarton Oaks and other national policy-making conferences. Of the fifty-six named, twenty-four were able to accept Mrs. Ogden Reid's invitation to be present last night. They were introduced to the audience individually.

"24 Women Leaders Introduced as Qualified for Peace Talks," *New York Herald-Tribune*, October 19, 1944. Reprinted by permission of the *New York Times*.

The list of women and their positions in public life follows:

Mrs. Patrick Henry Adams, of Maplewood, N.J., chairman of the War Service Committee of the General Federation of Women's Clubs; Mrs. Nancy R. Armstrong, of Houston, Tex., former chairman of the international relations department of the General Federation; Mrs. Margaret Culkin Banning, of Duluth, Minn., author; Mrs. Clara M. Beyer, assistant director of the Division of Labor Standards, United States Labor Department; Mrs. J. L. Blair Buck, of Richmond, Va., first vice-president of the General Federation; Mrs. J. Robert Bliss, president of the American Women's Voluntary Services in Washington.

Also, Representative Frances P. Bolton, Republican, of Ohio; Mrs. Saidie Orr Dunbar, of Portland, Ore., former president of the General Federation; Miss Virginia C. Gildersleeve, dean of Barnard College; Mrs. Beatrice B. Gould, co-editor of "The Ladies Home Journal"; Mrs. Florence Jaffray Harriman, former United States Minister to Norway.

Also, Dr. Emily Hickman, professor of history at the New Jersey College for Women, New Brunswick, N.J., chairman of the Committee for Participation of Women in Post-War Planning; Mrs. Hiram C. Houghton Jr., of Red Oak, Iowa, second vice-president of the General Federation; Miss J. Winifred Hughes, of Syracuse, president of Zonta International; Mrs. Marjorie Illig, of Marion, Mass., chairman of the public health department of the General Federation; Representative Clare Boothe Luce, Republican, of Connecticut.

Also, Mrs. Edgerton Parsons, member of the Committee for Participation of Women in Post-War Planning; Mrs. Ruth Bryan Rohde, former United States Minister to Denmark; Miss Josephine Schain, a member of the United States delegation to the United Nations Conference on Food and Agriculture at Hot Springs, Va.

Also, Mrs. William Dick Sporborg, of Port Chester, N.Y., chairman of the international relations department of the General Federation; Miss Dorothy Thompson, newspaper columnist; Dr. Charl Ormond Williams, field service director of the National Education Association; Mrs. Harvey W. Wiley, of Washington, chairman of legislation for the General Federation; Mrs. Ellen S. Woodward, member of the Social Security Board, and delegate to the United Nations Relief and Rehabilitation Administration governing body session at Atlantic City.

The women were entertained at a luncheon at the Shelton Hotel by Mrs. Grace Allen Bangs, director of the *Herald-Tribune*'s club bureau.

44 Letter, Emily Hickman to Fellow CPWPWP Member

Dear Fellow Member:

THE INTEREST IN THE PARTICIPATION of Women in Post War Planning has grown greatly during the summer. In June there was an all-day conference at the White House under the auspices of several of the national women's organizations. A roster of names of women well qualified in various fields has been prepared and will be presented to the Executive Departments. You will remember that our committee participated in the suggestion of names for the roster.

The *Herald-Tribune* of New York City has also asked for nominations of women qualified to serve in post war planning conferences and has conducted a straw vote.

The fact that no women were present as delegates at the Dumbarton Oaks Conference has aroused much concern and protest. The State Department holds that the Dumbarton Oaks Conference was an exploratory set of conversations by experts and not a regular international conference. Such a conference of all the United Nations is to be held in the near future and it is understood that the State Department is prepared to consider the appointment of women in the United States' delegation. The work of our Committee is certainly of value and is growing in importance.

At present there are two matters to urge upon you.

First—There is to be a general United Nations Economic Conference in the near future. Our Committee is recommending as its nominees for inclusion in the United States' delegation:

(a) Ethel B. Dietrich (Miss)

(b) Amy Hewes (Miss)

Biographical information about them is contained on the enclosed sheet. Please, if you approve these nominations, will you write at once endorsing them to the President and to Secretary of State Hull.

Letter, Emily Hickman to Fellow CPWPWP Member, October 23, 1944. Charl Ormond Williams Papers, Box 8, Folder, White House Conference, "How Women May Share in Post-War Policy Making," Press Materials, Manuscript Division, Library of Congress, Washington, DC.

(A gentleman disgruntled at the presence of Dr. Mabel Newcomer at the Financial and Monetary Conference grumbled that she was there only because a lot of women wrote letters for her. I hope a lot of letters were written. Yours was probably one of them.)

Second—Please use your best wisdom and nominate a woman or women whom you would like to have at the International Security Conference, the general international conference to which the Dumbarton Oaks agreements will be submitted. Please send these names to Miss Margaret E. Burton, 212 East 48th Street, New York City. Send them as promptly as possible, please, as the conference is likely to occur shortly.

May I send you thanks for your cooperation and for your interest in these matters of such importance to women and to the future world organization.

<div style="text-align:right">

Sincerely yours,
Emily Hickman, Chairman

</div>

Ethel B. Dietrich—Washington, D.C.

Miss Dietrich is a graduate of Vassar with graduate work at Wisconsin and the University of Chicago. She is a Professor of Economics at Mount Holyoke College but for the past three years has been on leave, engaged in government work.

Miss Dietrich organized the Statistical Division of the Industrial Relations Branch of the United Typothetae of America. She has been special investigator of the Women's Branch of the Industrial Service Section of the Army Ordnance of the War Department. She has made for the International Labor Office a survey of world cotton and woolen industries, visiting textile mills in England, the U.S.S.R. and other parts of Europe for the purpose.

Since 1941 she has been with the Foreign Economic Administration, at first as representative of Latin American countries on the Interdepartmental Foreign Requirements Committee, later as Chief of the Raw Materials and Semi-Fabricated Goods Division, and at present as Assistant Advisor on Trade with the rank of Head Economic Analyst.

Miss Dietrich has traveled extensively in England, Europe including the U.S.S.R., and South America.

Amy Hewes—South Hadley, Mass.

Miss Hewes is a graduate of Goucher College with graduate work at the Universities of Chicago and Berlin. She has had a long career of

teaching as Head of the Department of Economics and Sociology at Mount Holyoke College. She has also been a visiting professor at Sarah Lawrence College and has taught summers in both the Bryn Mawr Summer School for Women in Industry and in the Hudson Shore Labor School.

Miss Hewes has had a wide variety of administrative and advisory positions. She has done editorial work for Underwood and Underwood. She has been Executive Secretary of the Massachusetts Minimum Wage Commission. In the last war she was Executive Secretary of the Committee of Women in the Council of National Defense. She was supervisor of the Women's Branch, Industrial Service Section of the U.S. Ordnance and a member of the Advisory Council of the Massachusetts State Employment Service. She is at present a member of the sub-committee on Labor Standards in the Department of State.

Miss Hewes is the author of "Munition Workers in England and France," "Contributions of Economics to Social Work," "Industrial House Work in Massachusetts" and other books. She has contributed to the *American Economic Review, American Statistical Society Publications, Journal of Political Economy, Journal of Applied Psychology, Social Forces, American Political Science Review*, and other periodicals.

XI Undaunted Perseverance: Women Mobilize for Dumbarton Oaks Proposals

At the conclusion of the Dumbarton Oaks deliberations, the State Department initiated a campaign to ensure that the people of the United States would support the establishment of a United Nations organization. Ironically, the exclusion of women from Dumbarton Oaks did not prevent the State Department from enlisting women to use their well-honed organizational skills to educate the American citizenry about the importance of supporting a UN organization. In the hope that the mistakes that had occurred in the aftermath of World War I could be avoided, when isolationist forces helped to bring about the Senate's defeat of the League of Nations, women's groups took a leadership role in the campaign to gather support for the Dumbarton Oaks Proposals.

As the documents in this chapter demonstrate, the women's campaign for Dumbarton Oaks ranged from panel discussions at the White House to neighborhood conversations. The Women's Division of the Democratic National Committee conducted a series of high-level panel discussions in the nation's capital on the meaning of Dumbarton Oaks. Document 45 reprints the speeches delivered at these discussions.

The League of Women Voters was especially active in the Dumbarton Oaks campaign. The League trained five thousand members for a nationwide "Take It to the People" campaign that involved the distribution of over one million pieces of literature. Documents 46 and 47 describe the wide range of activities conducted by the League.

Documents 48 and 49 demonstrate how Mary McLeod Bethune and the National Council of Negro Women ensured that discussions of the Dumbarton Oaks Proposals extended to African-American communities throughout the nation.

45 Panel Discussion on Dumbarton Oaks Proposals: Women's Division, Democratic National Committee

Peace in Our Time

Mrs. Charles W. Tillett

Mrs. Roosevelt and friends, we appreciate very much the privilege of being here today and of having an opportunity to present a brief Panel Discussion on the Dumbarton Oaks Proposals. Even though those of you who are here today are familiar with the basic principles of these Proposals as a framework for world organization, I think you may be interested in seeing one of the ways in which the Women's Division of the Democratic National Committee, in its educational program, is working to get women—many of them busy with homes and children, or with professions and war work—to give time and thought to understanding the only plan we have before us at this time to prevent another war.

Secretary of State Stettinius has urged all organizations to join in a program of education on the Dumbarton Oaks Proposals.

I have written many of our organization leaders about this. Yesterday I had a letter from one of them. She reported that as soon as she got my letter she started to work. An electrician was at her home, repairing her washing machine. She opened her campaign on him with, "What do you think of Dumbarton Oaks?" "Well," he said, "we've specialized in elms. Found them more dependable."

We hope all groups will enter whole-heartedly into this undertaking, but it is our special responsibility to see that women of our organization meet their obligation to create, in every community in our country, an informed public opinion which can support our leaders in government in their effort to translate into a world organization for peace the principles embodied in the Dumbarton Oaks Proposals.

It is our aim, county by county, and neighborhood by neighborhood, to bring this peace plan so close to the people that they will see that it relates to their children, to their jobs, to their rent, and to their grocery bill. By so doing, we will give the great principles contained

Women's Division, Democratic National Committee, *A Panel Discussion on Dumbarton Oaks Proposals*, February 1945.

in the Dumbarton Oaks Proposals the roots to survive. In our day and generation, another peace plan will not fail.

Those participating with me in this program are Mrs. William H. Davis, wife of the Chairman of the War Labor Board, who will give you a brief summary of the Dumbarton Oaks Proposals; Miss Fannie Hurst, distinguished author, well known to each one of you, who will discuss the World Court; the Honorable Emily Taft Douglas, Congresswoman from Illinois, who, long a student of International Affairs, will discuss the Security Council; and Mrs. Trude Lash, one of our national speakers, and now doing valuable party work in New York State, who will discuss the General Assembly.

Women's Responsibility

Miss Fannie Hurst

I wish I could multiply this meeting by many, many thousands. I wish that over the face of our land, multitudes of women were meeting thus— that is, to consider the shape of things that are, in order to blueprint things to come! If there is a more important dedication of purpose than that, then I know nothing about it.

Once a sufficiently large number of American women begin to concentrate on the momentous considerations of this urgent *now*, we can solidify in our country a tremendous and scarcely yet awakened new public opinion!

And while the imagination sometimes finds it difficult to grasp the vast fact, it is the public opinion of Mr. and Mrs. Man in the Street, multiplied by one hundred and thirty million, which determines our way of life.

And now is the moment for woman-public opinion to come of age, and add its great pressure in the formation of the pattern of things to come. And the pattern of things to come is rapidly in the making, because we are living in a period of drastic change and readjustment. The destiny of every woman in this room, and what is more important to her, the destiny of her family, lies on the table at every world conference whether at Teheran, in the middle of the Atlantic, or at Dumbarton Oaks.

You dare not, at this time, permit these mighty conferences to remain remote and abstract to you. They are not merely dry-as-dust remote parleys among government heads, for the purpose of drawing up treaties, resolutions, and planning for some abstract future.

Dumbarton Oaks is our consideration today. And, women of America, when representatives of Allied governments foregathered at this

already historic conference, they were there for the consideration of matters that have to do with your twenty-four-hour-a-day way of life!

Imbedded in their profound, yet elementary, considerations were your husband's income; your children's education; their social security; your three meals a day; your Four Freedoms; your health, wealth, safety, and future.

Ladies, take no one's word for these vital matters. Think them through, along with those who are grappling with them. They have to do with the very heartbeat of your existence.

Dumbarton Oaks is your business! It is your responsibility to understand this mighty working-blueprint of your present new world and your children's newer world to come.

Do you remember the not-so-distant days when matters of state were not regarded as part of our world?

The phrase "Shall we join the ladies?" was coined out of that long, long period. We retired from the dinner table, you remember, after coffee had been served and made for the front parlor, there to discuss our dressmakers and housework, while the men remained at table to ponder the affairs of state, not meant for our pink ears. "Shall we join the ladies?" meant "Shall we now go into the parlor with the pretty things and revert to their level?"

Women of America, shall we join the men in consideration of affairs that concern human beings? Of course we shall, and on a scale hitherto undreamed of. As never before in the history of the world, we are all, men and women alike, in a position to study world affairs first hand.

National and international conferences are today being conducted in a fishbowl, so to speak, so that a great part of the procedures may be viewed from without. To a greater extent than ever before, the citizen can keep abreast with what is going on.

Within the last few years a series of such conferences—the Atlantic Charter meeting, Teheran, Dumbarton Oaks, and now Yalta—has been forming a pyramid of decisions that will re-shape a universe.

For every one of you who is intelligent, or who wants to be intelligent, considerations such as the one we have on the table before us today are a "must."

An informed woman in the home has it in her power to create an informed family! An informed woman has it in her power to help shape a public opinion that can shake the world.

It is your world, your family's world. You all have to live in it twenty-four hours a day.

Help make it, help shape it, help demand that it shall be a better one.

A Summary of the Dumbarton Oaks Proposals

Mrs. William H. Davis

The proposals for a general international organization for maintaining peace and security were discussed at Dumbarton Oaks last autumn by the delegations of the United States, the United Kingdom, the Soviet Union, and China.

They evolved a plan, which was not perfect, any more than our own American Constitution was perfect when proposed for adoption, but that plan that came out of the Dumbarton Oaks conversations was the first step agreed upon by the four great powers toward establishing peace and security in the world.

The purposes of the proposals are four. First, to maintain international peace and security. There are many ways to promote this: by taking collective measures to remove threats to the peace and measures to suppress acts of aggression and by an effort to settle international disputes by peaceful means. Men can never disagree about a fact. They can only be ignorant about it. Therefore, as soon as the facts are laid upon the table and fully understood by everyone, a peaceful solution is almost inevitable.

Second, to develop friendly relations among nations so that the peoples of various countries will understand one another and a feeling of goodwill will be built up. This might be helped by an exchange of students and by inexpensive tours arranged for by travel agencies, etc.

Third, the cooperation of nations in the solution of their economic, social, and other humanitarian problems. One cannot have peace without economic security, and, conversely, with the fear of want removed, it is difficult to get a people interested in war. The same holds true of a healthy people and a well-housed people.

Fourth, to have a center where delegates can come together to make certain they are all working for the same purposes; that is, a place for harmonizing the actions of nations toward these common ends.

The proposals, as they now stand, are not binding on any one or any nation, but they are the recommendations of the four great nations to the other powers of the world. Without the agreement of the four great powers, which, after weeks of thought and study, drafted the Dumbarton Oaks Proposals, there could be no hope for agreement first among the others; therefore, the necessity of agreement first among the four great powers..

The Dumbarton Oaks conversations cleared out the underbrush and charted the direction which any United Nations' charter of World Organization will have to follow.

The recent Yalta Conference was a massive achievement, as Ernest Lindley said in the *Washington Post*, because the Big Three [United States, Great Britain, and Soviet Union] agreed in principle, not only on how to treat Germany and how to work together on the problems of the liberated areas of Europe, but also on the rounding out of the world security organization outlined at Dumbarton Oaks. They agreed on the unsettled voting procedure, subject to approval of China and France. But, above else, everything done at Yalta indicates that the Big Three intend to see that world peace is securely organized in a way that will have the confidence and support of smaller nations and public opinion in the democratic countries of the west. At Yalta, also, San Francisco was chosen as the meeting place, April 25, of the nations invited by the sponsors—the United States, Great Britain, the Soviet Union, and, if they accept co-sponsorship, China and France. There the delegates will write the charter for a world security organization based on the Dumbarton Oaks Proposals.

The four main purposes of the Dumbarton Oaks Proposals are so far-reaching that they will affect the individual lives of every one of us, in the home, the school, the grocery store; for assured of world peace and security, every nation could forge ahead and make a beautiful world—the most beautiful man has yet reached, and that would be a wonderful thing for us to do for the next generation.

The principal organs of Dumbarton Oaks are: the General Assembly, the Security Council, the General Court, and the Secretariat.

The General Assembly of the International Security Organization

Mrs. Trude Lash

For the last two weeks I have been conducting my own poll among women of New York State. I wanted to find out not only how much they knew about the Dumbarton Oaks Proposals, but what specifically worried them or frightened them.

The question the women with whom I talked most often was, will this proposed international organization be democratic—will small nations as well as the three or five big ones have a voice and a vote in its decisions?

It is easy to understand why people should be bothered about that one question. Since the Dumbarton Oaks conference, most of the discussion in the press has been devoted to the Security Council, as if the Council were the central organ of the proposed security machinery which was tentatively developed at Dumbarton Oaks. And as only five

nations are to be permanent members of this Council and the six other seats are to be rotated among the many other nations belonging to the security organization, the fear seems natural.

And yet the question whether this security organization will be democratic can be answered very simply; yes, it will be completely democratic.

The nations represented at Dumbarton Oaks evolved a very simple plan. This plan is based on the belief that peace can be kept if all peace-loving nations unite in their determination to keep it. This determination can grow only out of mutual confidence, and mutual confidence only grows out of knowledge of each other, constant contact of working together. The Dumbarton Oaks Proposals are built also on the knowledge that you cannot devise peace machinery all in one piece, but that you have to establish the basic structure and then develop it over the years through the cooperation of nations.

The heart of this proposed security organization is to be the General Assembly in which all members are represented—in which every nation, large or small, will have an equal vote. This Assembly is really responsible for the success or failure of the security organization. It nominates the non-permanent members of the Security Council. It names the Secretary General and, most important, it will hold the purse-strings of the organization and allot to each member-nation its share of financial contribution towards the work of the security organization. Only if there is trouble will the other organs of the organization have to be called into action—namely, the International Court, for problems concerning international law, and the Security Council, for questions threatening the peace.

Which are the most important problems that might threaten the peace? President Roosevelt has stressed again and again since 1933 that nations who are unable to solve their domestic problems will in the end have to resort to aggression. Unfortunately, we know that his warnings were only too well founded, as during the last years aggression led to war after war and, finally, to a war that engulfed the whole world. Any security organization, therefore, that is to be realistic and effective will have to concern itself with the welfare of peoples—with the economic and social problems, which in the past have led to disruption of the peace.

Attempts have been made, of course, during the years since the last world war to create agencies and organizations where experts from all the different nations could bring their problems and where perhaps international solutions could be found. Some of these agencies have done invaluable work. The International Labor Organization has done outstanding work in the field of working conditions and living

standards. The International Institute of Agriculture has published studies on food production which are of great value to all nations. The Institute of Intellectual Cooperation has shown how closer cooperation could be effected in the cultural and educational field. But there has been no central place where all this information could be pooled— no effective coordination, and in the general confusion much of the valuable knowledge was never applied.

In this new organization the General Assembly is to establish this much-needed coordinating agency—namely, the Economic and Social Council. All the work done by international agencies in different fields will be brought to this Council and coordinated. The Council will also establish any study commission it might find necessary; will call together groups of experts in any field that needs analysis and study.

And all these agencies will be an integral part of the security organization. By joining the organization each nation will automatically take part in the work of the whole organization.

The United Nations have already proved that they are serious in their will to work together. In the conference at Hot Springs, in May, 1943, they worked out a plan for an International Food and Agriculture Organization; at Bretton Woods they proposed that an International Monetary Fund and an International Bank for Reconstruction and Development be established.

Little by little, the peace-loving nations can build an organization that may finally make the world secure. Governments alone cannot do it. We must be the builders, and only if we know and understand can we do our jobs well.

The Security Council

Congresswoman Emily Taft Douglas, Illinois

The chief innovation of the Dumbarton Oaks Proposals lies in the Security Council. It is proposed for the first time that an international organization shall be given ability to act with speed and potency. Here, in short, is both the hope and the danger of the new Council.

The Council is to be a small one geared for action. Its membership will be eleven, with permanent seats for the United States, Soviet Russia, Great Britain, China, and France, and with six places to be elected for two-year terms by the General Assembly. Voting by the Council has been a thorny matter, but we learn that the Yalta Conference resolved this point.

The primary responsibility of the Council will be the maintenance of peace. The Council will investigate any threats to security and take

appropriate measures. A large part of its functions will be of a diplomatic nature. Only when a dispute passed beyond the point where conciliatory or juridical or even economic solutions were possible would the final power of the Council be invoked.

It is the force vested in the Security Council which gives teeth to the Dumbarton Oaks Proposals. To implement this power, each member nation will put at its disposal a certain quota of its own air and armed forces, which shall be immediately available as an international police agency. In the United States the controversy over the Dumbarton Oaks Proposals centers on this matter of force and whether our participation in such a plan would be constitutional. Since the Congress alone declares war, it is argued that our forces could not be used by the Security Council without the vote of Congress. Certainly, Congressional power over both the purse and the sword has been democracy's bulwark against tyranny. On the other hand, if each case must first be referred to Congress, the effectiveness of the police force would be stymied. While free men debate, the dictators would act. That in fact has already proved the strength of the totalitarians as against the democracies. If we are not to lose the reality of freedom in preserving certain forms of it, we must resolve this seeming dilemma.

Fortunately, both tradition and good sense give an answer. Seventy-seven times in American history our troops have operated beyond our borders without any declaration of war by Congress. This has followed from the constitutional duty of the President to defend the integrity of the nation. Among the well-known cases when Marines or other forces have been so used are those of the suppression of the Barbary pirates, the Boxer episode of 1900, and numerous actions in the Caribbean.

Action by a specified quota of American forces would be in the nature of a police force rather than actual war. The distinction would be similar to that within the country where police are immediately available for suppressing crime, but the militia or army can be called in only after approval by National or State authorities. Distinguished authorities on International Law such as John W. Davis, Phillip Jessup, James Shotwell, and Quincy Wright have signed a joint opinion that this collaboration with the Security Council is consistent with our constitution. According to international law, moreover, the use of such a police force by the Council would not constitute "war" by authorized sanction to enforce peace upon lawbreakers.

To clarify our right to participate in such an international police force, however, the office of United States Delegate to the Security Council could be created by Congress and by statute. The choice of such a delegate could be made through any means Congress desires, by the appointment by the President with confirmation by the Senate,

by election by the Congress or by popular election by the whole country. Certainly, Congress has the right to delegate powers by a specific statute which it would ordinarily exercise itself.

In cases where the specified international police contingents were not adequate to deal with the trouble in hand, a new situation arises. If America were asked to send more than its standing quota of force, then Congressional approval would be needed and war might be declared.

In our shrunken world, in which 60 air hours separate the farthest points, and with our new technology of the blitz and rocket bomb, time will be of the essence in dealing with aggressors. If we prevent the new world organization from rapid action, it will be born impotent. It is curious today to see that many former isolationists no longer openly oppose world organization. All they want is to pull its teeth, make it as ineffectual as a debating society or a new League of Nations. Could it be perhaps that they are repeating Senator [Henry Cabot] Lodge's strategy and are trying to beat the new organization as Lodge said he would beat the League of Nations, not by direct frontal attack, but by reservations and amendments?

There is one other basic argument against the Security Council and that is that it gives ultimate control to those powers which have permanent seats. This is frank acceptance of the fact that those nations with the ability and resources to enforce the peace must have the final responsibility of doing so. The plans for the Council may not be perfect and perhaps, as Walter Lippmann suggests, they should be changed after a period. Experience after the last war suggests that it is not so much perfect machinery, however, that is needed, but a will on the part of the big powers to get along. The Dumbarton Oaks Proposals furnish the foundation stone on which to build.

International Court of Justice

Miss Fannie Hurst

We now come to the consideration of a long, far-reaching, and potent arm of the Dumbarton Oaks documents that has to do with the judiciary. I refer, of course, to an International Court of Justice.

I realize that to the average lay mind, highly technical considerations have the effect of a barbed wire barrier to understanding.

Now, formidable as this weighty department of the plan may seem, and is, it is not so impregnable as it sounds.

You see, there are two possibilities regarding the formation of a world court under the Dumbarton Oaks aegis. As you may or may not

know, a permanent Court of International Justice was established at Geneva following the first World War. Also, as you probably know, we, the United States, would have no part in it when it was brought up in 1920.

Now, at Dumbarton Oaks, it was proposed that this already-established International Court of Justice should either be annexed to the charter of organization, or that an entirely new court should be organized.

How that shall be done, and what the main duties of this court shall be, are problems to be further considered at future conferences.

Let us consider the already established Court of International Justice as it applies to the Dumbarton Oaks project.

As the name implies, we must understand that here is one of the most organic and vital departments in the family of organizations under consideration.

Because of the existence of this already functioning International Court of Justice, considerations surrounding it are quite special.

The most immediate decision which must be met is whether that twenty-year-old court shall stand. Or whether a new court shall be organized.

While it is not going to be easy for us as laymen to understand the delicate ramifications of statute involved in adjusting the ready-made Court of International Justice to contemporary needs, the more general aspects of the problem are fairly obvious.

In view of the cataclysm of war which has come upon the world, there are some who are disappointed in the hopes which they had entertained for the permanent Court of International Justice. They feel disillusioned. They are skeptical as to the role which such an agency may play in future international justice considering the fact that after twenty years of the first Court of International Justice, we now find ourselves plunged into unprecedented international lawlessness.

The Court, designed as a clearing house for international problems, did not entirely succeed in living up to its gargantuan ideals. But, on the other hand, a scrutiny of its special accomplishments proves that in the two decades of its existence many formidable international knots were united at Geneva.

Even though the United States refused to join the Court, forty-seven states have at one time or another accepted the Court's compulsory jurisdiction over legal disputes.

And even the United States, which had not joined in support of the Court, has submitted to its compulsory jurisdiction of the International Labor Organization.

It is extremely significant that only a few states of the world have stayed entirely aloof from the movement toward the extension of peaceful processes.

Don't let these abstract considerations bog you down. There is not time for further clarification. Bear in mind that what it means is that the evidence is in, that the permanent Court of International Justice has in many instances justified its existence. While it cannot be said to have reached fulfillment, its achievements warrant that it should be given consideration in planning for the future.

Remember, a whole generation of intelligent and conscientious effort preceded the establishment of the permanent Court of International Justice. For twenty years this Court has carried the majestic banner of international justice according to law.

Its records show that scores of governments and hundreds of men throughout the world have labored to make it a success. And, further, its records show that their labors have not been in vain.

At Dumbarton Oaks the proposal to use this original World Court as a springboard, so to speak, was brought under consideration; to salvage what is good, to adapt and adjust wherever possible, and to create a new approach where necessary.

In other words, salvage as much as possible.

Here are the vital subdivisions under Chapter 7 of the Dumbarton Oaks documents on international organization:

1. There should be an international court of justice which should constitute the principal judicial organ of the Organization.
2. The court should be constituted and should function in accordance with a statute which should be annexed to and be a part of the Charter of the Organization.
3. The statute of the court of international justice should be either (a) the Statute of the Permanent Court of International Justice, continued in force with such modifications as may be desirable, or (b) a new statute in the preparation of which the Statute of the Permanent Court of International Justice should be used as a basis.
4. All members of the Organization should ipso facto be parties to the statute of the international court of justice.
5. Conditions under which states not members of the Organization may become parties to the statute of the international court of justice should be determined in each case by the General Assembly upon recommendation of the Security Council.

Now I repeat: Don't let the technical phraseology obscure the almost classic simplicity of the rudiments of the plan.

We are faced with a choice of scrapping the existent Court of International Justice, or salvaging much that is valuable out of the experience of its twenty years. It seems logical to assume that we will not throw away the Court of International Justice.

Future conferences will determine that. But meanwhile it is imperative for us, who form public opinion, to bear in mind that imbedded in the ideas and ideals of an International Court of Justice is the very heartbeat of that international understanding toward which Dumbarton Oaks planning is directed.

Obstacles in Our Path

Mrs. Charles W. Tillett

In closing, I should like to point out some of the obstacles in the way of our entry into a world organization for peace. The most menacing of all, strangely enough, is an attitude of mind which resides in many people who sincerely favor the movement. I refer to the demand that so many persons make that no world organization shall be accepted unless it is completely lacking in flaws—and each has his or her own ideas as to what constitutes being totally without flaws. These people in their search for perfection endanger the cause. Their opposition to the particular system, or flaw, they are criticizing is joined to the avowed opposition of isolationists.

This was impressed upon me when I listened, a short time ago, to a discussion of the Dumbarton Oaks Proposals by several speakers of great national influence. I am sure that all of them favor a world organization for peace, but of the group, only one spent the allotted time discussing the points of excellence in the proposals, while the others busied themselves discussing those features where the proposals, in their estimation, fell short of perfection.

One kind of perfectionist who is especially difficult to deal with is the perfectionist who tests every proposed organization by comparing it to American methods—(I speak of methods, not principles) —and if it is found not to conform with exactitude to American ideas of how things should be done—(and note again, I am speaking of American methods and not American principles)—condemns it as totally unacceptable. Someone has called these people international isolationists.

The way to meet the arguments of the perfectionists is to point out that in the thousands of years that men have been learning to govern themselves, they have evolved certain basic techniques. These are law, the principle that force shall be used only by organized government in

the enforcement of law, the device of centering the responsibility for administration in a group of trained executives and institutions, such as the court, the assembly, and the vote.

By means of discussions such as we have listened to today, we learn that the Dumbarton Oaks Proposals contain all the governmental techniques of proven worth, and we become convinced that a world organization embodying these proposals is bound to succeed if sincerely supported by all of its members. We see that the Dumbarton Oaks Proposals, in utilizing these techniques, sometimes adopt American methods, and sometimes do not; that throughout the document there is a faithfulness to the fundamental devices of organized society that have, through the years, helped men to lift themselves toward this thing we call civilization.

~

This completes the First Panel given at the White House. The Panel was repeated with Mrs. Raymond Clapper giving the Summary of the Proposals, which was first given by Mrs. William H. Davis; and Mrs. Irving Berlin discussing the International Court, which Miss Fannie Hurst discussed originally. Mrs. Clapper's and Mrs. Berlin's speeches follow.

A Summary of the Dumbarton Oaks Proposals

Mrs. Raymond Clapper

The subject we are to talk about today—the Dumbarton Oaks Proposals—is really the responsibility of women. As Mrs. Tillett has said, this peace plan is so close to us that it relates to our jobs, to our homes and to our children—and the outcome will affect not only our own lives and those of our children but of the generations to come.

The next World War will hit us with 50 Pearl Harbors at once. The airplane, the super fortress, the robot bomb and the jet-propulsion plane will strike our great industrial arsenal and eliminate it before we can catch our breath. That awful moment may be only a few years away unless we accept and implement the only security plan for peace that has come out of this war: the proposals for the establishment of a General International Organization.

The purposes of the Organization should be:

1. To maintain international peace and security; and to that end to take effective collective measures for the prevention and removal of threats to the peace and the suppression of acts of

aggression or other breaches of the peace, and to bring about by peaceful means adjustment or settlement of international disputes which may lead to a breach of peace;

2. To develop friendly relations among nations and to take other appropriate measures to strengthen universal peace;
3. To achieve international cooperation in the solution of international economic, social and other humanitarian problems; and
4. To afford a center for harmonizing the actions of nations in the achievement of these common ends.

If we don't work twenty-four hours a day to see that the United Nations Charter which will be written in San Francisco, and whose framework was worked out at Dumbarton Oaks, is ratified, we may find the nightmare boundaries of human horrors far beyond the horizons of belief, and mankind actually reduced to such a ghastly situation as told in a little story I'd like to tell you.

> The third and fourth world war had ravaged the world until finally there were only two men left alive in all the world. They had one airplane. They got into the airplane, flew to Africa where they'd heard you could live off fruit and coconuts. But they didn't know much about planes, so they crashed as they landed in Africa. Both men were killed, the plane destroyed. A tribe of monkeys chattered up to view the sad remains. They ran 'round and 'round scratching and shaking their heads, until one old monkey said, "Too bad, too bad. Now we have to start to work all over again."

Are we a lot of dopes? Are we going to let this second—and probably final—chance to set up a world organization be defeated as we did the League of Nations?

The purpose of the conference at Dumbarton Oaks between the United States, the United Kingdom, the Soviet Union and China is so simple. It is only a cooperative effort to establish peace and security in the world. To hear some of the ravings of the defeatists, you'd think it was a proposal to fight—to war! It boils down to a pledge between nations to sit around conference tables indefinitely to ward off aggressors and cooperate to make peace, not war. The Charter may not be perfect. Neither were the thirteen articles that started the United States of America. Neither was the Bill of Rights. But, throughout the centuries, by patience and endeavor, we achieved great things along these lines. So with the United Nations. Sure, we don't like this guy or that; we may not like the way he flicks his eyelashes or the jut of his chin. That is sentimentality. But for the sake of our own hides we can't

afford sentimentalism. There is no sentiment in a life insurance company but it is a mighty good thing to belong to one, imperfect as they are.

We are adults; let's keep our shirts on and not go home everytime anyone doesn't see eye to eye with us. It is going to be a long, hard road of frustrations, heartaches, disillusion. But we can bring security to the human race. We have been the arsenal of war; we can be the arsenal for peace.

As a result of the Yalta Conference the call has gone out for delegates from the United Nations to meet in San Francisco on April 25th. They will adopt the Dumbarton Oaks Proposals and expand them into a workable plan. The delegates then will go home to their various ratifying bodies. In our country, that body is the United States Senate, where a vote of two-thirds of the Senate will put us into the new organization. Once we and our Allies set up the machinery, our real test will come. We cannot sit back blissfully and expect a perfect world. Rebuilding is hard. We'll have lots of trouble. That is where women are needed.

Into our hands from the conference at San Francisco will be given the first instrument to stem destruction of our homes and our beloveds. Our specific job, as women, is to see, with gritted teeth, that our government ratifies this international plan for peace. Then, year in, year out, through thick and thin, women on the eternal watch must see to it that our best alert brains confer endlessly with our Allies to make the United Nations mankind's arsenal of peace.

International Court of Justice

Mrs. Irving Berlin

The best way to begin to understand the plans for a new court is to know a little about the existing World Court and the relations of the United States to the Court.

The present World Court was established in 1921 as an organ of the League of Nations. It was set up, however, by separate statute so non-members of the League might belong to it as well as those that were members. The purpose of the Court was to decide cases brought before it on the basis of law, making international law a concept in the voluntary settlement of disputes and to build up by a series of judicial rather than arbitral decisions an expanding body of law.

Elihu Root was one of the formulators of the original statute of the World Court. And both Charles Evans Hughes and Frank B. Kellogg served in the Court. You see, working for peace must be a non-

partisan affair. That is one of the aims of such discussion as ours: to work together regardless of party affiliations for the new world organization.

All of the American Presidents since 1923 have recommended to the Senate the adoption, with reservations, of the protocol which would make the United States a supporting member of the Court. They all failed. The last time it was by a very narrow margin. In 1935 the Senate rejected the protocol by the vote of 52 for and 36 against—seven votes less than the two-thirds majority necessary for ratification of a treaty.

Now, before coming here I looked up these facts I have just given you in the encyclopedia and in the "Diplomatic History of the United States" by Samuel Flagg Bemis. And that makes me an example of what none of us must be this time. We mustn't read vaguely in the newspapers about Dumbarton Oaks and then pay so little attention and do so little about it that twenty-five years from now we'll have to look up this world organization and this world court in a history book. If we do that, if enough of us fall into indifference again, I'm afraid the books twenty-five years from now will again have a sad story to tell—and that story might be fatal to civilization and hope.

Now we have another chance. A beginning is being made—a beginning of a world organization. One new plan, already incorporated in the Dumbarton Oaks Proposals, is to have a Court of International Justice which will be an integral part of the world organization. One of the questions that will arise in setting up the court this time is whether to use the old court under the old statute, at least in part, or to have an entirely new one under a new statute. One of the things that I personally would like to see us keep is the concept of building a body of judicial rather than arbitral decisions. On such a body of decisions is our own justice founded, and I believe it would be a good foundation for international justice.

Last time we won the war and thought we had won the peace. But through neglect, through indifference, perhaps through optimism, we lost it. We can't afford to lose it again. Because of our failure before we have learned to be realistic. This time we may be not too optimistic, but too fearful. And while despair is not good, a little fear may be all right. I get courage from our fear because our fear of failure may make us work for success. It is going to take a lot of work for the nations of the world to learn to live together in peace and justice.

Cooperation isn't easy. It isn't easy in a family. It isn't easy in a community. But families have learned to live in peaceful communities, and communities have become nations. We know what it is to live according to justice in a free country.

We want to know what it is to live in a free world without fear. That is a universal dream, and we have a chance to make it come true. But it means work—work for all of us in this nation and in all peace-loving nations of the world.

46 Women Seek Ideas on Peace

To the Editor of the *New York Times*:

A LETTER IN THE *TIMES* of Dec. 3 from Miss Claire E. Fischer expresses fear that our citizens will not try to understand or realize the importance of the Dumbarton Oaks proposals for a general international organization to keep the peace, but will begin to object when the charter for such an organization is ready to be adopted. We in the League of Women Voters have the same concern.

I think Miss Fischer will be glad to know that the league is calling on all its members in thirty-four States and in 1,500 communities to stimulate discussion of the Dumbarton Oaks proposals by every individual citizen they can reach, gathering neighbors in small groups in homes, schools, churches, even over the back fence and supplying simple, factual material as a basis for talking it over; that the league in New York State is making this plan its first, most urgent commitment; that the New York City League of Women Voters has already held a course of meetings to train discussion leaders for home groups here in the city, which they call "Preludes to Peace," and is constantly enlarging its speakers' bureau, which can scarcely meet the demands made on it.

I know the New York City League would welcome Miss Fischer's help and that of all like-minded people who want to know others' and make known their own ideas, their doubts, fears and convictions about international plans for peace and security. We believe that "out of the clash of opinion comes the spark of truth."

> Lucile W. Heming, President
> New York State League of Women Voters
> New York, Dec. 8, 1944

"Women Seek Ideas on Peace," Letter to the Editor, *New York Times*, December 14, 1944.

47 Women Rally for Peace

WOMEN IN THE METROPOLITAN AREA [of New York City] voiced yesterday their desire for permanent peace in varied programs marking the opening of Dumbarton Oaks Week.

Street corner rallies were held jointly by the City League of Women Voters and the American Association for the United Nations. A sound truck carried speakers from these groups to the Chelsea and Greenwich Village areas. Today they will go to Wall Street and Union Square. Other sections will be visited later this week.

"Women Rally for Peace," *New York Times*, April 17, 1945. Reprinted by permission of the *New York Times*.

48 Letter, Mary McLeod Bethune to Congressman William L. Dawson

Congressman William L. Dawson
Old House Office Building
Washington, D.C.

Dear Congressman Dawson:

THE NATIONAL COUNCIL OF NEGRO WOMEN in its effort to cooperate with the State Department in getting the Dumbarton Oaks Proposals across to the citizens of the United States is holding a meeting Sunday, April 8, 1945 at 4 P.M., at the Asbury Methodist Church, 11th and K Streets, N.W., Washington, D.C.

Because it is so necessary that our people understand fully the proposals as outlined in the Dumbarton Oaks Document, we are asking you to be one of our guest speakers on this occasion.

The meeting will be in the form of a panel discussion, the subject of which is "Guides to World Security."

We have asked Mr. Archibald MacLeish, of the State Department, to talk on Dumbarton Oaks and Mr. Nelson Rockefeller to talk on the

Letter, Mary McLeod Bethune to Congressman William L. Dawson, March 17, 1945. Records of the National Council of Negro Women, Series 5, Box 38, Folder 54, World Security Month Programs 1945. Reprinted by permission of National Park Service, Mary McLeod Bethune Council House National Historic Site, Washington, DC.

Inter-American Conference recently held in South America. We have also asked Dr. Rayford Logan, Dean Harriet Elliott and Dr. Ralph Bunche to participate in the panel discussion.

Since Congress will play an important role in ratifying the Dumbarton Oaks and Bretton Woods Proposals, we would like for you to talk from the point of view of a Congressman on "World Security."

Kindly let us know, as soon as possible, whether or not you can be with us.

<div align="right">
Sincerely yours,

Mary McLeod Bethune

President
</div>

49 NCNW Memo, World Security Month

T HE PURPOSE OF THIS WEEK is to:

Achieve full public support of:

1. The Dumbarton Oaks proposals as released by the Department of State on October 9, 1944, or if at the time of "World Security Month" an agreement has been concluded as a result of the San Francisco Conference, public support for that agreement.

2. The Bretton Woods Articles of Agreement.

The public must be fully informed on these proposals for world peace. Forty-four nations have agreed that if we are to prevent a third world war and have a lasting peace, the following must happen:

1. Unitedly, nations must work together on common problems.

2. International employment and a sound economic and monetary structure must be established.

3. Peaceful settlements must be made among nations who have disputes.

4. Aggressors must not be allowed to use force against their neighbors.

5. There must be established the principle of economic stabilization and cooperation as the foundation for expanded world trade.

Important!!!

NCNW Memo, World Security Month, April 8–May 12, 1945. Records of the National Council of Negro Women, Series 5, Box 38, Folder 541, World Security Month Programs 1945. Reprinted by permission of National Park Service, Mary McLeod Bethune Council House National Historic Site, Washington, DC.

I. What to do in your local community during "World Security Month"

Plan meetings, forums, radio programs, school programs, church meetings, home meetings, luncheons, teas, or other demonstrations.

II. Laying the groundwork for "World Security Month"

1. Get "World Security Month" endorsed in your community by the governor of your State and the mayor of your city, as well as your Congressman.

2. Call together immediately, representatives of leading white and Negro organizations (and others) in your community to discuss observing "World Security Month." If possible, get these groups to act as Sponsors for your celebration.

3. Choose which of the two documents (Dumbarton Oaks or Bretton Woods) you will discuss and secure speakers immediately.

4. Set a date for your celebration and appoint the following Committee Chairmen:

 a. Publicity Chairman, to head a committee which will:

 1) Arrange for newspaper publicity in the form of press releases, feature stories and editorials designed to make your community aware of the importance of observing "World Security Month."

 2) Arrange for radio time, church, club and other announcements regarding the meeting.

 3) Publicize speakers, time and place of meeting, also the proposals (Dumbarton Oaks or Bretton Woods) you have chosen for discussion.

 b. Education Chairman, to head a committee which will:

 1) Gather all of the information possible in the document you have chosen for discussion.

 2) Assemble a kit of material on the subject which will be given out at the meeting.

 3) Work with Publicity Chairman in preparing articles for newspapers, radio scripts and other forms of education such as leaflets, posters, etc.

 c. Program Chairman, to head a committee which will:

 1) Plan the demonstration meeting or meetings.

 2) Arrange for speakers, entertainers, meeting places and the program for the week.

 d. Telephone Chairman, to head a committee which will:

 1) Follow up preliminary contacts on getting people out to the meeting.

 e. Exhibit Chairman, to head a committee which will:

 1) Work with the Education Committee in securing posters and materials for the meeting.

 2) Get flags of as many of the forty-four nations as possible and display them at place of meeting.

 f. Sponsor Chairman, to head a committee which will:

 1) Secure the endorsement or sponsorship of as many organizations, individuals, legislators, professional and business men and women, ministers and others [as possible].

 2) Secure the widest possible support for the meeting.

III. Steering Committee

1. Set up a Steering Committee (if necessary) which will be composed of the chairmen of all committees. This Committee would coordinate the activities of all committees.

2. Choose a dynamic and forceful chairman for the Steering Committee.

IV. Choose Your Speakers

 1. Dumbarton Oaks

 a. The State Department, Mr. Edward Stettinius, Secretary, Washington, D.C.

 b. Americans United Organization, Mr. Ulric Bell, Executive Vice President, 5 West 54th Street, New York 19, New York.

 c. Women's Action Committee for Victory and Lasting Peace, 1 East 57th Street, New York 1, New York.

 d. Your local community where persons of international experience or knowledge may be residing.

 e. Other sources you may know about.

 2. Bretton Woods

 a. The Treasury Department, Mr. Henry Morgenthau, Secretary, Washington, D.C.

 b. Americans United Organization, Mr. Ulric Bell, Executive Vice President, 5 West 54th Street, New York 19, N.Y.

 c. Your local community where persons of international experience or knowledge may be residing.

 d. Other sources you may know about.

Please let the National Council of Negro Women know the kind of meeting you plan to have during "World Security Month," and if you will need material on the subject you have chosen.

We would also be interested in receiving newspaper clippings, and a copy of the program of your celebration, posters, leaflets and other material used during "World Security Month."

XII Women at San Francisco: The United Nations Conference

The February 13, 1945, appointment of Virginia Gildersleeve, dean of Barnard College, as one of the eight official U.S. delegates to the United Nations Conference in San Francisco marked a significant victory for the campaign to have women represented at postwar planning councils. Gildersleeve acknowledged that she "was appointed because American women made a drive for representation and my name was on the roster they compiled." She was one of only six women at the San Francisco Conference who held full delegate status. However, numerous other women were attached to delegations as advisers and aides. Documents 50 and 51 focus on Gildersleeve and her work as a member of the official U.S. delegation to San Francisco.

In addition to the official U.S. delegation, the State Department issued invitations to forty-two private organizations, including five women's groups, to the San Francisco Conference as consultants. No African-American women's organizations were on this list. The National Council of Negro Women promptly fired off a series of letters to State Department officials exhorting them to appoint Mary McLeod Bethune as a NCNW consultant to the U.S. delegation. Documents 52–55 provide examples of this correspondence. Although the State Department rejected these requests, Bethune eventually found her way to San Francisco as a representative of the National Association for the Advancement of Colored People. Documents 56 and 57 include Bethune's account of the San Francisco Conference. In these documents, Bethune emphasized "the growing awareness among women themselves of their contributions as citizens of the world."

50 Portrait of a Dean and Delegate

Edith Efron

A S THE LONE AMERICAN WOMAN to attend the San Francisco Confer-
ence of the United Nations in April, Virginia Crocheron Gilder-
sleeve will be regarded with considerable curiosity—and perhaps some
apprehension—by her co-delegates and the nation at large. Not only is
she a woman; she is also a college dean, a member of that professorial
group so frequently taunted by professional politicians. What kind of
delegate will she be to that all-important conference? Is she a conser-
vative or a radical? A nationalist or an internationalist? What, as one
anonymous citizen recently demanded in a letter to the editor, is her
"racket"?

Dean Gildersleeve, First Lady of Columbia University and of
Barnard College, has no "racket." Peculiarly devoid of ideologies, she
is both nationalist and internationalist, conservative and radical. She
smilingly calls herself a "progressive conservative," and is probably a
little right of the Rooseveltian "slightly left of center."

Delegates to the San Francisco Conference, if they are meeting
Miss Gildersleeve for the first time, will encounter a woman whose
basic international views are simply formulated.

"I am deeply concerned," the 68-year-old dean says, "that my coun-
try, which I love, should play a great role as a citizen of the world.
There is no conflict between true internationalism and true patriotism."

Miss Gildersleeve believes, in common with all the delegates to
the San Francisco Conference, that two things are necessary to pre-
serve peace and secure cooperation between nations. "The first," she
says, "is political machinery, such as a world court, a security council.
The second is public opinion, that is, the 'international mind' among
the peoples of the world so that they will support this machinery."

"Almost any machinery," she adds, "which at least keeps the na-
tions in touch and in conference, will be better than no international
machinery. But we can, I am sure, do better than this minimum. The
proposals agreed on at Dumbarton Oaks seem to me an excellent foun-
dation. On that foundation we can build well."

Miss Gildersleeve holds we have a better start than we had at the
close of the last war. "Even before the end of the fighting, we have a

Edith Efron, "Portrait of a Dean and Delegate," *New York Times Magazine*,
April 1, 1945.

good blueprint of a world organization to keep the peace," she says. "And we have a far better informed people here to back up the new world order. There has been a lot of spreading of information about international cooperation, and a lot of discussion about our country's part. There must be lots more to build up that public opinion, that atmosphere of understanding without which event the best political machinery will fail to work."

She has a great faith in the political wisdom of the American people, and is convinced that they have truly learned the lessons of this war. "Many people," she maintains, "have talked as if all we had to do to get peace was to do nothing, or perhaps to say loudly and frequently that we loved peace and hated war. Now we have learned that no matter how much we love peace and hate war, we cannot avoid having war brought upon us if there are convulsions in other parts of the world."

"Isolationism, most of us admit, is no longer possible. We can no longer indulge in that deep American instinct to wrap our oceans about us and have nothing to do with the quarrels of the rest of the world. The oceans protect us no longer."

In her personal reaction to her own appointment she recognizes the significance of her mission.

"My appointment as a delegate to the San Francisco Conference," she says, "is a great honor and a great responsibility. I shall be one of those trying to embody in definite plans, to carry out a charter of the United Nations, our deep desire to end wars, the deep desire of all the peace-loving people to guarantee somehow that our sons and their sons shall not again have to die in battle."

Modestly, she adds, "I have attended too many international conferences to have any illusions as to what one person can contribute. I can only say that I realize the responsibilities and shall meet them to the best of my abilities."

Miss Gildersleeve has been called "an obvious choice" by many. Few people can mention any woman better qualified to attend the conference. The dean alone contends that there are "masses" of qualified women who might have been appointed in her place.

"I am aware," she comments, "that I have been appointed in great measure because I am a woman, but I prefer to think that I represent my fellow-citizens as a group. Women and men alike are seeking peace and security. There is perhaps only one respect in which women are different, and that is that women are less belligerent and more willing to sacrifice for the ideal of peace."

It is quite apparent that Miss Gildersleeve's thirty years of international experience, as well, played a large part in her appointment.

She is no stranger to the workings of international political machinery. Nor is she unfamiliar with the problem of molding the "international mind." She was a member of the League to Enforce Peace—the 1916 forerunner of the League of Nations. She was a hopeful sponsor of the World Court. She is today an active member of the Commission to Study the Organization of Peace.

The capitals of the world—Paris, London, Oslo, Vienna and Stockholm—know her well as a founder and president of the International Federation of University Women, an intellectual organization dedicated to international understanding. In part this federation attempted to exert an educational influence on the youth of all countries, and as far back as 1918 Miss Gildersleeve said: "It is especially our duty to scrutinize history textbooks used in our schools. Our children must be taught that the greatness of a nation lies in the welfare and ideals of its own people and in its helpfulness in international affairs."

In her capacity of dean of Barnard for the last thirty-four years, she has stimulated the cause of international friendship by encouraging foreign students and visiting professors to study and teach at the college. Barnard students under the shadow of their dominant dean develop a pleasant version of the "international mind," and the curriculum has recently been extended to include an "international studies" program.

"International relations," says Miss Gildersleeve, "is my favorite hobby. It has been a delightful hobby, if slightly depressing in recent years."

Conferees in San Francisco, meeting the dean for the first time, will encounter a medium-sized, active-looking woman, who appears to be twenty years younger than she is. Her face is distinguished. Startlingly dark and brilliant eyes gleam out from under heavy curved eyebrows. Her nose is finely chiseled, her cheekbones pronounced, and her lips are restrained and thin. Her skin is taut and slightly tanned, and there is a cavernous quality to her face. Her voice is rich, sometimes almost strident.

During the weeks of the conference, the dean will probably march through San Francisco, as she marches through the Barnard campus—in her gay woolen dresses, her English tweeds and strange, Queen Mary-like hats—with a firm step, nodding briskly at passers-by. She will attend all meetings, receptions, dinners—just as she does in her professional life. She will probably live up to her description given by a Barnard official—"a well-oiled steam engine."

Miss Gildersleeve is expected to play the part of a catalytic agent at the conference, influencing the speed and emotional temper of the operations at hand. She is adept at handling people fairly, and translat-

ing concepts into sound constitutional action—exercising a faculty which comes of three decades of experience at international meetings.

Her outstanding quality which will be called into play in San Francisco is one in which she has great pride. She is judicially minded, and has long emulated the professional characteristics of her father, Henry Alger Gildersleeve, who was a New York Supreme Court Justice. To be judicial, to Miss Gildersleeve, is to possess not only the power of weighing evidence but also "the ability to remain in a state of suspended judgement." The dean can suspend her judgement "indefinitely," she says.

Judicial equilibrium is also maintained in her emotions. She rarely gets angry; she never flies into a passion, and she neither idolizes nor hates. As a result, Miss Gildersleeve is well-equipped with the impartial, investigating spirit of compromise which she herself considers an essential qualification for a delegate to the April meeting.

"At San Francisco," she says, "we are to try to adopt definitely a charter or constitution for the United Nations. It is a very difficult task to draw up a constitution for a world organization. It was a difficult task long ago, to draw up a Constitution for these United States. The document that resulted from that Convention was the product of compromise."

"We must be willing to compromise, to accept as a plan for world organization something we do not entirely like," continues the dean, "something different from the perfect ideal we have formed in our minds. The charter which is adopted at San Francisco will not be perfect. It will be made by imperfect human beings, who will have to adjust and adapt and compromise to meet the desires and needs of the various nations. It will not completely satisfy anyone."

"At San Francisco, I am confident no really dangerous compromise will be necessary. A good plan for world security will be adopted. It may not be perfect, but there is an excellent chance that it will save us from a World War III."

Not only can the dean be counted on to compromise and collaborate where necessary to preserve that international organization she has supported for so many years, but she can also be relied on to treat the delegates of the weaker war-torn European countries with delicacy and understanding.

"There is something people must realize," she explains, "if they are to help during the difficult weeks of delicate negotiation and discussion which will, we trust, result in a charter for the United Nations. That is, they must realize that many of the nations of the world have suffered horribly at home as well as on the battlefronts. They have been cold and hungry for years. Their children have been killed

at their own firesides. Worst of all, in the occupied countries, they have suffered bitter humiliation from the horrid presence of a cruel conqueror."

"Many of them are sensitive. Their nerves are on edge. They may seem unduly irritable and unreasonable. But we who have suffered so much less, must be patient, very patient, not put off by any temporary peculiarities of any of our comrades among the United Nations, but patiently persisting in our effort to help find the best possible plan for securing peace for this wounded and suffering world."

Because of this determined tolerance, this trained spirit of understanding and compromise which characterize Miss Gildersleeve, and casts her in the difficult role of Lady Justice, the delegates to the San Francisco Conference may find her austere. It is a common reaction to the dean, and one with which she is familiar. One anecdote—one of the very few which circulate about her—perhaps best penetrates the aura of austerity which undeniably hovers about her.

It is told that she was once invited to a Barnard College party, and after an hour was privately scolded by a friend.

"Virginia!" chided the friend. "Please try to look as though you're enjoying yourself. After all, you're the guest of honor."

"I am enjoying myself," answered Miss Gildersleeve, ruefully. "It's just my grim old face that doesn't show it."

Her intimates explain that her aloof poise is a mere camouflage for a basically shy and sheltered nature.

Most of her life has been spent within the peaceful cloistered atmosphere of a young girls' school. For many years, she has lived in the quiet "Deanery" with its black shiny door, its sunny antique living room, snug within a gray stone terrace and a high green fence.

Beneath her august façade, the dean conceals a quiet whimsy, and romantic spirit. Her nonprofessional reading is of an escapist nature, plunging into the past, the future, and the unreal present. In her hotel room in San Francisco, there may well be a few books on archaeology, several of the best English detective stories, and perhaps a book on Polar explorations.

This paradoxical delegate—cold and realistic, yet tender and compromising—with her scholarly background strengthened with administrative ability, and her international concepts flavored with romanticism, knows why she is going to San Francisco and she knows what she hopes to bring back. She is confident for the future. Perhaps there is one little prayer she will whisper before getting on the train for the city with the Golden Gate:

"I hope there's not too much economics. I never could understand it."

51 Women Must Help Stop Wars

Virginia C. Gildersleeve

A s I TRAVEL THROUGH OUR COUNTRY I often see the stars of service flags in the windows of little homes in remote valleys of the New England hills or on the wide plains of the middle west or by southern rivers. It still seems very strange that war can have reached out across the oceans and taken young men from these remote American homes, taken them out to fight and often die far away by the Rhine or on some Pacific island.

What do the wives and mothers of these young men think about this war that reaches out to break the peace of their homes? Will they understand and try to help stop the next war? I believe they are beginning to understand and, along with other citizens, to want to act promptly and practically to avoid such suffering in the future.

Through the ages it has been accepted that men must fight and women must weep—at home, helpless. Two things have happened to change that. War has come into the home. And women are not helpless; they can now do something about it.

What plans can be made to prevent wars? First, peace-loving nations must agree on some organization of the world which will have machinery for stopping wars before they get started. No one nation can be safe alone, not even our own great and powerful country. Remember that Hitler almost succeeded in conquering the world this time, because the other nations had no effective plan for uniting to oppose him. Today we have made great progress in working together as allies in waging the war. And we have made a good start on getting together to set up an organization to bring world security.

At Dumbarton Oaks last autumn, four nations agreed on proposals for a constitution for the new world organization. Fortunately both our great political parties, Democratic and Republican, have expressed approval of the general idea. Others of the United Nations, our comrades, have been discussing the proposals and at the San Francisco conference we shall all have a chance to act definitely on this plan.

After that, the constitution agreed on at San Francisco will be submitted by our government to our Senate. And here is where the women of our country can be very useful. There are many millions of us, some

Virginia C. Gildersleeve, "Women Must Help Stop Wars," *Woman's Home Companion* (May 1945): 32.

working in factories and offices and fields, some serving as doctors or teachers, some in the armed forces, and millions bearing children and caring for them and keeping the homes strong. We women must see to it that our representatives at San Francisco and in Congress really represent our great desire for a world of security and well-being.

We must not forget that we have votes, even a majority of the votes in the whole country if we would use them. So we can have a great say in choosing our representatives in Congress in the future, and if they realize this they may listen to us now.

There are several things we must all get clear in our minds and explain to others. The first is that to secure peace you must do something definite and active. Some people talk as if all we have to do to avoid war is to say fervently and frequently that we love peace and hate war; or to adopt, on paper, fine resolutions about it. On the contrary, as we have learned by bitter experience, our country must take action—take our share of responsibility for making decisions on world problems, provide our part of the armed forces necessary to carry out these decisions.

Some women may find this last duty particularly hard. They may say that our young men should never again be sent overseas to help police the world. But what more useful service could they perform for their own country? By this temporary service of a few of our men abroad we might avoid a war which would cost hundreds of thousands of young lives in battle and the shattering of homes in all the states of our Union. Providing some armed forces to police the world is part of the price we shall have to pay for peace.

Another thing we must all realize is that the new charter or constitution for the world organization will not be perfect. It will not suit any of us precisely. It will not suit any nation precisely. For it will necessarily be the result of give and take, of adjustments to meet as far as possible the desires and the needs of many different peoples.

It troubles many of us that we should thus have to compromise on our ideals. But we should all try to realize that in political affairs you have to compromise on your ideals, at least to some extent and temporarily. You have to be willing to take as much as you can get of your ideals and wait for a later time to get some more. In our private lives and professional obligations the case is otherwise, and we should certainly not compromise regarding our ideals.

Is there anything peculiar about the attitude of women toward this problem of securing peace? Will they feel differently from men? Should they act differently? I have always felt that there was less difference between men and women than most people think. But there is one great difference:

Women have generally a stronger instinct for creating and preserving life and developing it. So war, with its destruction of life, naturally seems even more terrible and more unreasonable to women than it does to men. They instinctively hate it.

We can count on them, I believe, to urge upon their representatives the paying of the necessary price—to urge that our country should join the world security organization, that it should thereby give up some of its independence of action, that it be willing to adjust and modify some of its ideas to enable us to work with our allies, and that it should give some of its armed forces to help keep the peace of the world.

Our first great task, all of us, men and women, is to push this present war to a victorious end. And if ever again we are forced to choose between war and being conquered by a foreign foe, we will choose as we did this time and fight. But our second task now is to do everything possible to set up a security organization that will make such a terrible choice unnecessary, that will prevent future wars, and thus save the lives of our children and grandchildren.

At San Francisco we are to take a great step toward that desirable end.

52 Letter, Jeanetta Welch Brown to William L. Clayton

Mr. William L. Clayton
Assistant Secretary of State
Department of State
Washington 25, D.C.

M y dear Mr. Clayton:

ENCLOSED IS A COPY OF A TELEGRAM we sent to the Honorable Edward Stettinius, Secretary of State, and a letter sent to the Assistant Secretary of State, Mr. Archibald MacLeish, with regard to representation of the National Council of Negro Women at the San Francisco Conference.

Letter, Jeanetta Welch Brown to William L. Clayton, April 11, 1945. Records of the National Council of Negro Women, Series 5, Box 34, Folder 493, United Nations 1944–1947. Reprinted by permission of National Park Service, Mary McLeod Bethune Council House National Historic Site, Washington, DC.

These copies are sent to you with the hope that you too will give this matter your serious consideration.

Sincerely yours,
Jeanetta Welch Brown
Executive Secretary

53 Letter, Jeanetta Welch Brown to Archibald MacLeish

Mr. Archibald MacLeish
Assistant Secretary of State
Department of State
Washington, D.C.

My dear Mr. MacLeish:

I AM ENCLOSING A COPY OF A TELEGRAM which we sent to the Honorable Edward Stettinius, Secretary of State, with regard to representation of the National Council of Negro Women at the San Francisco Conference.

The content of the telegram expresses our position with regard to the representation of Negro women. Our organization came into being because of the lack of participation which Negro women were forced to experience.

The National Council of Negro Women has a membership of 800,000 representing the six and one-half million Negro women of this country. On behalf of them we urge you to give the matter of representation from this organization serious consideration.

This letter comes directly to you because we believe that you agree with us, that the Council is entitled to representation.

Sincerely yours,
Jeanetta Welch Brown
Executive Secretary

Letter, Jeanetta Welch Brown to Archibald MacLeish, April 11, 1945. Records of the National Council of Negro Women, Series 5, Box 34, Folder 493, United Nations 1944–1947. Reprinted by permission of National Park Service, Mary McLeod Bethune Council House National Historic Site, Washington, DC.

54 Telegram, Jeanetta Welch Brown to Edward Stettinius, Jr.

Mr. Edward Stettinius, Jr.
Secretary of State
Department of State
Washington, D.C.

T HE NATIONAL COUNCIL OF NEGRO WOMEN representing six and one-half million Negro women of this country, call upon you to appoint Mrs. Mary McLeod Bethune, President of the Council, as Consultant to the San Francisco Conference. It is imperative that along with other women's organizations Negro women be given the opportunity to get first hand information. None of the women's organizations named represent Negro women. We urge your careful consideration in this matter.

<div align="right">

Jeanetta Welch Brown
Executive Secretary

</div>

Letter, Jeanetta Welch Brown to Edward Stettinius, Jr., April 11, 1945. Records of the National Council of Negro Women, Series 5, Box 34, Folder 493, United Nations 1944–1947. Reprinted by permission of National Park Service, Mary McLeod Bethune Council House National Historic Site, Washington, DC.

55 Letter, William L. Clayton to Mary McLeod Bethune

Mrs. Mary McCloud [*sic*] Bethune
1318 Vermont Avenue, N.W.
Washington, D.C.

M y dear Mrs. Bethune:
I TRIED TO GET YOU ON THE TELEPHONE today but was told you were out of the city.

Letter, William L. Clayton to Mary McLeod Bethune, April 13, 1945. Records of the National Council of Negro Women, Series 5, Box 34, Folder 493, United Nations 1944–1947. Reprinted by permission of National Park Service, Mary McLeod Bethune Council House National Historic Site, Washington, DC.

I presented your request for representation of the National Council of Negro Women at the San Francisco Conference but regret to say that this request was denied.

The Council for the Advancement of Colored People [National Association for the Advancement of Colored People] will be represented at the San Francisco meeting.

Furthermore, it was felt that if an invitation should be extended to the National Council of Negro Women, an invitation would also have to be extended to the Council of Jewish Women, Council of Catholic Women, etc.

Regretting this and hoping you will understand, I remain,

Sincerely yours,
W. L. Clayton

P. S. This question of representation at the San Francisco has been an extremely difficult one for us.

56 Letter, Mary McLeod Bethune to Dear Friends

2066 Pine Street
San Francisco, Calif.

Dear Friends:

I THINK YOU WILL BE GLAD to hear from me in this beautiful coastal city of lovely California, where I am spending a few weeks on what I believe to be the crowning assignment of my many and varied achievements.

I am here as one of the three Negro consultants to the U.S. delegations to the United Nations Conference, appointed by the U.S. Department of State under Mr. Edward Stettinius, and I serve along with Dr. W. E. B. Du Bois and Mr. Walter White as representatives of the N.A.A.C.P. Consultants are intermediaries between the people and the

Letter, Mary McLeod Bethune to Dear Friends, May 10, 1945. Records of the National Council of Negro Women, Series 5, Box 34, Folder 493, United Nations 1944–1947. Reprinted by permission of National Park Service, Mary McLeod Bethune Council House National Historic Site, Washington, DC.

delegates, channeling to the delegates of every nation the wishes and aspirations of the masses in order that they may be inculcated into the structure of international planning. We also serve as interpreters to the people on the activities of the Conference, meeting constantly with the representatives of national organizations who have banded themselves together in one united group here in San Francisco. We advise with them and they advise us.

We are greatly concerned as to the fate of the peoples of the world. Colonial problems are in the forefront, and human rights for all people everywhere must be insisted upon. This is the most delicate and technical problem, requiring careful exploring, deep meditation, great wisdom and, above all, spiritual guidance.

It has been most interesting listening to the plea of forty-nine nations presenting their viewpoints in five different languages. Imagine looking into the face of stout little [Russian delegate V. M.] Molotov, who, though unable to speak a word of English and must depend upon his interpreter standing at his right ear, never misses a trick in political astuteness. And then the handsome and dapper [British delegate] Anthony Eden, splendid with his Chesterfieldian air and Oxfordian accent. I must confess that our own Stettinius is not far behind, either in manner or in sartorial excellence. He makes a marvelous presiding officer. The soft-spoken, perfect English-speaking Dr. T. V. Soong, the brother of Mme. Chiang Kai-shek, rounds out the picture of the four presiding officers who rotate as chairmen of the Plenary sessions. There are colorful Arabs in the persons of four sons and a grandson of King Ibn Saud, with ministers and body-daggers, and cartridge bandoliers. Egyptians, Liberians, friendly Latin American delegations and aloof Haitians, all there with India, Africa, Australia, Asia, Europe, and Americans to architect a peace for all people, in all lands.

Every nation is trying to make it clear that this organization which they intend to build shall function in accordance with the principle of justice, to safeguard and develop a respect for human rights and fundamental freedom. They are sincere in their effort to make the Rule of Moral Responsibilities supersede the Rule of Expediency, and in their belief that this moment, while the world is still in the agonies and suffering of war, is and must be the moment of action for peace, if we are to save ourselves from the doom of another world war.

You understand that the U.S. has seven delegates here: Edward Stettinius, Secretary of State; Rep. Sol Bloom; Rep. [Charles A.] Eaton; Dean Virginia Gildersleeve; Senator [Arthur H.] Vandenberg; Commander [Harold] Stassen; and Senator [Tom] Connally. There are three consultants for each of forty-two national organizations, totaling one hundred and twenty-six, only three of whom are Negroes.

We meet for special instructions and consultations as often as necessary. We contact the consultants of other nations on matters of international interests and concern, such as the future of the Mandate System and the trusteeship and full integration of colonial peoples into the rights of the Four Freedoms.

There are many different viewpoints which in the final analysis must be harmonized by the delegated representatives of the several nations. The interest of the American people at large is being manifested by the presence and participation in mass meetings and assemblies and in personal contact with the delegates as they meet in hotels, on the streets and in the Conference. It has been heartening to see the interest manifested by the Negro. We have here in San Francisco representatives of almost every national Negro organization—church, fraternal, political. They are making the plea for the masses of Negroes who cannot speak or plead for themselves. There has been a conspicuous getting together by the people of darker races. A fellowship and brotherhood among them is being formulated which will mean much in the tomorrow. This is a realization both spoken and meditated on the part of this Negro group in America, that America itself must do a great deal of house-cleaning in its treatment of the Negro here within its own borders before democratic ideals of human rights can be adequately projected from our viewpoint into this world program of freedom and brotherhood.

There are many such serious-thinking and well-formulated resolutions developing on all sides. Negroes are not asleep in San Francisco. White America is not asleep. We must clinch this opportunity for human rights now if it is ever to come.

The Negro has an unprecedented opportunity in this Conference on world security to lift his sights to encompass a world view of the problems of peace, and to think in unison with the representatives of all the forty-nine nations on the most effective means of settling national differences, of adjusting all grievances justly and equitably. This opportunity not only challenges the Negro to broaden his personal viewpoint but to establish a firmer basis for himself in the elevation of his own status in America.

Through this Conference the Negro becomes more closely allied with the darker races of the world, but more importantly he becomes integrated into the structure of the peace and freedom of all peoples everywhere. I am particularly interested in the trend of thought of the darker peoples of the world who are no longer to be reckoned as a numerical minority. One of the big questions of the Conference will be how to set up machinery for the inclusion of all small and depen-

dent peoples whose status is undetermined, yet whose voices are needed in clinching a durable peace. It is heartening and unique that we are, in contrast to all previous wars, while yet in the agony and suffering of a war-torn world, striking boldly for a lasting peace. To the Negro people, the World Security Conference in San Francisco has but one meaning, that is, how far democratic practices shall be stretched to embrace the rights of their brothers in the colonies as well as the American Negro's own security at home.

I am sending out a meditative petition for wisdom, guidance, judgment and courage for all heads of our great nations who must unitedly make the decision at this history-making Conference.

I feel humbly grateful for this opportunity to serve. My friends everywhere must send out prayers for wisdom, guidance and courage at a time like this. I have been wonderfully received as the only Negro woman consultant to the International Conference. I have been provided with two interviews with outstanding press. I have had conferences with many representatives and international conferees. I have found Mme. Pandit of India most interesting with a yearning in her heart for the delivery of her people. All of the darker races are pleading for equality of opportunity without discrimination because of color, and the right of self-determination. This is a great moving Conference.

Never before has the common man had such an opportunity to be heard. It is soul-stirring and awe-inspiring. I regard it as the greatest opportunity of my life to lend my strength and spiritual power to the building of a new and better, one world. I have great hopes for the outcome of the Conference, for its progress to this point has been encouraging.

I know that you are listening to the radio and reading the press on the important issues of this Conference. However, are you, in your study groups, social, political and church clubs, reviewing the proposals as they come through? I cannot emphasize too greatly the importance of your becoming familiar with their texts. Simple, free pamphlets have been prepared by the State Department and the Treasury Department. Among them are the following:

Dumbarton Oaks
Bretton Woods
The Agricultural Conference

Get them and study them.

Those of you who are listening daily must keep faith with us here on the firing-line that the goal may be achieved. We miss the voice of

our great, lamented Commander-in Chief, President Roosevelt [who
had died on April 12], but his spirit is here and the vindication of the
giving of his life that we, all of us, all nations here represented, are
determined to reach the worldwide humanitarian ideals he gave to all
of us.

Sincerely,
Mary McLeod Bethune

57 Our Stake in Tomorrow's World

Mary McLeod Bethune

THE SAN FRANCISCO INTERNATIONAL SECURITY CONFERENCE is a great
historic occasion for all of us. It marks a new epoch of world de-
mocracy—for here we see the world in action with sincerity and faith
as never before, absorbed in perfecting the blueprint for a new world
of tomorrow.

Women are interestingly and impressively a definite part of the
Conference, performing a variety of services ranging from authority
and responsibility at the core of developments—on issues and poli-
cies—to the fringe on the outskirts of the Conference where we see
the high-school girl gazing with naïve fascination at some delegate
from the Far East in picturesque garb. But it is not the mere presence
of the few women delegates, counselors, consultants, special advisers,
observers, secretaries, stenographers, teletype operators, messengers,
information booth attendants, and canteen workers that is significant.
The presence of women here marks their maturing political vision and
the gradual recognition of them by men, as well as the growing aware-
ness among women themselves of their contributions as citizens of
the world.

The extended horizon that has so rapidly appeared for women dur-
ing the war has opened new areas which of necessity have brought
rich experiences. Women have found themselves in new fields of work
and service which have given them an unparalleled opportunity to de-

Mary McLeod Bethune, "Our Stake in Tomorrow's World," *Aframerican
Woman's Journal* (June 1945): 2. Records of the National Council of Negro
Women, Series 13, Box 2, Folder 17. Reprinted by permission of National Park
Service, Mary McLeod Bethune Council House National Historic Site, Washing-
ton, DC.

velop new skills and habits of thought and behavior—a new kind of mental attitude and stamina, essential in tomorrow's world. May we accept the challenge to work together toward a new world of peace and security! It will take great skill in human relations—it will take common sense and an alert consciousness of national and world problems.

May we never think of the National Council of Negro Women as a segregated force in the building of this new world, but as a vastly important grooming ground for citizens who must eventually take their places in tomorrow's world. There are zones of activity which call for equally vital, strong, if not spectacular leadership in which women can give significant service. They are the areas in which women naturally work—areas which require high standards of human relationships.

May I conclude with a quotation from the undelivered [due to FDR's sudden death] Jefferson Day Address, April 1945, of Franklin Delano Roosevelt: "Today we are faced with the preeminent fact that if civilization is to survive, we must cultivate the science of human relationships—the ability of all peoples, of all kinds, to live together and work together in the same world, at peace. . . . The only limit to our realization of tomorrow will be our doubts of today. Let us move forward with strong and active faith."

XIII A Nearly Forgotten Legacy

Following the conclusion of World War II, American women continued their campaign to create a postwar world that promised equal rights and responsibilities for all, regardless of gender, race, religion, or social class. To achieve this end, they persisted in their call for the appointment of women to national and international assemblies. The designation of a woman to the U.S. delegation of the newly formed United Nations was given the highest priority. Document 58 is an October 10, 1945, letter written by Emily Hickman to members of the Committee on the Participation of Women in Post War Planning and reminding them that "we have to exert tremendous effort in urging upon the President and the State Department the appointment of a woman in this delegation." Attached to the letter was a list of six possible nominees for the UN position. Heading the list is the name of Eleanor Roosevelt, who was appointed to the delegation by President Harry S. Truman in December 1945.

Mary McLeod Bethune, like Emily Hickman, continued to press for women's inclusion on important national and international councils. Document 59 is a September 28, 1945, letter that Bethune wrote to Nannie H. Burroughs, the well-known African-American educator and founder of the National Training School for Women and Girls in Washington, DC, that emphasizes the important work that is still to be done.

In November 1945 the Committee on the Participation of Women in Post War Planning changed its name to the Committee on Women in World Affairs (CWWA). Document 60 is a November 30, 1945, letter to CPWPWP members announcing this name change. In Document 61, Emily Hickman discusses the challenges facing the CWWA. She remained its chair until her death in an automobile accident on June 12, 1947. In one of her last official communications to the members, she presented a detailed report of the important work of the CWWA during 1945–46. The report expressed pride in the fact that the CPWPWP was the first group to

obtain Eleanor Roosevelt's consent to submit her name for nomination as a delegate to the United Nations. The report also documented several other notable achievements of the CWWA. In reading this report, reprinted in Document 62, one cannot help but be impressed by the indefatigable nature and indomitable spirit of Emily Hickman as she carried on the work of the CWWA in the immediate aftermath of World War II.

Following her death, the CWWA remained in existence until April 1954, when the organization disbanded. Document 63 is a 1958 tribute to Emily Hickman written by Lucy Somerville Howorth. The world that Eleanor Roosevelt, Emily Hickman, Lucy Somerville Howorth, Mary McLeod Bethune, and other women activists of World War II so tirelessly strove to create has yet to be realized. Still, their vision and nearly forgotten legacy serve as a model for us as we approach the challenges of the twenty-first century.

58 Letter, Emily Hickman to Fellow Members of the CPWPWP

D ear Fellow Members of the Committee:

THE FIRST MEETING OF THE ASSEMBLY of the United Nations Organization is scheduled for December. It is very essential that the United States delegation of five includes at least one woman.

I am told that it is not safe to take it for granted that a woman will be appointed. That means, of course, that as members of the Committee, we have to exert tremendous effort in urging upon the President and the State Department the appointment of a woman in this delegation. Precedents which will affect the future considerably will be made as delegates are named for the first meetings of the organizations of the United Nations. The Charter explicitly contemplates the membership of both women and men as delegates to the principal organizations. Now is the time to see that that understanding is carried out.

Letter, Emily Hickman to Fellow Members of CPWPWP, October 10, 1945. Somerville-Howorth Papers, Series III, Lucy Somerville Howorth, Box 7, Folder 145, Committee on Women in World Affairs. Reprinted by permission of Arthur and Elizabeth Schlesinger Library on the History of Women in America, Radcliffe College, Cambridge, MA.

We are sending you an unusually good list of qualified women. May I urge your prompt support of these women in letters to the President and the Secretary of State, James F. Byrnes.

Sincerely yours,
Emily Hickman
Chairman

Qualified Women Suggested for Appointment in the American Delegation to the First Meeting of the United Nations

Anna Eleanor Roosevelt (Mrs. Franklin D.)

Mrs. Roosevelt was educated in private schools. She has the degree of Hebrew Literature from Russell Sage College. She is the mother of five children. Her many activities in educational, social, and political affairs are well known. From 1941–1942, she was the assistant director of the Office of Civilian Defense. Mrs. Roosevelt is a member of the New York State League of Women Voters. She is the author of a number of books including "It Is Up to the Women," "My Days," "Christmas, A Story, by Eleanor Roosevelt," and "The Moral Basis of Democracy." Probably no woman in the country has had a closer knowledge of both the domestic and foreign affairs of the nation. Mrs. Roosevelt has the confidence of a great body of American women.

Gladys A. Tillett (Mrs. Charles W.)

Mrs. Tillett is a graduate of the University of North Carolina and has made special studies in government at Columbia University. In 1941 she became Vice Chairman of the Women's Division of the Democratic National Committee and is still serving in that capacity. She is active in increasing the number of states in which women are given equal representation in the committees of the party organizations. Mrs. Tillett has three children. She has long been active in international interests. For ten years she was a member of the National Conference of the Cause and Cure of War Committee. She is a member of the National Board of the Y.W.C.A. and has been President of the North Carolina League of Women Voters. She is the State Chairman of the North Carolina Women's Action Committee for Lasting Peace. She

has been active in obtaining legislation in Congress and is widely known throughout the country.

Dorothy Smith McAllister (Mrs. Thomas F.)

Mrs. McAllister lives in Grand Rapids, Michigan, with her family of husband and two daughters. She is a graduate of Bryn Mawr College. From 1937–1941 she was the Director of the Women's Division of the Democratic National Committee. In Michigan she has been a member of the Michigan Constitutional Convention of 1933, the State Liquor Control Commission, and the Social Security Commission. She has also been a member of the National Committee to Abolish the Poll Tax. She is a member of the American Association of University Women, of the Woman's Organization for National Prohibition Reform, and was President of the Junior League of Grand Rapids from 1928–1931. She is a Director of the American Free World Association. Mrs. McAllister has had broad experience in public affairs and is accustomed to working with men similarly interested.

Ruth Bryan Owen Rohde

Mrs. Rohde is a daughter of William Jennings Bryan and was born in Illinois. She was educated at Nebraska University and Monticello College. Her present residences are in West Virginia and New York City. From 1928–1932 she was a member of Congress from Florida and served on the Foreign Affairs Committee at that time. From 1933–1936 she was Minister to Denmark. At the San Francisco Conference she was a Special Assistant to the Chief of the Liaison Division of the Department of State. Mrs. Rohde holds honorary degrees from Rollins College, Temple University, Hillsdale College, Florida State College and Russell Sage University. She is a member of the Board of Trustees of the University of Miami at which, for a time, she was a member of the faculty, as she was also at Monticello College, Illinois, teaching government and social science. During the first World War, Mrs. Rohde was Secretary for the Duchess of Marlborough Maternity Hospital and Superintendent of five workrooms for unemployed women in London. For three years she was a V.A.D. nurse in Egypt. She was a member of the Board of Advisers of the Federal Reformatory for Women and trustee of the Star Commonwealth for Boys. She is a member of Delta Gamma fraternity [*sic*], Delta Kappa Gamma, Theta Sigma Phi (women's journalists fraternity [*sic*]), the D.A.R., the Federation of

Women's Clubs, and an honorary member of the Business and Professional Women's Club. She is a Consultant for the Women's Action Committee for Lasting Peace. Mrs. Rohde speaks French, Danish, and German. She has lived in the West Indies, England, Germany, Denmark, Egypt and the Far East for periods of from six months to four years.

Frances Perkins

Miss Perkins was Secretary of Labor from 1933–1945. She is a graduate of Mount Holyoke College, taking her M.A. from Columbia University. She has honorary degrees from the University of Wisconsin and from Amherst College. She has one daughter. She has had considerable experience serving on government agencies. She was Chairman of the President's Committee on Economic Security, and a member of the Board of Economic Stabilization, the War Manpower Commission, the Federal Advisory Board for Vocational Education, and the National Archives Commission. She has written a number of books, among others, "A Plan for Maternity Care," "Women as Employers," "A Social Experiment under the Workmen's Compensation Jurisdiction," and "People at Work." She was awarded the medal for eminent achievement by the American Woman's Association. She is at present the chief government delegate to the I.L.O. [International Labor Organization] meeting in Paris.

Frances Payne Bolton (Mrs. Chester C.)

Mrs. Bolton has served in Congress from Ohio since 1939. Her district includes about one-third of Cleveland. Mrs. Bolton is a member of the Foreign Affairs Committee of the House. Last year Mrs. Bolton spent two months inspecting hospitals and medical installations on the European war front. She is at present on an official trip as member of the Sub-Committee on Eastern Europe and the Near East. Mrs. Bolton was a member of the Republican State Committee of Ohio. At the time of the first World War, Mrs. Bolton was instrumental in the establishment of the Army School of Nursing and she has been greatly interested in obtaining higher standards of education and service in nursing. She has been made an honorary member of the American Social Hygiene Association, and she has directed the work of the Payne Fund along these lines. Mrs. Bolton has honorary degrees from Colgate University, from Ohio Wesleyan University, from Baldwin-Wallace College, and from Western Reserve University. Mrs. Bolton has three sons.

59 Letter, Mary McLeod Bethune to Nannie Helen Burroughs

M_y dear friend:

THIS YEAR, THE NATIONAL COUNCIL of Negro Women will hold one of the most important meetings in its history. Now that the war has been brought to a victorious close, there is great need for solidarity and constructive planning, if we are to win the peace.

Negro women, like others, have a tremendous role to play in building the peace—our homes must be knit together, our children must be more closely guarded, more jobs must be obtained and made secure, our veterans must be rehabilitated, vital price controls must be kept, interracial and international relations must be extended and cemented. Until these and other things are done, there can be no relaxing, no settling down to a "before the war" attitude. We must help build a united and democratic world.

The National Council of Negro Women, realizing and facing the above problems, needs the counsel of strong women throughout the country. We are writing to ask that you make a special effort to be present this year at our Workshop. These are the days when women must think and work together.

Our meeting will be held October 30 and 31, 1945, at the Interdepartmental Auditorium, Constitution Avenue, N.W., Washington, D.C.

For further information, write to us here at National Headquarters. We shall anticipate your presence at this meeting.

Sincerely yours,
National Council of Negro Women
Mary McLeod Bethune
Founder-President

Letter, Mary McLeod Bethune to Nannie Helen Burroughs, September 28, 1945. Nannie H. Burroughs Papers, Box 3, Manuscript Division, Library of Congress, Washington, DC.

60 Letter, Emily Hickman to CPWPWP Fellow Member

My Dear Fellow Member,

THE EXECUTIVE COMMITTEE SUGGESTED that it would be a good idea to send an occasional letter to our members telling them what the matters are in which the Committee is concerned. The first matter is that the Executive Committee has voted to change the name of the Committee. It is now to be the Committee on Women in World Affairs. The former name was very long. It was also somewhat dated by the word Post War. I hope you will approve of the shorter name. I am enclosing a reprint of an article by Malvina Lindsay. It is very much to the point of our work.

We are planning an all-day meeting in Washington in January to discuss the whole problem of securing the appointment of women to policy-forming groups in the United States and in the international field. We find that it is difficult to learn of qualified women in the various fields, that we need close contacts with the State Department to learn when conferences will be held and what office in the Department is in charge of them, and we need to see what we can do to get more power behind our requests for appointment of women. It is possible that we need a paid or volunteer secretary in Washington, with an office address and a telephone. These are some of the matters which will be discussed at the January meeting. Any extension of our work will mean increased finances. That, too, will be discussed. Seven of the national women's organizations are cooperating in planning the program. As soon as the date is scheduled we will send you notice of the meeting and hope very much that you will be able to attend.

The conferences on which we worked recently to secure the appointment of women were the Conference on the Educational, Scientific, and Cultural Organization [UNESCO], which is now meeting in London. Dean C. Mildred Thompson of Vassar was appointed as a delegate and Dean Harriet Elliott of North Carolina was appointed as an advisor. These two women were the only women in the group of sixteen, fourteen of them being men. And this is a field in which about three-fourths of the people concerned are women.

Letter, Emily Hickman to CPWPWP Fellow Member, November 30, 1945. Records of the National Council of Negro Women, Series 5, Box 28, Folder 415, Post War Planning Committee of NCNW 1945, 1947, 1948. National Park Service, Mary McLeod Bethune Council House National Historic Site, Washington, DC.

We have worked also for the appointment of a woman to the United States delegation to the first Assembly of the United Nations Organization, which will meet in London the first week in January. It is doubtful if there will be a woman appointed. It is still not too late to write to the President and to the State Department, the office of Mr. Alger Hiss, urging the appointment of a woman. You might do this even if you did write at the time the first notice of the women whom the Committee was suggesting was sent you.

We have six conferences ahead of us: The Inter-American Institute of Geography and History, the Conference of the International Health Organization, the Inter-American Peace and Security Conference, the Ninth Inter-American Conference, the Inter-American Technical Economic Conference, and the International Trade Conference. There is plenty of work ahead. The Executive Committee appreciates very much your support of the Committee. We should welcome any communication from you and any suggestions which you would like to make. They would be very helpful to us.

<div style="text-align:right">

Sincerely yours,
Emily Hickman
Chairman

</div>

61 Letter, Emily Hickman to CPWPWP Fellow Member

Dear Fellow Member:

I WAS VERY MUCH PLEASED at the response from the membership which came back from the letter of information which we sent you in November. This is the December letter though it may be delayed until early January before it reaches you. We are planning the meeting in Washington called to consider the problem of getting women into the policy-forming groups for the last week in January. The exact date and place are not yet set. When they are, you will be notified and if possible, I hope you will attend. The meeting is in the nature of a conference between our Committee and women's organizations which are not members of the Committee but are interested in the same problem. We hope to discuss the problem, the difficulties, the ways of accom-

Letter, Emily Hickman to CPWPWP Fellow Member, January 4, 1946. Records of the National Council of Negro Women, Series 5, Box 7, Folder 134, Committee on Women in World Affairs 1945–1949. National Park Service, Mary McLeod Bethune Council House National Historic Site, Washington, DC.

plishing our objects, and the necessary machinery including financial measures.

We are confident that the time is come in which women are making great strides forward in their concern in public affairs. A considerable number of women was elected to the French Assembly. In Japan we understand that the women are being active politically in the reconstruction of that country. In all possibilities American women are not making very much use of the power which is theirs or of the ability which they have. We are concerned to see what can be done in pooling the interests of all the organized women's groups and in channeling their activities to a common goal. At the present time we have gotten only far enough to ask for one woman on a delegation. It is certainly time that women were appointed in larger numbers and without any regard to sex but rather to ability. It is still true that women have very little to share in the policy-planning groups. We are anxious to see what can be done to improve this.

The Committee feels that it has had a substantial part in securing the appointment of a woman to the United States delegation to the Assembly of the United Nations Organization. We are anxious to be equally successful in the conferences which are crowding the calendar for 1946. We are working on the Inter-American Conference of Peace and Security, on the Inter-American Technical Economic Conference, on the International Conference on Trade and Employment, and on the International Health Conference, all of which may occur in the next three or four months. Any suggestions of suitable women for nomination to any of these conferences will be appreciated.

Sincerely yours,
Emily Hickman
Chairman

62 Report of the Committee on Women in World Affairs, 1945–46

Chairman
Dr. Emily Hickman
27 Seaman Street
New Brunswick, N.J.

Secretary-Treasurer
Miss Helen Raebeck
1819 Broadway
New York 23, N.Y.

Report of Committee on Women in World Affairs, 1945–1946. Records of the National Council of Negro Women, Series 5, Box 15, Folder 246, Committee

(Please read and note requests)

THE RECORD OF THE WORK OF THE Committee on Women in World Affairs for 1945–1946 is a full and effective one. The primary business of the Committee has been to urge the appointment of women to the American delegations at international conferences and to present names of women qualified to serve in these capacities. The Committee has worked on representation for some seventeen international bodies during the year.

Five of these have been the new organs of the United Nations, beginning with the Assembly. The Committee submitted a list of six names to the Department of State for possible nomination to membership in the United States delegation. At the head of the list was the name of Mrs. Roosevelt. The Committee was the first group to get Mrs. Roosevelt's consent to the use of her name. We publicized this permission to our membership and to other women's organizations enlisting their endorsement. No other nomination of a woman has received such general support as did this of Mrs. Roosevelt.

Nominations of women were also presented for four other United Nations bodies: the Economic and Social Council, the Commission on Human Rights, the Temporary Social Commission and the sub-Commission on the Status of Women. Mrs. Roosevelt has been appointed chairman of the Commission on Human Rights. The Committee is actively urging the appointment of Judge Dorothy Kenyon to the sub-Commission on the Status of Women.

Four great international conferences either have been held or are scheduled for the immediate future. At the conference which organized the United Nations Educational, Scientific and Cultural Organization (UNESCO), Dr. Esther Brunauer was included in the delegation and has been appointed the United States representative to the organization, with the rank of minister. The conference to draw up a United Nations Health Organization is now in session. Of 13 advisers to the delegation, 3 are women as are 3 of the 4 secretaries and assistants. Dr. Elliott and one of the Advisers, Miss Mary Switzer, were nominated by the Committee. We are also much pleased that Mrs. Elmira B. Wickenden, Executive Secretary of the National Nursing Council, was named as an Adviser. The National Nursing Council is one of the member organizations of our Committee.

on Women in World Affairs, Correspondence H, January–July 1946. National Park Service, Mary McLeod Bethune Council House National Historic Site, Washington, DC.

The two international conferences in the immediate future are the International Trade Conference and the International Peace Conference. You received a list of nominations for each of these conferences. If we energetically urge the appointment of qualified women we can secure them.

At the Fourth Council meeting of the United Nations Relief and Rehabilitation Administration, Mrs. Ellen S. Woodward and Miss Doris H. Cochrane were 2 of the 14 advisers of the delegation.

Four inter-American conferences were announced for this year. We made recommendations for nominations for all of them. Three of them, however, have been postponed: the Inter-American Institute on Geography and History, the Inter-American Conference on Peace and Security, and the Inter-American Technical Economic Conference. The Third Inter-American Conference on Agriculture was held last July with Dr. Hazel Stiebeling as a member of the delegation.

The International Labor Organization held its third Inter-American Conference on Labor Problems. Two of the five advisers to the delegation were women. The United States Mission to observe the Greek elections numbered one woman among the advisers. She was Dr. Sarah Wambaugh, whom the Committee warmly sponsored.

The original list of educators to visit Japan contained the names of 28 men and 2 women. The Committee earnestly protested this proportion and was instrumental in securing the nomination of 4 women in the final delegation of 20.

The Committee has also furnished the Administration with a list of some women educators using the term in a broad sense to include various fields of education. It has, too, compiled for the government a list of women who would be qualified to serve on ad hoc committees of the Commission on Human Rights and of the sub-Commission on the Status of Women.

Occasional recommendations have been made, such as that of a woman as member of the New York State World Trade Corporation and as member of the Federal Advisory Panel on Juvenile Delinquency.

The Committee has called to the attention of its members these seventeen international bodies. It has sought and found qualified women who could be nominated as members. It has insistently urged upon the government the necessity for the inclusion of qualified women in these bodies. It has met with government cooperation. It has afforded its members an opportunity for united and intelligent effort in securing the services for the country of our able women.

During the year the Committee changed its name from "Committee on the Participation of Women in Post-War Planning" to the

"Committee on Women in World Affairs." The change has met with unanimous approval.

The Committee has set up two committees to list outstanding women in two fields, Economics and Sociology, and Law. It is working on a committee to list outstanding women educators.

The Committee is one of the organizations which receives the publications of the State Department on a reciprocal basis. It has been accorded the privilege of attendance at the meetings of the United Nations Assembly in London, the Security Council, the Economic and Social Council and its commissions, the Council meetings of UNRRA, and the Food and Agriculture Organization meeting.

On January 30 the Committee held an open meeting in Washington with an admirable program planned with the cooperation of our Washington chairman, Mrs. James W. Irwin. Mrs. Spikes from the British Embassy, Miss Connelly and Judge [Lucy Somerville] Howorth from the Veterans Administration, Mrs. Morgan from our Washington Committee, Dr. [Kathryn] McHale of the American Association of University Women, Miss Raebeck our Secretary-Treasurer, Mrs. Chase Going Woodhouse, Congresswoman from Connecticut, Dr. Esther Brunauer of the State Department and Mr. Dean Acheson the Under Secretary of State were the speakers. They discussed the positions open to women, the difficulties in the way of advancement for women in the Departments, the effect of veterans legislation, and the openings for women in the United Nations. It was very evident that the women in the Departments need the support of women, and their appreciation of the work of the Committee was keen.

The meeting also discussed how the Committee could best carry on its work. It was clear that work to secure women appointees in government service in fields other than the international was crying for attention and would promise real rewards. To undertake extension of the Committee's work would require the employment of a secretary and additional funds. At the meeting a special fund of contributions was begun to be available when the work of the Committee was enlarged and to encourage the finance committee in securing further gifts. The January meeting acquainted many persons in Washington with the Committee and its work.

During the year a new organization, "The Multi-Party Committee of Women," has been formed "to work for the appointment and election of qualified women in public office." The chairman is Mrs. Mary O'R. Bollman, President of the New York City Federation of Business and Professional Women's Clubs. This committee is composed of individual members. The organization hopes to have similar committees set up in each of the states and has now two or three such committees.

Their aim at present is chiefly confined to securing local and state appointments for women. The New York City committee, however, evidently expects to serve as the committee for New York State and a national committee and to act, as it becomes interested, in various national appointments.

The two Committees held a joint meeting May 28 in New York and described to each other their plans of action. Mrs. Begtrup, Chairman of the United Nations sub-Commission on the Status of Women, also addressed the meeting. The Executive Committee of our Committee voted to exchange with the "Multi-Party Committee" lists of nominations as made and to take action on such nominations of the "Multi-Party Committee" as the Executive Committee directed.

In the immediate future, September and October, there are two international conferences scheduled: the meeting of the International Labor Organization and the Food and Agriculture Organization. We are at work now on suggestions for those nominations and lists will be sent you shortly. Later, in December, will come the ninth International Meeting of the American States. Other meetings will appear as the year goes on.

Good government is a crucial interest with us all. We are accustomed to urging women to vote, to take part in the primaries. Another road to good government is through the appointment of qualified women to office. The record of these women is amazingly heartening. Is it possible that we women do not yet recognize the necessity of getting qualified women appointed if we want good government?

The picture of progress is not all rosy-colored. A government plan for reorganization now pending will eliminate practically all of the top positions held by women. You will shortly receive a communication about the effect of this reorganization plan.

There is considerable discussion in Washington about putting women into some of the still existing top positions and into some new ones to be created. A letter on suggestions for women for these positions has probably already reached you.

The Committee gives its members an opportunity to work effectively for the appointment of qualified women. It is painstaking in its search of suitable nominations. It deserves confidence as a specialized committee working in a special field. It has considerable "know-how" in finding qualified women. Thank fortune, there are many of them.

Previously we have asked of our members chiefly letters to the appointing officers, urging the appointments suggested. Those letters are still an important service members can render. They must now be supplemented, however, by personal support. This can certainly be

accomplished by the members of the Washington Committee and of the Executive Committee. Probably best of all it can be done through the Washington representatives of the national organization members of the Committee. Each of these organizations has a member on the Executive Committee and so knows intimately the work of the Committee. Will your organization help through your Washington representative?

Our opportunity is great. Government cooperation is available. One of the Assistant Secretaries of State wrote me, "I am personally in complete agreement with the purposes of your Committee on Women in World Affairs. All my life I have believed that women are just as good as men in professional work, and in many executive positions I would prefer to place a woman." Surely we should give thought and determined effort to this work. We are relying on you for this.

Before closing this report, I must express to Miss Helen Raebeck and to the National Council of Jewish Women whose International Relations Secretary she is, the very real appreciation of the Committee for the helpful, devoted work she has done as its Secretary-Treasurer for three years. Through Miss Raebeck's interest, the National Council has mimeographed without charge and sent out all the communications of the Committee. Now both Miss Raebeck's responsibilities and the work of the Committee have increased and it is necessary to engage secretarial aid to carry on.

The Committee will welcome comments, criticisms, and suggestions on the work. Please send them to us.

<div style="text-align:right">Emily Hickman
Chairman</div>

63 1958 Tribute to Emily Hickman

Lucy Somerville Howorth

To accompany file of Women in World Affairs, Successor to Committee for Participation of Women in Postwar Planning—I think I destroyed my file on the Committee for Participation of Women in

Lucy Somerville Howorth, "1958 Tribute to Emily Hickman." Somerville-Howorth Papers, Series III, Lucy Somerville Howorth, Box 7, Folder 145, Committee on Women in World Affairs. Reprinted by permission of Arthur and Elizabeth Schlesinger Library on the History of Women in America, Radcliffe College, Cambridge, MA.

Postwar Planning and I kept very few of the papers relating to the successor organization.

Dr. Mary Woolley had the idea, a very sound one, that unless women organized to advance the representation of women in the peace conference which everyone anticipated, they would not be present at the peace table, as the expression went. Dr. Woolley was unwell and she persuaded Dr. Emily Hickman to be the active Chairman [of the CPWPWP, later CWWA]. The latter years of Dr. Woolley's life were dedicated to the promotion of peace and she was firmly convinced that a permanent peace was more likely if women had a share in shaping post war policies.

I became a member of the Washington Executive Committee very early in the life of the Committee and want to put in the record a tribute to Dr. Hickman. She combined scholarly attributes with a very practical turn of mind. She was indefatigable and the accident which took her life was probably due to overwork for this Committee. She came to Washington frequently and whenever those of the Washington group thought she should. I was with her in many of the conferences here and she was patient, wise and persistent.

Some have sniffed at the Committee and have said it did nothing substantial to accomplish its purpose. The fact remains, that in the plethora of meetings, committees and commissions and conferences which began as WWII was coming to an end, women were present to a greater extent than ever before. There were other forces working for the same end. If this committee had done nothing but alert other groups, notably the Women's Division of the Democratic National Committee, it would have rendered a necessary service. Dr. Hickman checked at times almost daily with the State Department and other agencies of the Government to make certain we knew when a meeting was being planned. Knowing how generally weak women are in this area, I think nothing should be discounted; certainly, women owe a great deal to Dr. Hickman and this Committee.

Lucy Somerville Howorth

Suggested Readings

Primary sources on women and postwar planning are scattered in various archives throughout the United States. Unfortunately, the papers of Emily Hickman and the leadership role that she undertook as founder and chair of the Committee on the Participation of Women in Post War Planning have not survived. The work of the CPWPWP can be pieced together by culling the records of the National Council of Negro Women at the Mary McLeod Bethune Council House National Historic Site in Washington, DC, and the Lucy Somerville Howorth materials in the Somerville-Howorth Papers at the Arthur and Elizabeth Schlesinger Library on the History of Women in America at Radcliffe College. The Charl Ormond Williams Papers at the Library of Congress contain detailed records of the June 1944 White House Conference, "How Women May Share in Post-War Policy Making." Relevant materials may also be found in the Clare Boothe Luce Papers at the Library of Congress, the Nannie Helen Burroughs Papers at the Library of Congress, the Mary Church Terrell Papers at the Library of Congress, the Margaret Chase Smith Papers at the Margaret Chase Smith Library at Skowhegan, Maine, and the Margaret A. Hickey Papers at the Western Historical Manuscript Collection at the Thomas Jefferson Library, University of Missouri, St. Louis. In addition, the *New York Times* and the *New York Herald-Tribune* provided significant coverage of the postwar planning work of U.S. women.

Although a number of important works on women and World War II have been published, the topic of women and postwar planning has received scant attention. Significant works on women's role and status during World War II include William H. Chafe, *The American Woman: Her Changing Social, Economic, and Political Role, 1920–1970* (New York, 1972); Leila J. Rupp, *Mobilizing Women for War: German and American Propaganda, 1930–1945* (Princeton, 1978); Karen Anderson, *Wartime Women: Sex Roles, Family Relations and the Status of Women during World War II* (Westport, CT, 1981); Susan M. Hartmann, *The Home Front and Beyond* (Boston, 1982); D'Ann Campbell, *Women at War with America: Private Lives in a Patriotic Era* (Cambridge, MA, 1984); Maureen Honey, *Creating Rosie the Riveter: Class, Gender and Propaganda during World War II*

(Amherst, 1984); Sherna B. Gluck, *Rosie the Riveter Revisited: Women, the War and Social Change* (Boston, 1987); Ruth Milkman, *Gender at Work: The Dynamics of Job Segregation of Sex during World War II* (Urbana, 1987); Mary Martha Thomas, *Riveting and Rationing in Dixie: Alabama Women and the Second World War* (Tuscaloosa, 1987); Amy Kesselman, *Fleeting Opportunities: Women Shipyard Workers in Portland and Vancouver during World War II and Reconversion* (Albany, 1990); Judy Barrett Litoff and David C. Smith, *Since You Went Away: World War II Letters from American Women on the Home Front* (New York, 1991); Judy Barrett Litoff and David C. Smith, *We're in This War, Too: World War II Letters from American Women in Uniform* (New York, 1994); and Judy Barrett Litoff and David C. Smith, eds., *American Women in a World at War: Contemporary Accounts from World War II* (Wilmington, DE, 1997). With the exception of two paragraphs in Hartmann, *The Home Front and Beyond*, 148–49, these works do not focus on women and postwar planning.

In addition, studies that focus on women and American foreign policy do not discuss this topic. See, for example, Rhodri Jeffreys-Jones, *Changing Differences: Women and the Shaping of American Foreign Policy, 1917–1994* (New Brunswick, 1995); Ann Miller Morin, *Her Excellency: An Oral History of American Women Ambassadors* (New York, 1995); Nancy E. McGlen and Meredith Reid Sarkees, *Women in Foreign Policy: The Insiders* (Wilmington, DE, 1993); Edward P. Crapol, ed., *Women and American Foreign Policy: Lobbyists, Critics, and Insiders* (Wilmington, DE, 1992); Blanche Wiesen Cook, " 'Turn Toward Peace': ER and Foreign Affairs," in *Without Precedent: The Life and Career of Eleanor Roosevelt*, Joan Hoff-Wilson and Marjorie Lightman, eds. (Bloomington, 1984), 108–21; Jason Berger, *A New Deal for the World: Eleanor Roosevelt and American Foreign Policy* (New York, 1981); and Homer L. Calkin, *Women in the Department of State: Their Role in American Foreign Affairs* (Washington, DC, 1977). Three works that give cursory attention to U.S. women and postwar planning are Cynthia Harrison, *On Account of Sex: The Politics of Women's Issues, 1945–1968* (Berkeley, 1988); Leila J. Rupp and Verta Taylor, *Survival in the Doldrums: The American Women's Rights Movement, 1945 to the 1960s* (New York, 1987); and Leila Rupp, *Worlds of Women: The Making of an International Women's Movement* (Princeton, 1997).

Recent studies that emphasize the importance of exploring the place of gender in the study of foreign policy include J. Ann Tickner, *Gender in International Relations: Feminist Perspectives on Achieving Security* (New York, 1993); Jill Stearns, *Gender and International Relations: An Introduction* (New Brunswick, 1998); Judith Papachristou,

"American Women and Foreign Policy, 1898–1905: Exploring Gender in Diplomatic History," *Diplomatic History* 14 (Fall 1990): 493–509; Laura McEnaney, "He-Men and Christian Mothers: The America First Movement and the Gendered Meanings of Patriotism and Isolationism," *Diplomatic History* 18 (Winter 1994): 47–57; and Emily Rosenberg, " 'Foreign Affairs' after World War II: Connecting Sexual and International Politics," *Diplomatic History* 18 (Winter 1994): 59–70.